ITALIAN GLASS

CENTURY 20

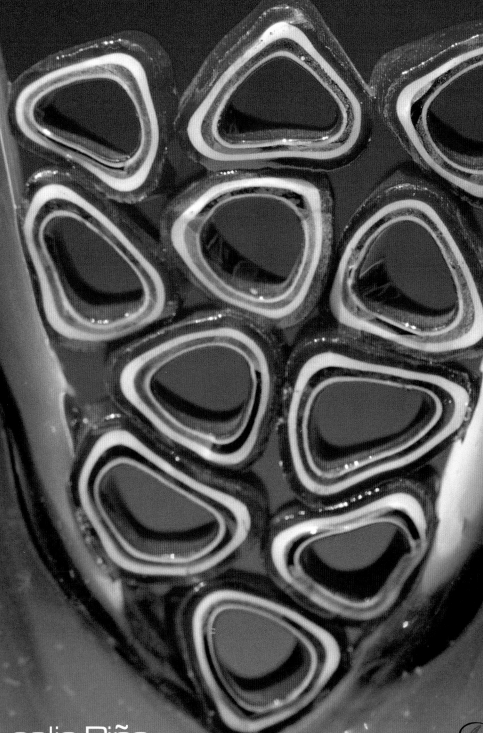

Leslie Piña

Schiffer Publishing Ltd®

4880 Lower Valley Road, Atglen, PA 19310 USA

Library of Congress Cataloging-in-Publication Data

Piña, Leslie A., 1947-
 Italian glass: century 20/by Leslie Piña.
 p. cm.
 Includes bibliographical references.
 ISBN 0-7643-1929-9 (pbk.)
1. Glassware—Italy—History—20th century—Catalogs. I. Title.
NK5152.A1 P56 2003
748.295'09'04075—dc21

 2003012448

Designed by Leslie Piña
Layout by John P. Cheek
Type set in Korinna BT

ISBN: 0-7643-1929-9
Printed in China
1 2 3 4

Published by Schiffer Publishing Ltd.
4880 Lower Valley Road
Atglen, PA 19310
Phone: (610) 593-1777; Fax: (610) 593-2002
E-mail: Info@schifferbooks.com
Please visit our web site catalog at
www.schifferbooks.com
We are always looking for people to write books on
new and related subjects. If you have an idea for a
book please contact us at the above address.

This book may be purchased from the publisher.
Include $3.95 for shipping.
Please try your bookstore first.
You may write for a free catalog.

In Europe, Schiffer books are distributed by
Bushwood Books
6 Marksbury Ave.
Kew Gardens
Surrey TW9 4JF England
Phone: 44 (0) 20 8392-8585;
Fax: 44 (0) 20 8392-9876
E-mail: Bushwd@aol.com
Free postage in the U.K., Europe; air mail at cost.

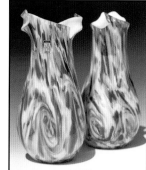

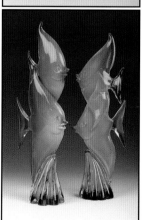
CONTENTS

Credits

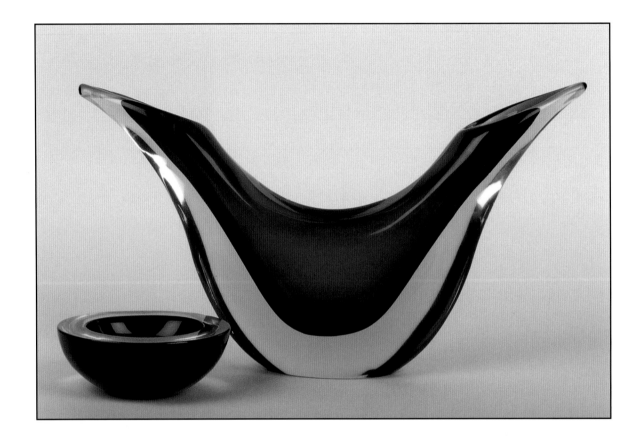

Special thanks to David Rago Auctions in Lambertville, New Jersey for generously permitting me to reproduce beautiful photos from their Modern Italian Glass auction of October 2000; to Carlo Moretti of Murano, Italy for permission to reproduce portions of their recent brochures, photographed by Sergio Sutto; to Memphis in Milano, Italy for permission to use photos from Memphis brochures; Laura Friedman who provided photos of some of the wonderful pieces from her web site PlanetGlass.net; to Lorita Winfield for her photos of Venice, Murano, and a sample of the glass factories; to Geoff Clarke for his photos of glass in Australian collections of M. Lacis and J. Dilder; to collectors Michael Ellison, Lorenzo Vigier, and others who provided the glass for us to photograph. Special thanks to Lorenzo for proof reading, adding information, and correcting errors; I always take for granted Ramón's invaluable photography assistance, but he understands.

No book is possible without the painstaking research that others have already done. The books and auction catalogs in the bibliography are only a sample of the many contributors to the field, and to this endeavor. Many thanks to the Ursuline College library, OhioLINK, and the Interlibrary Loan system. And once again, I would like to thank my editor, Doug Congdon-Martin, my friend Peter Schiffer, and the staff at Schiffer Publishing.

Introduction

Italian, or more specifically Murano, glass is sought after by collectors for good reasons. Since the Renaissance, some of the world's most talented glassmakers were born into families already established in the traditions of glassmaking on the island of Murano off the coast of Venice. The most astounding technical virtuosity became a hallmark of Venetian glass that was crafted for kings and the social elite. This tradition flourished for centuries, and Italy captivated an audience with its apparent monopoly on intricate *murrines*, twisted filigree, and *aventurine*, inclusions of gold and copper particles and powders. The skill and versatility remained unchallenged, until success was taken for granted and Muranese companies became complacent.

By the eighteenth century, other European countries had already learned the techniques from Muranese glass artists who "defected" from the island of Murano. Motivated by success, glasshouses in England, Bohemia, and throughout Europe developed their own styles and techniques. Focus on cold decorating techniques of cutting and engraving occupied the Northern Europeans, while Italy continued a tradition of making hot-decorated Renaissance styles. The popularity of mirrors and chandeliers contributed to the demand for Venetian glass, but Italy had lost a good deal of its international leadership in creativity.

The nineteenth century witnessed further decline. European and American preoccupation with the past, excessive decoration, and sentimentality affected Italian glassmaking as well. Not only were already-tired Renaissance styles revived, they were smothered with applied decoration in carnival colors. Technical skill, though not necessarily as high as the original Renaissance work, was overshadowed by arbitrary interior and exterior decoration on vessels, regardless of their function. Off-hand mouth blown glass was still the Italian staple at a time when machinery was enlisted to produce huge quantities of cheaper, newer, more novel glass in America and England. Even the icons of Italian glass — twisted ribbons, canes, and filigree — were used elsewhere, notably by the French to make astounding paperweights in the mid nineteenth century. Italian glass had apparently lost its way. Yet in the second half of the nineteenth century, Fratelli Toso initiated a revival in the old techniques and creative spirit. Followed by another great company, Salviati, in the later part of the century, the Muranese glass industry now had more to offer than beads.

It is the twentieth century that marks the transition between old and new. Rather than a revival of anything and everything historic, this new Italian glass was again lively and innovative. Implied or actual function was freely abandoned in favor of artistic merit. The line between functional decorative art and fine art became blurred. Though many Muranese furnaces continued to turn out more of the same old styles (adding to the confusion of dating these pieces), a new generation of designers, trained in fields such as architecture and painting, appeared. Inspired by the onset of modernism in all design, these new leaders pulled the Muranese glass industry out of the doldrums and into the twentieth century. By the 1920s, figures such as Vittorio Zecchin were helping to inject Italian glassmaking with principles of modernism.

The Venini firm was founded in 1921, and by mid-century it was still considered to be the leading glassmaker in Murano. Some of the 1950s designs by Carlo Scarpa, Fulvio Bianconi, and Paolo Venini actually date back to the 1930s and 1940s, but greater production and recognition at international exhibitions occurred during the 1950s. In addition to Venini, other Muranese superstars, such as Alfredo Barbini, Ercole Barovier, Gino Cenedese, Antonio Salviati, and Archimede Seguso created such momentum in the

1950s that the glass factories they were associated with are among the leaders in Murano today, and their earlier production has gained well-deserved recognition.

Although mid-century designs by Venini and others were modern, they were not done without reference to the history of Venetian glassmaking. If one technique can characterize that history it would be *latticino*, the use of fine thread-like and thicker strands of filigree internally decorating the otherwise clear cristallo. Similarly, if one technique or set of techniques could characterize the Venini factory it would also be filigree, especially the *zanfirico*, or twisted filigree patterns. Venini's designers and master glassblowers took the glass thread and colored, twisted, and wove it as it had not been done before.

Another decorative technique that gives Venetian glass its distinctive look is the use of metallic particles and powders. These can be controlled within the glass by first mixing the metal with liquid *cristallo* and using it in stripes and patches, which is called aventurine. Another method involves taking thin sheets of gold or silver leaf, applying them to the surface of the hot glass, then blowing the vessel. As the hot vessel expands, the thin metal on the surface breaks apart, leaving tiny patches or particles. Aside from the company's early years, Venini did not usually use metal particles as decoration, but other important furnaces such as Archimede Seguso, Barovier & Toso, and Barbini achieved some intriguing effects with metallic inclusions.

A technique used for Murano glass that gives it a distinctive mid-century look can also make attribution of unmarked pieces confusing. *Sommerso*, or colored shapes encased in very thick glass, was used successfully from mid century on. Flavio Poli designed some of the most outstanding examples for Seguso Vetri d'Arte, and Archimede Seguso designed similar forms. These heavy sculptural vessels seemed to make the transition between decorative, or applied, art with a function and fine art without any practical use. Eventually, the opening was omitted, the implied function of a vase or other vessel was deemed unnecessary, and art glass crossed the line to glass art. Usually unsigned, *sommerso* designs are being made today in Murano as well as other European glass centers.

This combination of talent and creativity, dedication and technical skill, is what makes Italian glass one of the best examples of good design in the twentieth century. The focus of this book will be on some of the accomplishments by leading figures of modern Italian glass. In addition to "museum" pieces, many of these designs are neither rare nor particular valuable. Yet even some of the production pieces are important in the century's design picture — such as Carlo Moretti's long-necked vases with satin finish or the lavish ashtray-bowls Ermanno Toso designed for Fratelli Toso. These more common items were designed well, and their larger production allows more people to enjoy an example of good Italian glass.

With the high costs of producing glass by hand, many glass factories in the United States and Western Europe have disappeared. No longer able to hire designers to work with teams of glass artists, much of the factory glass production has shifted to Asia and Eastern Europe. Studio glass, the result of a movement that began in the 1960s in the United States, has blossomed in an international arena. With all of the changes that have occurred in the manufacture of decorative glassware and art glass during the later 20th century, Italy has remained a stable force and staple source. Some factories on the island of Murano have closed; others have opened; some have endured economic and social pressures and continue today. The following pages sample the legacy of the past stars and the living tradition of today's leading furnaces.

A Note on Pricing

It would be too idealistic to think that artistic pleasure is the reader's only interest. Glass is also a collectible and a commodity, and in some instances an investment. The glass shown in this book is the kind that appears at auction, in shows, malls, shops, flea markets, and web sites. It is exchanged; it has value; it has a price. The price ranges included in the captions are simply reports of actual transactions that have occurred recently in this varied regional and international marketplace. Prices will vary even more in this marketplace than indicated in the ranges published here, and similar items will be found outside of these ranges. My intent is to provide a sense of relative value from the common piece to the masterpiece. And of course, *neither the author nor publisher is responsible for any outcomes from consulting the price guide*. We would like to take some responsibility, however, for the aesthetic pleasure you are likely to experience.

Prices are in US dollars. Centimeters are rounded to the nearest half.

Venice

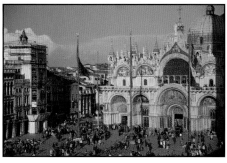

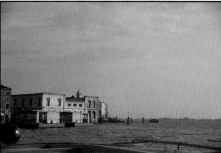
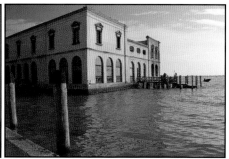

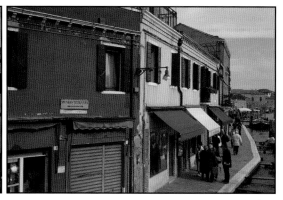

For the first time ever, the best known and most successful companies of Murano Crystal glass-art have come together in just one show-room to allow the public to view and purchase their creations at controlled prices and with a full guarantee of authenticity.

Articles created by the best known modern designers are present: from the classic ones for collections to the most recent creations available.

It is also possible to view the complete catalogues of the producing companies and receive full information.

murano collezioni
Fondamenta
Manin 1 CD
30141 Murano
Venezia · Italy
phone
+39 041736272
fax
+39 0415276196
e-mail
muracoll@tin.it

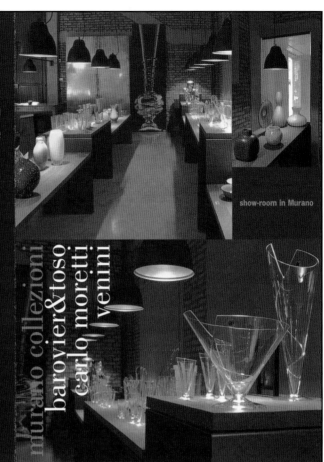

show-room in Murano

murano collezioni
barovier&toso
carlo moretti
venini

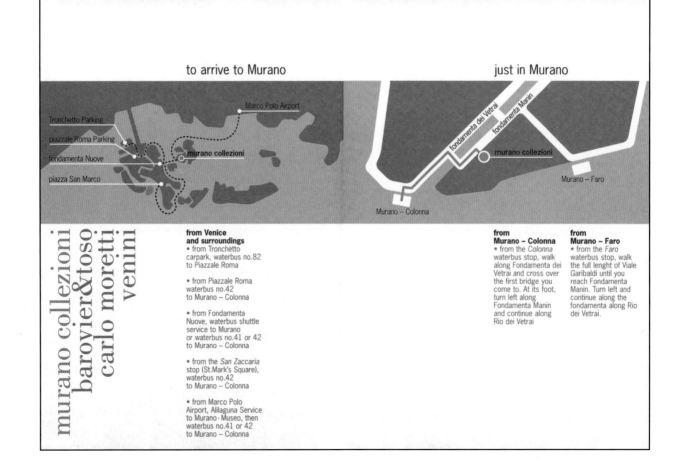

to arrive to Murano

just in Murano

Marco Polo Airport

Tronchetto Parking
piazzale Roma Parking
fondamenta Nuove
piazza San Marco

murano collezioni

fondamenta dei Vetrai
fondamenta Manin

murano collezioni

Murano – Colonna

Murano – Faro

murano collezioni
barovier&toso
carlo moretti
venini

from Venice and surroundings
• from Tronchetto carpark, waterbus no.82 to Piazzale Roma

• from Piazzale Roma waterbus no.42 to Murano – Colonna

• from Fondamenta Nuove, waterbus shuttle service to Murano or waterbus no.41 or 42 to Murano – Colonna

• from the *San Zaccaria* stop (St.Mark's Square), waterbus no.42 to Murano – Colonna

• from Marco Polo Airport, Alilaguna Service to Murano · Museo, then waterbus no.41 or 42 to Murano – Colonna

from Murano – Colonna
• from the *Colonna* waterbus stop, walk along Fondamenta dei Vetrai and cross over the first bridge you come to. At its foot, turn left along Fondamenta Manin and continue along Rio dei Vetrai

from Murano – Faro
• from the *Faro* waterbus stop, walk the full lenght of Viale Garibaldi until you reach Fondamenta Manin. Turn left and continue along the fondamenta along Rio dei Vetrai.

Companies

A.VE.M. (Arte Vetraria Muranese) (1932-)

A.VE.M. was founded in 1932 in Murano by the master glassmakers who had left Succussori Andrea Rioda: Antonio, Egidio (1889-1968), Galliano (1896-1984), Ottone, and Ulisse Ferro and Emilio Nason (1891-1959). Giulio Radi (1895-1952) became a partner and artistic director in 1935. The first designs by Vittorio Zecchin (1878-1947) were exhibited at the 1932 Venice Biennale and Milan Triennale. In 1937 Emilio Nason's son Aldo joined the firm as a glassblower. The most important postwar work was innovative and colorful, designed by Giulio Radi (until his death in 1952) and under the supervision of Aldo Nason (b. 1920). Nason worked as a glassblower and then a designer at A.VE.M. from 1953 until 1967, when he left to form his own company. Egidio Ferro's son Luciano (1925-1972) was a master glassblower who worked on fiery and vibrant pieces designed by Ansolo Fuga, who free-lanced for A.VE.M. from 1955-1969. Giulio Ferro died in 1976 and his sister Ada Ferro reorganized as A.VE.M. Arte Vetraria Muranese s.a.s. She heads the company today, but they are not producing. A.VE.M. did not sign the pieces but used a green, red, or blue metallic circular paper label.

Barbini Glassworks (Vetreria Alfredo Barbini) (1950)

After working for S.A.I.A.R. Ferro Toso, Zecchin Martinuzzi, Seguso Vetri d'Arte, and V.A.M.S.A., Alfredo Barbini became a partner at Gino Cenedese & C. in 1947. He began his own furnace, Barbini Glassworks, in 1950 and excelled at making heavy sculptural forms for which he won international awards, such as the *Croce di Cavaliere al merito* in 1955. Barbini's daughter Oceania Barbini-Moretti joined the firm in 1952, and his son Flavio (b. 1948) joined as a designer in 1968. Designers included Luciano Gaspari and Vinicio Vianello in the early 1950s, Raoul Goldon in the 1960s, and Napoleone Martinuzzi from 1960 to 1975.

The company also made knickknacks, such as ashtrays and figurines, which were imported exclusively by Weil Ceramics & Glass Inc. in New York City with branches in Hingham, Massachusetts and Los Angeles. The firm reorganized in 1983 under the name Alfredo Barbini S.r.l. They are still producing and are one of the major glasshouses in Murano.

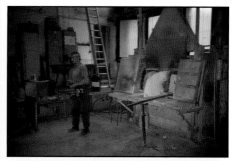

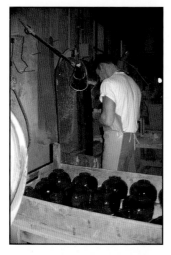
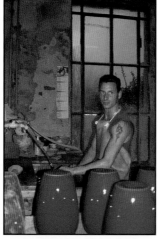
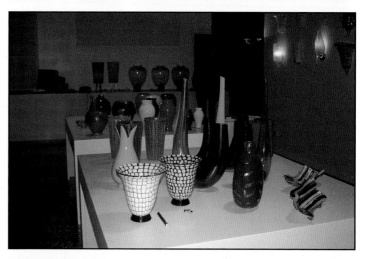

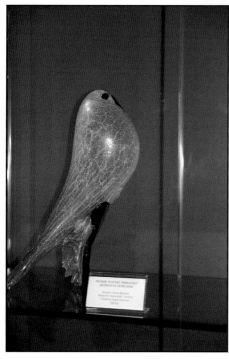

Barovier & Toso (1877-)

The company was founded in 1877 by Antonio Salviati (1816-1890), Giovanni Barovier (1839-1908), and his cousins, but had origins in the 14th century in Murano. It went under the name Artisti Barovier at the end of the 19th century and then Vetreria Artistica Barovier in 1919. At that time, Nicolò Barovier (1895-1947) began working as a designer and left in 1933.

In 1936 Artemio and Decio Toso (owners of S.A.I.A.R. Ferro Toso) merged with Barovier to form Ferro-Toso-Barovier, which became Barovier & Toso in 1942. Their highest achievements were during the 1950s, especially with the imaginative and technically superior use of patchwork and *murrine*. Several other designs such as the textured surface of *barbarico* are unique to the company and were the work of Ercole Barovier, head designer from 1930 until 1972. His son Angelo joined the firm in 1947, began designing in 1951, and became artistic director in 1972. Later designers include Matteo Thum (b. 1952), Noti Massari (b. 1939), architect Renato Toso (b. 1940), and architect Toni Zuccheri (b. 1937). Many different paper and foil labels were used, as well as an engraved signature, and these can be useful in dating pieces. Today the company is directed by Angelo Barovier, his son Jacopo, and Mario Toso's son Giovani. In 1995 Barovier& Toso opened its museum with more than 250 masterpieces from the nineteenth century to 1975. In 1998 they acquired B.A.G. in the Czech Republic, which is now called Barovier & Toso Czech Republic s.r.o.

www.barovier.com
barovier@barovier.com

M.V.M. Cappellin (Maestri Vetrai Muranesi) (1925-1931)

Giacomo Cappellin (1887-1968), a co-founder of Venini & Co. in 1921, left the firm in 1925 with Rafaello Levi, Enrico Galvani, and several master blowers from Venini. Together they founded M.V.M. Cappellin. Not known for decoration other than applied glass threading, especially on rims and bases, they concentrated on making light monochrome pieces designed by Vittorio Zecchin. He left in 1926, and Carlo Scarpa joined in 1927. The company experienced financial problems and ceased production in 1931. Giacomo Cappellin went to Paris in the late 1930s to produce perfume bottles. An acid stamp signature was used on some of the Cappellin glass.

Cenedese & C. (Vetreria Gino Cenedese) (1946-)

The company was established in 1946 in Murano by Gino Cenedese and others. Alfredo Barbini became a partner, artistic director, and master glassblower in 1947. When Barbini left in 1950, Cenedese designed glass along with freelance designers. Fulvio Bianconi designed for Cenedese in the mid 1950s and exhibited at Venice Biennales. Painter Riccardo Licata (b. 1929) and Napoleone Martinuzzi also designed for the firm in the 1950s. In 1959 architect Antonio Da Ros (b. 1936) became artistic director and used the *sommerso* technique; he also produced figural and sculptural pieces. He worked with glassblower Ermanno Nason (b. 1928) in the 1960s. As artistic director, Da Ros still uses the *sommerso* technique. When Gino Cenedese died in 1973, his son Amelio reorganized under the name Gino Cenedese & Figlio. In 1993 Cenedese absorbed Seguso Vetri d'Arte, but Seguso soon returned as a separate company. Pieces were often not signed or labeled, but both paper labels and engraved signatures can be found.

I.V.R. Mazzega (Industrie Vetrarie Riunite) (1938-1983)

Founder Romano Mazzega operated a small glass factory in the 1930s producing glass inspired by other Murano companies. After selling the factory to Aureliano Toso in 1937, Romano, his brother Gino, and sister Maria Mazzega formed a new factory in 1938. This was originally called Fratelli Mazzega, but after World War II became I.V.R. Mazzega.

Ermanno Nason and Pino Signoretto were master glassblowers for the firm. In the 1950s Ermanno Nason executed designs by famous artists including Jean Hans Arp, Georges Braque, Marc Chagall, Jean Cocteau, Max Ernst, Pablo Picasso, and Gio Ponti. Others who provided designs included Aldo Bergamini (b. 1903) in 1960, Renzo Burchiellaro, Luigi Scarpa Croce, painters Ansolo Fuga and Gianfranco Purisiol (b. 1939), and Carlo Scarpa. The company ceased production in 1983.

Carlo Moretti (1958-)

The company was founded in 1958 by Carlo Moretti, who was later joined by his brother Giovanni. Throughout the company's history Moretti has stressed the importance of color in both traditional and innovative glassmaking techniques. Early products included a line of matt finish *satinato* brightly-colored vessels, often with clear stem or foot, marbleized patterns, and *bicolore* cased pieces. Through the 1970s and 1980s Moretti produced a range of items from drinkware to decorative vases in both colors and clear crystal. In the 1990s they returned to a predominantly bright palette and introduced striking designs for decanters and stemware. They are still operating today producing a range of high quality tableware and decorative pieces.

In addition to an incised signature, Moretti used three different labels. The round paper and gold foil label with black lettering was used in the 1960s; the square cellophane label with red lettering was used in the 1970s; and the square cellophane label with black lettering has been used since the early 1980s. In addition, import labels of Rosenthal Netter or Sunset are often found on Moretti pieces.

Carlo Moretti

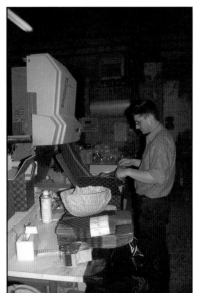
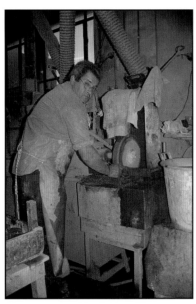
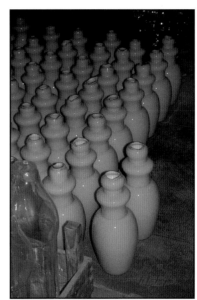

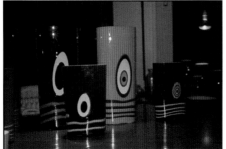
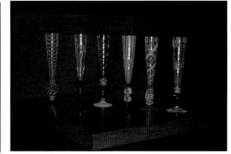

Nason & Moretti (1923-)

In 1923 the Nason and Moretti families of glassmakers — Ugo (1870-1939), Guiseppi (d. 1949), Vincenzo (d. 1948), Antonio (1892-1957), and Umberto (1898-1964) Nason; and Cesare (1879-1914), Germano (1908-1972), Luigi (1867-1946), Ulderico (1892-1956), and Vincenzo (1907-1958) Moretti merged to form one company. In 1949 the Morettis left to form a separate company, and Nason & Moretti continued to produce under the direction of the Nason family. Its tableware, lighting, and decorative items have been both colorless and in bold colors. Later wares make use of *murrines* and colorful decorative elements as well.

Salviati & Co. (1859-)

Founded in 1859 by Antonio Salviati (1816-1890) and partners in Murano, the company was active in the revival of Venetian glass in the 19th century; it was sold to the Barovier family in 1883. In 1898 Maurizio Camerino (1859-1931) managed the glassworks and then became sole proprietor. His sons, Mario and Renzo (b. 1904), became active in the 1920s and headed the firm beginning in 1931. Dino Martens designed for them in the 1930s, and Luciano Gaspari began to design for Salviati in 1950; in 1960 architect Romano Chirivi (b. 1931) and Renzo Camerino designed several series; architect and industrial designer Sergio Asti (b. 1926) designed sporadically from 1961 to the present. Livio Seguso was a master glassblower for Salviati in the late 1950s and 1960s, and Loredano Rosin from the late 1960s to mid 1970s.

Salviati won several awards at Venice Biennales for its long tradition of excellence, and Asti won the *Compasso d'Oro* in 1962 The company was sold in 1987, the name sold to French investors in 1995, and it continues to produce. A circular silver foil label was used in the 1950s and 1960s, followed by a different style label beginning in the 1970s.

Vetraria Archimede Seguso (1946-)

The company was created in 1946 by Archimede Seguso, who had left Seguso Vetri d'Arte in 1942. He was his own chief designer and artistic director and is especially noted for the *merletto* technique using a variety of fine lacework and netted patterns, introduced in 1951, for the use of color gradations and sprays of metallic flecks, and for figural works. Painter Riccardo Licata (b. 1929) designed a series in 1952. Archimede's oldest son Gino joined the firm in 1959, and his second son

Giampaolo joined in 1964. In 1985 Gino's son Antonio joined them.

Giampaolo Seguso started his own glassworks Seguso Viro in 1993. In 1999 the master Archimede Seguso died. The combination of original designs and fine craftsmanship have made Archimede Seguso one of the important masters of Murano, still active today. In addition to signatures, red and silver foil labels were used.

Seguso Vetri d'Arte (1932-1972)

The company was formed in 1932 by Archimede Seguso, Napoleone Barovier (1881-1957), Antonio Ernesto, Luigi Olimpio Ferro, and the brothers Angelo and Bruno Seguso. It was called Artistica Vetreria e Soffiera Barovier Seguso e Ferro for one year, and it became Seguso Vetri d'Arte in 1937. They collaborated with Vittorio Zecchin in the beginning and exhibited at Venice Biennales and Milan Triennales in the 1930s. Archimede Seguso became the *maestro di prima piazza,* while Flavio Poli, who began to free-lance in 1934, served as artistic director from 1937-1963. When Ferro left in 1937, Poli took his place as a partner. Poli is known for his designs calling for the *sommerso* technique, in which thick layers of colored glass appear to float inside other layers. Archimede Seguso, who executed and influenced Poli's designs, left in 1942 to form his own glassworks, Vetreria Archimede Seguso. His brother Angelo Seguso (b. 1921), also a master glassblower, worked at Seguso Vetri d'Arte until 1972 when the company closed and was liquidated. In 1976 Maurizio Albarelli opened a company and called it Seguso Vetri d'Arte, but without the original partners, they relied on free-lance designers. By 1992 that company was gone too.

Of the many postwar successes, the *valva* series won the *Compasso d'Oro* in 1954. Poli left in 1963, and Mario Pinzoni (b. 1927) was artistic director from 1963 until 1971. Although etched signatures were used in the 1930s and 1940s, and some pieces are engraved "Seguso," most are unsigned.

Aureliano Toso (1938-)

In 1938 Aureliano Toso (1884-1979), an accountant from Murano, opened the firm and called it Decorativi Rag Aureliano Toso (*ragioniere* means accountant) and began producing glass in traditional styles. In 1944 Dino Martens began to design for the firm in 1939, and in 1944 he began to design very modern glass, which was executed by master glassmaker Aldo "Polo" Bon (1906-1988). The work is distinguished by the use of filigree, canes, and

aventurine (metallic particles) in patches or spontaneously scattered in the glass. The inclusion of irregularly-placed and brightly-colored threads and shapes resemble abstract paintings, not at all surprising since Martens was trained as a painter. His *Oriente* series with opaque glass patches and patterns in bold primary colors is the easiest to identify and the most collectible.

Each design or version of the design was given a serial number. Several standard sizes were used, but if the design technique was the same, they were given the same serial number. These were exhibited at Venice Biennales from 1948 through the 1960s. Aldo Bon left the company in 1960 to form his own company Vetreria Artigiana Aldo Bon. He was replaced by master glassblower Mario Zanetti. Martens began to work on a free-lance basis in 1959. He created his last design for the company in 1962, and it was exhibited in the Biennale of that year. A young designer Enrico Potz (b. 1943) was artistic director from 1962 to 1965; after leaving Venini, Gino Poli (b. 1919) became artistic director in 1965 and remained until 1976. Aureliano Toso died in 1979, and Gianfranco Toso became director of the firm then called Vetreria Artistica Aureliano Toso di G. Toso.

Aureliano Toso is active today in the production of lighting fixtures under the direction of Aldo Bon's son Bruno. However, their most creative years and greatest contribution to modern glass design occurred in the 1950s. Round silver foil labels were used from the 1940s to about 1960, and rectangular paper labels in the 1950s and 1960s.

Fratelli Toso (1854-1980s)

The company was founded in 1854 in Murano by the six Toso brothers: Angelo (1823-1892), Carlo (1831-1881), Ferdinando (1830-1921), Giovanni (1826-1888), Gregorio (1835-1897, and Liberato (1837-1890). They produced lighting and tableware in traditional Venetian styles, as well as items using *murrines* and *millefiori*. Ermanno Toso (1903-1973) joined in 1924 and became artistic director from 1936 to 1973. He worked with his sons Giusto, who began to design in 1960, and Renato, whose last original series was exhibited at the 1966 Venice Biennale. Vittorio Zecchin also designed for the firm and exhibited.

Some of the company's most interesting work was created in the 1950s when Ermanno Toso designed vessels with striped *mezza filigrana, mosaico*, and patterns of *murrines. Nerox* was the name given to vessels with a black background, often with metallic finish. They continued to innovate and exhibit at Venice Biennales through the 1960s. In 1979 the company was split into Fratelli Toso and Fratelli Toso International, but they were both bankrupt by the early 1980s. In 1981 Arnoldo Toso began the

company Antica Vetreria Fratelli Toso, which is still in business today.

In addition to a variety of innovative bowl forms designed by Ermanno Toso, the company Fratelli Toso is perhaps best known for its work with *millefiori*. In the early 20th century, Fratelli Toso made many of the small *millefiori* vessels found with matte finish, handles with bunched canes, and blurred *murrines* in the body of the piece. These runny *murrines* plus unusual colors and specks of sand or coal in the body are characteristic of early Fratelli Toso *millefiori*. At mid-century the company made *millefiori* bowls, pitchers, and vases in a more limited color palette with reds, white, and blues dominating. They continued to use a matte finish and a variety of *murrine* designs in one piece. The import labels KB and ER were used and may help in identifying a piece. If the pattern of *murrines* overlaps, is too regular, or seems too perfect, or if there is gold foil present (other than in a *murrine*) it is not likely to be a Fratelli Toso production piece.

Venini (1921-)

The company was founded in 1921 in Murano by Paolo Venini, a lawyer from a glassmaking family, Andrea Rioda (1878-1921), a Venetian glass factory owner, and Giacomo Cappellin, an antique Venetian glass dealer. It was incorporated in 1924 as Vetri Soffiati Muranesi Venini Cappellin & C., and hired the most creative and talented artists and designers, including the Muranese painter, Vittorio Zecchin, as art director. In 1925 Cappellin withdrew to form his own glass company, taking the art director and master glassmakers Francesco Zecchin and sculptor Napoleone Martinuzzi to also join the new company, Maestri Vetrai Muranesi Cappelin & C, while Venini formed the new Betri Soffiati Muranesi Venini & C. Martinuzzi became art director but left with Zecchin in 1932. Architects Carlo Scarpa, who left Maestri Vetrai Muranesi Cappellin, and Tomaso Buzzi (1900-1981) were hired as designers in 1932. Buzzi was artistic director until 1933, followed by Scarpa, who exhibited heavy sculptural pieces in Sweden in 1938. This began a collaboration between Venini and Scandinavian companies through exhibitions and working with designers, such as Swedish Tyra Lundgren (1897-1979) and Tapio Wirkkala. Architect Gio Ponti (1891-1979) designed for Venini in the 1940s, and Fulvio Bianconi arrived in 1948 to become one of the most influential designers of the 1950s. Through the years other important designers have included painter Eugène Berman (1899-?), Riccardo Licata, architect Tobia Scarpa (b. 1935), American sculptor Thomas Stearns, Charles Linn Tissot, architect Massimo Vignelli (b. 1931), and Toni Zuccheri.

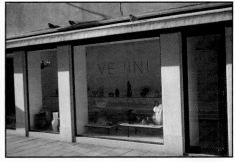

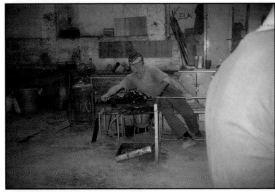
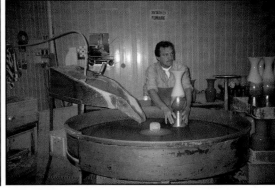
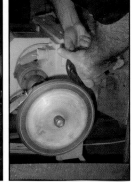

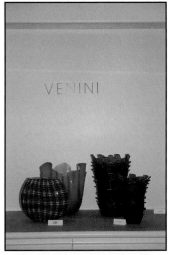

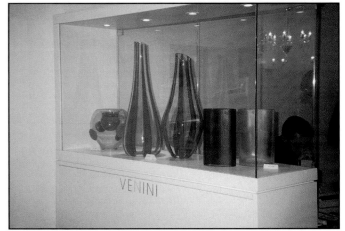

The company is noted for the revival of filigree techniques and innovative use of canes and *murrine*. It is considered to be the most important of all Murano glassworks, especially during Venini's lifetime. When Venini died in 1959, Ludovico Diaz de Santillana (1931-1989) married Venini's daughter Anna and became head of the company in addition to designing. Their daughter Laura Diaz de Santillana joined the firm in 1976, and her brother Alessandro Diaz de Santillana joined in 1981. The firm was reorganized in 1985 as Venini S.p.a, and in 1988 it purchased the factory of Salviati & Co. Then in 1998 Venini was purchased by the Royal Scandinavian group of Denmark. Though the Venini family no longer owns the company, it is active today. Various acid signatures and paper labels can be helpful in dating pieces.

www.venini.it
venini@venini.it

Vetreria Vistosi (1945-1985, present)

Founded in 1945 by Guglielmo Vistosi (1901-1952) for the production of lighting fixtures, the most creative work was done in the 1960s. In 1956 architect Alessandro Pianon (1931-1984) joined the firm, and together with Guglielmo Vistosi's son Luciano (b. 1931), helped to restructure the firm towards more artistic production. In addition to glass, Pianon designed the company logo and catalogs. When he left in 1962, Pianon was succeeded by architect and free-lance designer Peter Pelzel (b. 1937). Pieces were usually form-blown with enclosed decoration of glass pieces and *murrine*. The series of comical birds with metal legs and feet have become Vistosi symbols. Designers in the late 1960s and 1970s include Luciano Vistosi, his brother Gino Vistosi (1925-1980), Fulvio Bianconi, Paolo Audifreddi, painter and graphic artist Mario Abis (b. 1924), industrial designer Angelo Mangiarotti (b. 1921), and architect/industrial designers Ettore Sottsass (b. 1917), Enrico Capuzzo (b. 1924), Gae Aulenti (b. 1927), and Vico Magistretti (b. 1920). Paper labels were used. When Gino Vistosi died in 1980, Luciano Vistosi took over. In 1985 the company was taken over by the owner of Seguso Vetri d'Arte, and they now produce only lighting.

Zanetti Vetreria Artistica (1956-present)

Abott Vincenzo Zanetti founded the Museo del Vetro in Venice in the 19th century. The Zanetti family continued the glass tradition when glassmaker Oscar Zanetti and his son Licio founded a glassworks in 1956. Licio Zanetti became known for his glass sculpture, especially of animals and people. In 1989 Licio's son Oscar (b. 1961) became maestro glassblower. Oscar Zanetti had been working with his father from about age 14 while still attending the Art Institute in Venice. Their work is a combination of ancient glass techniques and new ones developed at the furnace. Oscar's love of nature is expressed in massive glass sculpture and other renditions of plants and animals.

Artists and Designers

Alfredo Barbini (b. 1912)

A descendant of 17th-century glassmakers, Barbini began studying at the age of ten at Abate Zanetti, the design school attached to the Murano Glass Museum. After apprenticing at S.A.I.A.R. Ferro-Toso, and earning the title of *maestro* at the Cristalleria di Murano, working for Zecchin and Martinuzzi beginning in 1932, working briefly with Seguso Vetri d'Arte, and serving as art director for Gino Cenedese (company began in 1946), he began his own workshop in 1950. Barbini is noted for the use of heavy glass sculpture and thick-walled vessels, and was responsible for new techniques of internal decoration such as *vetro fumato*. He has won several international awards, such as *Croce di Cavaliere al Merito* in 1955. His son Flavio (b. 1948) joined in the 1960s, and they are active today. In 1996 Alfredo Barbini was honored with an award in recognition of an outstanding career and lifetime commitment to glass art.

Angelo Barovier (b. 1927)

The son of Ercole, Angelo is a painter and a glass designer. After studying at the Universities of Padua and Ferrara, he earned a doctorate in law. He joined Barovier and Toso in 1947 and developed new series that were exhibited at Milan Triennales and Venice Biennales. Angelo became export manager of the firm and has been managing director since 1974. He was also vice president of the Venetian Industrialists and is now national president of the Italian Art Glass Industry.

Ercole Barovier (1889-1974)

A descendant of Angelo Barovier, the renowned 15th-century artist and glassmaker who is credited with perfecting Venetian *cristallo* and *calcedonio* glass, Ercole Barovier was an artist and a chemist. He joined the family glass business with his brother Nicolò in 1919 when Artisti Barovier became Vetreria Artistica Barovier & C. In 1933 he was the sole owner of the factory, and in 1936 he founded a glass factory with another old company, Ferro Toso. The managers of Ferro Toso, Artemio and Decio Toso, were from a family that had been in the glass business since the 17th century. The new company, called Ferro-Toso Barovier, changed to Barovier & Toso & C. in 1939, and Barovier & Toso in 1942, which is the current name. Barovier developed new colors and technical processes, and during his long life as president and artistic director (until 1972) he created thousands of models of art glass and won numerous prizes and awards. His most significant contributions are with new and exciting uses of *murrine* glass, especially in the 1940s and 1950s.

Fulvio Bianconi (1915-1996)

After studying at the Instituto Statale d'Arte Carmini and the Accademia di Belle Arte in Venice, Bianconi designed glass for Madonna dell'Orto in Venice. After designing for Cenedese and Vistosi, he met Venini in 1948. His *fazzoletto* design soon became a symbol for Venini, and he stayed with the company until 1951, the year that he exhibited at the Milan Triennale. Bianconi freelanced for various firms including Venini, and notable designs included *La Commedia dell'Arte* and other figures, further development of the *fazzoletto* vase, vessels in biomorphic shapes, and plaids. He also freelanced for Cenedese in 1954. After working for Vistosi in the early 1960s and winning awards at Milan Triennales in 1963 and 1964, he returned to Venini in 1966. Bianconi collaborated with Licio Zanetti and others in the 1970s, worked independently with several furnaces in Murano and in Switzerland in the 1980s, and continued designing into the 1990s.

Tomaso Buzzi (1900-1981)

After studying architecture and design at del Politecnico di Milano, Buzzi earned a Ph.D. in 1923. In 1924 he and Gio Ponti, glass designer Pietro Chiesa (1892-1948), Giovanni Martelli, and Paolo Venini opened a modern interior design studio called Il Labirinto. After developing a friendship with Venini, Buzzi met Napoleone Martinuzzi, and in 1932, through Buzzi, Martinuzzi became acquainted with the Venini style. Buzzi held the highest position at the school of architecture in Milan, as director from 1930-1954. As artistic director for Venini from 1932 to 1933 he was involved with both the design

and implementation of glass and developed the series *Alga & Laguna*. From 1958 he concentrated on painting.

Gino Cenedese (1907-1973)

Cenedese first worked in glass for the Giacomo Cappellin factory. He began his own firm in 1946 and designed sculpture and vessels in abstract shapes with Alfredo Barbini until the end of 1950. He collaborated with sculptor Napoleone Martinuzzi and designer Fulvio Bianconi in the 1950s, and creations included *azquari,* big blocks of glass with inclusions of figures, which were sometimes abstract. From 1959 Antonio Da Ros was artistic director, and from 1964 to 1970 maestro Ermanno Nason collaborated with him at Cenedese. One of their accomplishments was the work with the *sommerso* technique producing vessels in layers of graduated color. His son Amelio Cenedese heads the company.

Laura Diaz de Santillana (b. 1955)

Born in Venice, she attended the School of Visual Arts in New York City. After working for Vignelli and Associates, she returned to Venice in 1976. She joined Venini and worked at the furnace before managing the firm with her father Ludovico Diaz de Santillana. She served as designer and artistic director of her father's company EOS from 1986 to 1992.

Ludovico Diaz de Santillana (1931-1989)

After graduation from high school in Rome, Diaz de Santillana studied architecture in Venice in the early 1950s. In 1959 he also joined the Architecture department at MIT in Cambridge, Massachusetts. Son-in-law of Paolo Venini, Ludovico managed the Venini factory from 1959 to 1985. In 1980 his daughter Laura joined him in managing the company. His collaborations included those with Tobia Scarpa in 1961. In 1969 he created the series for Pierre Cardin. From 1986 to 1992 he ran his own glass company in Murano called EOS.

Alberto Dona (b. 1944)

Born in Italy in 1944, Dona began working in glass at age thirteen. After learning from several masters, he opened his own furnace in Murano in the 1970s. Dona became known for his skill with manipulating colors and for his ability to invent unusual combinations. Most characteristic of his work are large and elegant shapes. Throughout his extensive glassblowing career he gained international acclaim, and he exhibits his work throughout Europe and the United States.

Giorgio Ferro (b. 1931

Son of Murano glassmaker Galliano Ferro, Giorgio studied painting in Venice. After A.VE.M art director Giulio Radi died in 1952, Galliano Ferro became a partner, and his son Giorgio became a designer for the company. Galliano left to form his own company in 1955, and Giorgio became its artistic director. In 1956 Lino Tagliapietra became maestro at the company. Giorgio Ferro has been the owner of Galliano Ferro since 1972.

Ansolo Fuga (1915-1998)

Fuga earned a diploma from the Instituto d'Arte di Venezia with specializations in illustration, printmaking, and art glass design. He met Guido Balsamo-Stella, who encouraged him to dedicate his talent solely to art glass. He opened a studio after World War II with a focus on stained glass windows. Then from 1955 to 1962, he worked as a free-lance designer for A.VE.M. specializing in large abstract pieces, often decorating them with *murrine* under the guidance of Luciano Ferro. He also collaborated with Domus Vetri d'Arte and I.V.R. Mazzega. From 1949 to 1972 Fuga also taught at the Abate Zanetti evening art school attached to the Murano Glass Museum, from which several of the greatest glass teachers have graduated.

Luciano Gaspari (b. 1913)

Gaspari studied painting at the Accademia di Belle Arti in Bologna and became a professor at the Academy of Fine Arts in Venice in 1941. He designed heavy *sommerso* glass for Salviati & Co. from 1950 until 1968, exhibited widely, and won the Enapi Prize at the 1959 Milan Triennale. He continues to free-lance for before joining Flygsfors in Sweden in 1949. During the 1950s he designed fantastic biomorphic and other asymmetrically shaped pieces, notably the *Coquille* series (along with Paul Kedelv), which made the transition from vessel to sculpture.

Corrado "Dino" Martens (1894-1970)

Martens studied painting and earned a diploma from the Accademia di Belle Arti di Venezia and initially worked as a painter. He then designed glass for S.A.L.I.R in 1925, Salviati in 1932, Cooperativa Mosaicisti Veneziana, and for Vetreria A. Toso before becoming artistic director for Aureliano Toso from 1946 to 1963. Martens worked with

polychrome *zanfirico* and asymmetric patchwork and participated in international exhibitions. His famous *Oriente* and *Zanfirici* series have become symbols of fifties glass.

Napoleone Martinuzzi (1892-1977)

After studying sculpture in Rome in 1910, Martinuzzi returned to his birthplace of Murano in 1925. He then joined the recently formed Venini & Co. as a partner and became artistic director until 1932. When he left Venini, Martinuzzi formed a partnership with engineer Francesco Zecchin (1894-1986) and founded the glass company Zecchin & Martinuzzi. He left that company in 1936 and later, in the 1950s, designed for Alberto Seguso and for Cenedese; in the 1960s and early 1970s he designed for the publisher Pauly & C. with Alfredo Barbini executing the work in the Barbini factory.

Aldo Nason (b. 1920)

Son of Emilio Nason, he was one of the founders and a master glass artist at A.VE.M. until founding his own glassworks.

Ermanno Nason (b. 1928)

Son of Otello Nason from Vetreria Artistica Barovier, Ermanno apprenticed there under his father and with his uncle Emilio at A.VE.M. After World War II he was a glassblower for Fratelli Ferro and then at A.VE.M. In the 1950s Ermanno Nason was a master glassblower at I.V.R. Mazzega executing designs of artists such as Georges Braque, Marc Chagall, Jean Cocteau, Pablo Picasso, and Gio Ponti. He ran his own workshops in Murano on and off from the 1960s to 1990s.

Flavio Poli (1900-1984)

An interior decorator and ceramic artist, as well as a glass designer, Poli collaborated with I.V.A.M. *Zodiaco* panel. In 1937 the company became Seguso Vetri D'Arte, and Poli became artistic director until 1963. From 1952 to 1963 he was best known for the *sommerso* technique. One of Italy's leading glass designers, Poli founded his own factory in 1964 called Società Veneziana di Conterie e Cristallerie, but it lasted only until 1966 due to his ill health. His work is usually unsigned and has won awards such as the grand prize at Milan Triennales in 1951, 1954, and 1960, the *Compasso d'Oro* in 1954, and a grand prize at the 1958 Brussels International Exposition.

Gio Ponti (1891-1979)

Born in Milan, Gio Ponti studied architecture at the Milan Polytechnic and graduated in 1921. A major modernist designer in Italy, Ponti was known for his work in a variety of materials, of which glassware was only one. He designed ceramics for Richard Ginori, architecture, stage sets, interiors, appliances, lighting, metalware, textiles, and furniture. In 1928 he founded the important design journal *Domus* and became its first editor; *Stile* was founded in 1941. His multi-faceted career included directing the Monza Biennale 1925-1979, collaborating in the development of the Milan Triennale Exhibitions and the *Compasso D'Oro* award programs, teaching architecture at the Milan Polytechnic 1936-1961, designing ocean liner interiors such as the Conte Grande and the Andrea Doria in 1950, and contributing regularly to *Domus* and to *Casabella*. In the 1950s he collaborated with Piero Fornasetti to design furniture and interiors. Ponti also wrote nine books and about 300 articles.

Giulio Radi (1895-1952)

Born into a family of important Murano glass technicians, Giulio Radi worked in his father's glass furnace and then with Andrea Rioda. In 1932 he was one of the founding partners of A.VE.M. and took the role of artistic director in 1939. His work is characterized by the use of metallic oxides, *murrine*, and gold and silver dust for exceptional coloring techniques.

Carlo Scarpa (1906-1978)

A graduate of the Accademia di Belle Arti di Venezia in 1926 and an important architect, Scarpa worked for Vetri Soffiati Muranesi Cappellin Venini & Co. until 1925, for Maestri Vetrai Muranesi Cappelin & C. until 1932, experimented with new color techniques and the application of gold and silver leaf, and rejoined Venini as artistic director in 1932. Scarpa is credited with Venini's revival of *murrine* glass in 1938, and exhibited several *murrine* designs in the 1940 Venice Biennale. He left in 1947, but may have continued to collaborate with Venini while devoting himself almost entirely to architecture. In 1951 Frank Lloyd Wright visited Murano and became influenced by Scarpa.

Some of Scarpa's enormous contrubution to Venini include designs in *a bollicine* and half filigree (1932-1936); Roman *murrine*, blown transparents, and *lattimi* (1936); corroded (1936-1938); dots and stripes (1937-1938); rings and bands, variegated knurled, and two-

colored *incalmo* (1938); lined and ribboned (1938-1940); Chinese, grainy, black and red lacquered, *a bugne*, bloomed, hammered, veiled, opaque and transparent *murrine*, and applied bands (1940); engraved (1940-1942); threads and bands, variegated, brushstroked, marked, shells, and thread decoration (1942).

Tobia Scarpa (b. 1935)

Carlo Scarpa's son, Tobia Scarpa, was born in Venice and educated as an architect. Following his father's lead, he joined Venini in 1958. Some of his most successful designs were large *battuti, occhi,* and *murrine* series. He and his wife Afra collaborated with numerous other companies, such as the furniture leaders Cassina and B & B Italia. In the 1980s the husband and wife team designed glass collections for VeArt.

Archimede Seguso (1909-1999)

Born to a family that had been in the glass business since 1575, Seguso began at age 13 at Vetri Artistica Fratelli, where his father Antonio was one of ten partners. At age 20 he was the youngest master glassmaker in Murano. Together with his father and Antonio and Napoleone Barovier, he formed Seguso Vetri d'Arte in 1933 and made extremely avant garde massive glass sculpture. He left in 1942 and started his own company, Vetreria Archimede Seguso, in 1946. Latticino and delicate lacework are among his most important designs, and Seguso has exhibited widely and has won many international awards for designs such as *merletto* in 1951, *composizione lattimo* in 1954, and *Piume* in 1955. His later work included sculpture made in solid *sommerso* glass.

Lino Tagliapietra (b. 1934)

Born in Murano, Tagliatietra began apprenticing to glass houses at an early age. In 1956 he became maestro at Galliano Ferro and collaborated with other companies such as Venini and La Murrina. Tagliapeitra became artistic director of Effetre in 1976. He then began to teach Murano glassmaking techniques at schools in France, Australia, Japan, and at Pilchuck in Stanwood, Washington. His work can be seen in major museums including the Victoria and Albert in London, the Musée des Arts Décoratifs in Paris, and the Corning Museum of Glass in Corning, New York. Considered the supreme glass artist today, Tagliapietra's style in unmatched. Intricate yet bold rods of colored glass form textural and

sculptural works of art. In addition to extraordinary vessels, his pictorial quality also lends itself to panels and other forms.

Ermanno Toso (1903-1973)

The company Fratelli Toso was founded in 1854 by the five Toso brothers. Ermanno Toso joined the firm in 1924, became a partner in 1927, and was artistic director from the 1936 to 1973. During the 1950s, he worked with colorful *murrine* glass and filigree, but rarely signed pieces other than an occasional paper label. His wide variety of bowls in organic shapes with wild colors and gold powders are among the most commonly found pieces today.

Paolo Venini (1895-1959)

A Milanese lawyer from a family of glassblowers, Venini formed a company in 1921 and incorporated in 1924 as Vetri Soffiati Muranesi Venini Cappellin & Co. The company is noted for the revival of *filigrano* techniques and has been the leading art glass producer in Italy. Venini oversaw the firm's operations, designed glass, and worked closely with some of the most important glass designers of the modern period. His genius helped to make the company's name synonymous with fifties Italian glass.

Massimo Vignelli (b. 1931)

Vignelli studied architecture in Milan and Venice. From 1953 to 1957 he worked for Venini designing lighting, windows, and tableware. His work can be seen in major museums throughout the world. With a base in New York City, Vignelli designs anything that needs design, from glass to silver, plastic, furniture, graphics, and entire interiors. Vignelli is recognized as one of the major designers of the twentieth century and beyond.

Vittorio Zecchin (1878-1947)

Son of a Murano glassblower, Vittorio Zecchin graduated from the Accademia di Belle Arti di Venezia as a skilled painter and designer. His association with the Secessionist movement brought some of its flavor to Murano glass. He was artistic director of Vetri Soffiati Muranesi Cappellin Venini & C. in the early 1920s and introduced some of the first modern works in Murano glass. In the 1930s Zecchin collaborated with S.A.L.I.R., Ferro Toso, A.VE.M., Seguso Vetri d'Arte, and Fratelli Toso. In addition to his important work in glass, he designed mosaics, ceramics, furniture, silver, tapestries, and embroidery, all of which were shown at Venice Biennale exhibits.

Vases

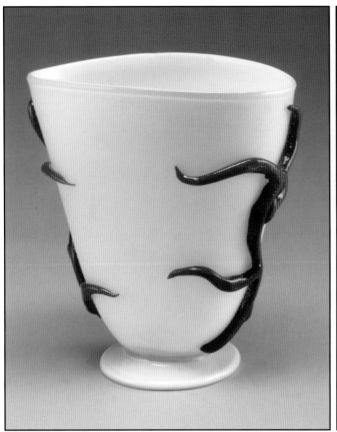

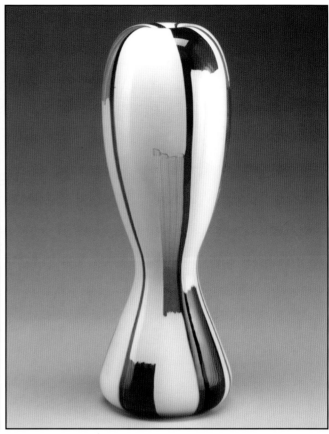

A.VE.M.
Flared and footed pillow vase in *lattimo* glass with applied coral-red branches,
Unmarked
Height 8-1/2 in; 22 cm.
$4,000-5000
Photo courtesy of Rago Modern Auctions

A.VE.M.
Patchwork vase of *vetri lattimo* in elongated gourd form, with red, yellow, blue, and green patches of canes, designed by Ansolo Fuga.
Unmarked
Height 18 in; 46 cm.
$7,000-9,000
Photo courtesy of Rago Modern Auctions

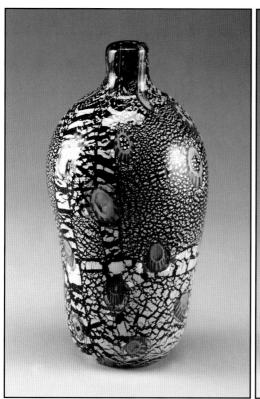

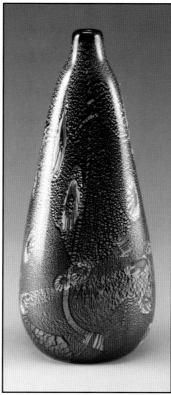

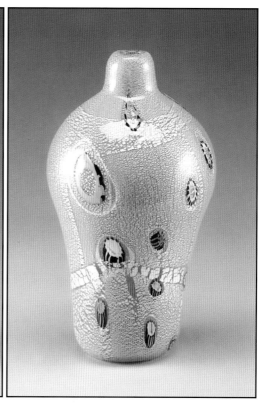

A.VE.M.
Bulbous bottle-vase with red and white
murrines and gold and silver foil on a cobalt
ground, from the Yokohama series, designed
by Aldo Nason.
Unmarked
Height 11 in; 28 cm.
$4,000-5,000
Photo courtesy of Rago Modern Auctions

A.VE.M.
Teardrop-shaped bottle-vase
with red and white *murrines*
and gold and silver foil from the
Yokohama series, designed by
Aldo Nason.
Signed, Aldo Nason for G.S.
Height 13 in; 33 cm.
$4,000-5,000
*Photo courtesy of Rago
Modern Auctions*

A.VE.M.
Bulbous bottle with blue and white *murrines* on
an orange ground with silver foil, from the
Yokohama series, designed by Aldo Nason.
Unmarked
Height 11 in; 20 cm.
$4,000-5,000
Photo courtesy of Rago Modern Auctions

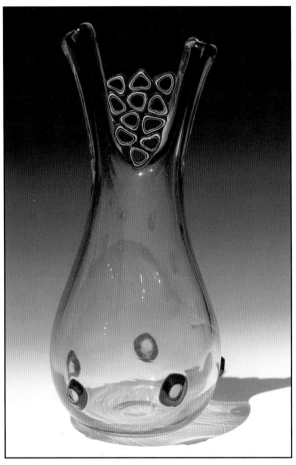 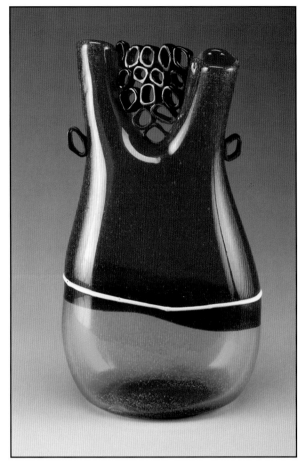

A.VE.M.
Double-spout bottle-vase in blue with red *murrines* and applied rings between the spouts, designed by Ansolo Fuga and executed by Luciano Ferro.
Unmarked
Height 15-1/2 in; 39.5 cm.
$7,000-9,000

A.VE.M.
Double-spout bottle-vase with blue bottom and red top with thin white line, applied rings between the spouts, designed by Ansolo Fuga and executed by Luciano Ferro.
Unmarked
13-1/2 in; 34 cm.
$6,000-8,000
Photo courtesy of Rago Modern Auctions

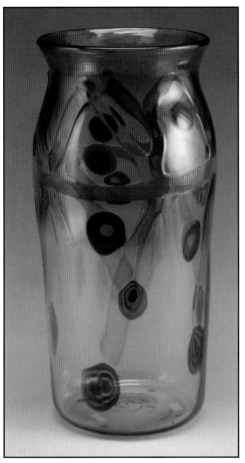

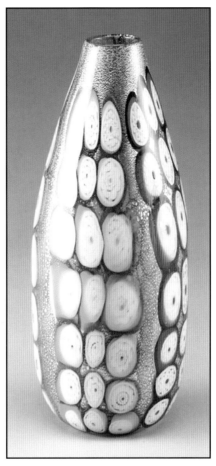

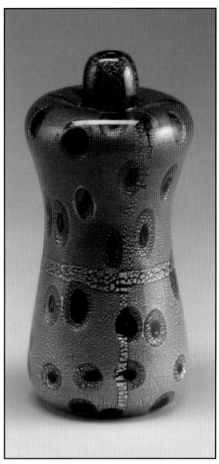

A.VE.M.
Blue and red vase with applied stripe and *murrines*, designed by Ansolo Fuga and executed by Luciano Ferro.
Paper label, "from the collection of Luciano Ferro".
Height 14-1/2 in; 37 cm.
$7,000-9,000
Photo courtesy of Rago Modern Auctions

A.VE.M.
Teardrop-shaped bottle-vase with four panels of *murrines* in different colors on a gold foil ground, designed by Ansolo Fuga.
Unmarked.
Height 10-1/2 in; 27 cm.
$4,000-5000
Photo courtesy of Rago Modern Auctions

A.VE.M.
Bottle-vase with pinched waste and broad shoulders, gold foil ground with amethyst *murrines,* designed by Giulio Radi.
Unmarked.
Height 9 in; 23 cm.
$4,000-5,000
Photo courtesy of Rago Modern Auctions

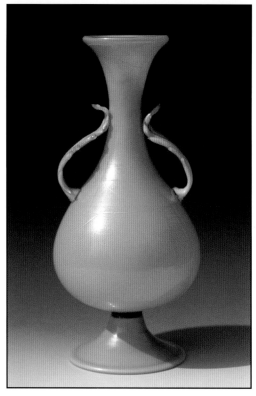

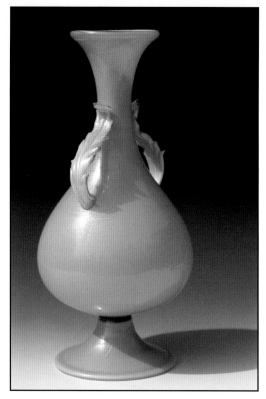

A.VE.M.
Footed bulbous vase in blue opaline with gold powder, tapered neck, applied feathery leaf-form handles.
Foil label, A.VE.M. Made in Murano
Height 15 in; 38 cm.
$3,000-4,000

View of handles.

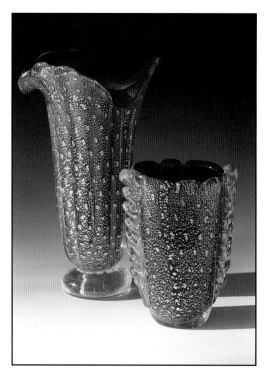

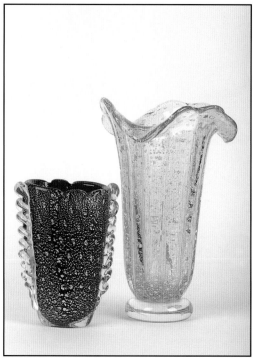

A.VE.M
Red and crystal vases with mica inclusions; left with clear base and floriform rim, right with applied crystal wings.
Unmarked
12 in; 30.5 cm. and 7-1/2 in; 19 cm.
$500-700 each

A.VE.M.
Turquoise and crystal vase with mica inclusions with clear base and floriform rim, with same design in red.
Unmarked
12 in; 30.5 cm. and 7-1/2 in; 19 cm.
$500-700

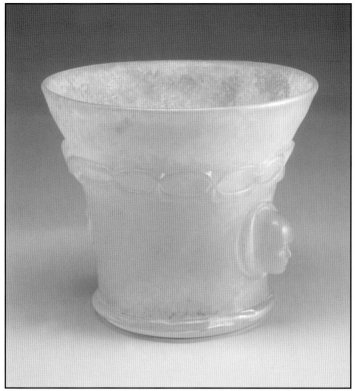

Alfredo Barbini (attributed to)
Lime green *scavo* vase with applied chain link and handles.
Unmarked.
10 x 11-1/2 in; 25.5 x 29 cm.
$2,000-2,500
Photo courtesy of Rago Modern Auctions

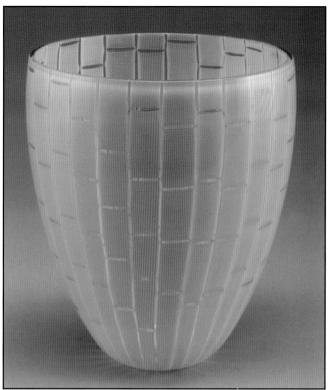

Alfredo Barbini
Ovoid *pezzato* vase in apricot and white.
Acid-etched signature on body, Barbini/Murano.
Height 8-3/4 in; 22 cm.
$1,500-2,000
Photo courtesy of Rago Modern Auctions

Alfredo Barbini
Square vase of raspberry *corroso sommerso*, with small opening.
Unmarked.
5-1/2 in; 14 cm. square
$500-800
Photo courtesy of Rago Modern Auctions

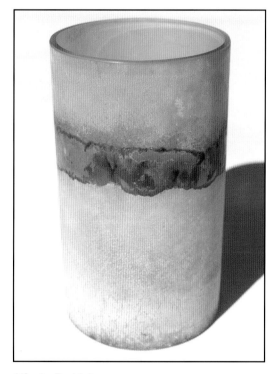

Alfredo Barbini
Cylindrical *scavo* vase in beige and tan with a
horizontal band in browns and cobalt blue.
Signed, Barbini
Height 10 in; 25.5 cm.
$2,000-3,000
Courtesy of Michael Ellison

Camer label

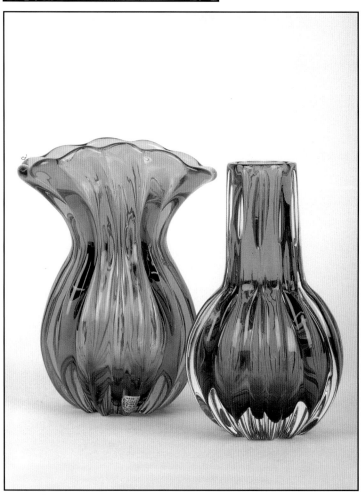

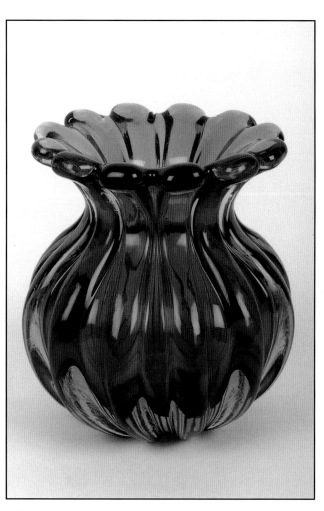

Alfredo Barbini
Green and gold ribbed *sommerso* vase with flared top; and amber ribbed vase with narrow neck.
Paper label, Camer Glass
Height 8 in; 20 cm. and 7-1/2 in; 19 cm.
$200-300
Courtesy of Lorenzo Vigier

Alfredo Barbini
Ribbed *sommerso* vase of bulbous form with cinched neck and flared rim, with an internal layer of transparent amethyst cased in sapphire glass, designed by Alfredo Barbini, ca. 1960s.
Unmarked
Height 5 in; 12.7 cm.
$100-200
Courtesy of Lorenzo Vigier

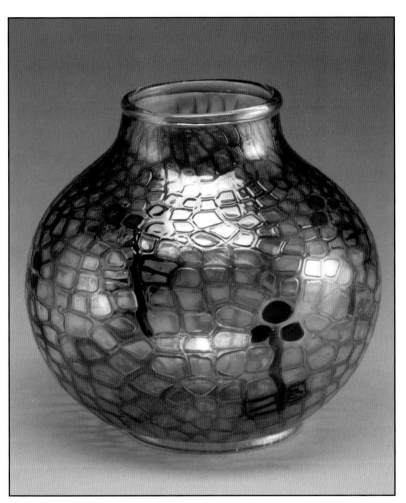

Artisti Barovier
Mosaic vase in blue with red and green flowers, designed by Ercole Barovier.
Unmarked
8-1/2 x 8 in; 21.5 x 20 cm.
$25,000-30,000
Photo courtesy of Rago Modern Auctions

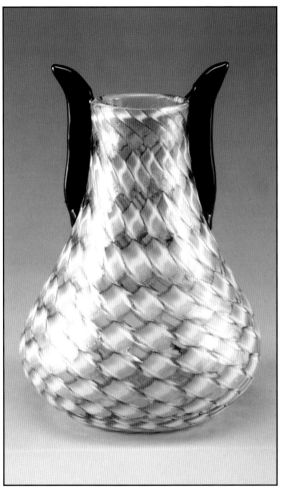

Barovier-Seguso-Ferro
Tapered bulbous vase with *murrine* pattern and amethyst wing handles.
Unmarked
Height 10 in; 25.5 cm.
$3,000-4,000
Photo courtesy of Rago Modern Auctions

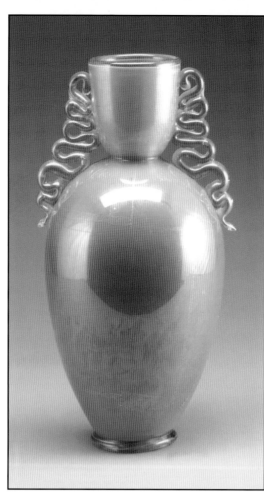

Barovier-Seguso-Ferro
Pink *laguna* vase with gold
snake handles, designed by
Flavio Poli and executed by
Alfredo Barbini, 1932.
Unmarked
Height 17 in; 43 cm.
$20,000-25,000
*Photo courtesy of Rago
Modern Auctions*

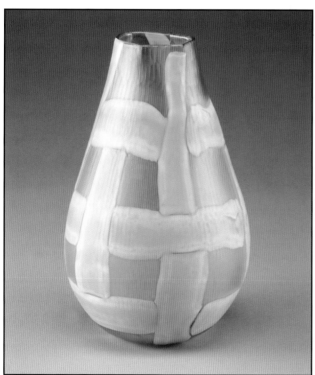

Barovier & Toso
Teardrop-shaped *pezzato* vase with *battuto* surface in blue
and white plaid.
Unmarked.
Height 9-1/4 in; 23.5 cm.
$5,000-7,000
Photo courtesy of Rago Modern Auctions

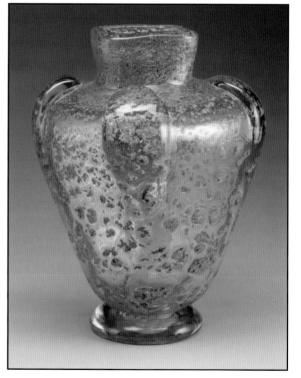

Barovier & Toso
Autunno gemmato vase with applied shoulder epaulets,
designed by Ercole Barovier 1935-36.
Unmarked
Height 16-1/2 in; 42 cm.
$8,000-10,000
Photo courtesy of Rago Modern Auctions

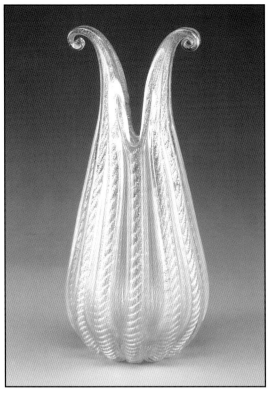

Barovier & Toso
Corondato oro fluted vase with elongated scrolled rim, designed by Ercole Barovier, 1950.
Unmarked.
Height 13 in; 33 cm.
$700-900
Photo courtesy of Rago Modern Auctions

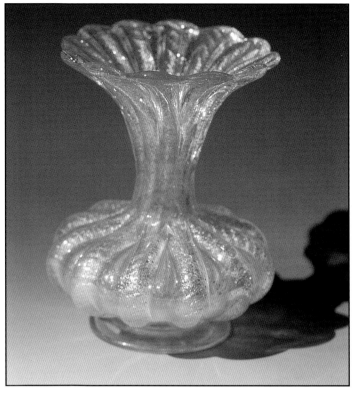

Barovier & Toso
Cordonato oro vase with flared rim.
Unmarked
Height 7 in; 18 cm.
$250-350

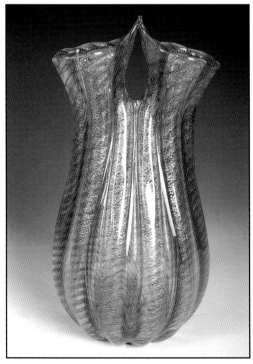

Barovier & Toso
Cordonato oro fluted vase with double neck, clear glass with gold and red inclusions, designed by Ercole Barovier, 1950.
Paper label with numbers 19840.
Height 10 in; 25.5 cm.
$1,000-1,200
Courtesy of Lorenzo Vigier

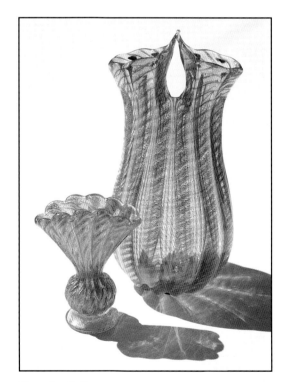

Barovier & Toso
Vase in different lighting to show red inclusions, with smaller *cordonato oro* vase with flared top.
Unmarked
Height 4-1/2 in; 1.5 cm.
$150-250
Courtesy of Lorenzo Vigier

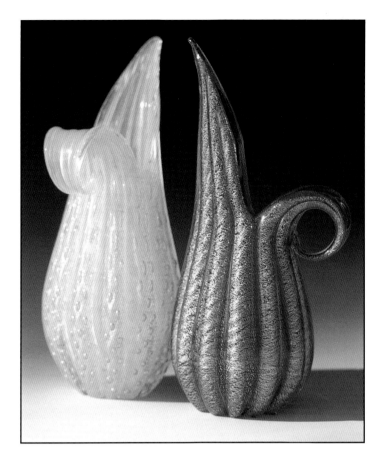

Barovier & Toso
Cordonato oro
fluted vases, each
with split and
stretched rim and
one side bent over
to form handle; pale
yellow vase with
bubbles, red with
gold inclusions.
Unmarked
Height
$500-600 each
*Courtesy of Lorenzo
Vigier*

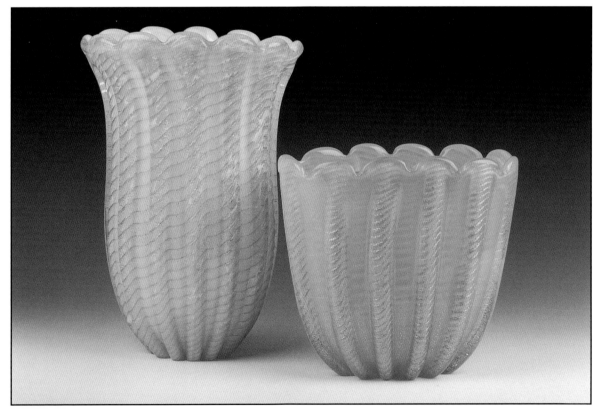

Barovier & Toso
Fluted and scalloped *cordonato oro* vases, left in white, right in light blue.
Unmarked
Height 13 in; 33 cm; and 9 in; 23 cm.
$1,600-1,800 each
Courtesy of Lorenzo Vigier

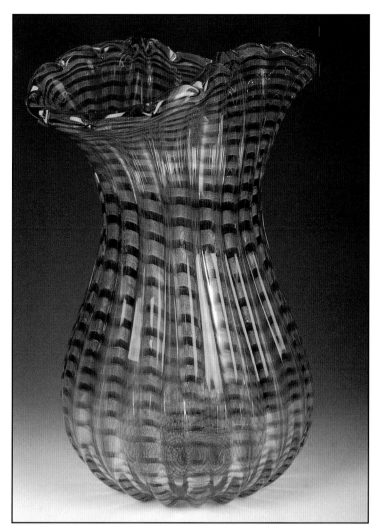

Barovier & Toso

Zebrati vase in same fluted form as *cordonato oro*, but with horizontal stripes of gold and dark inclusions, designed by Ercole Barovier, 1949.
Unmarked
Height 15-1/4 in; 39 cm.
$3,000-4,000

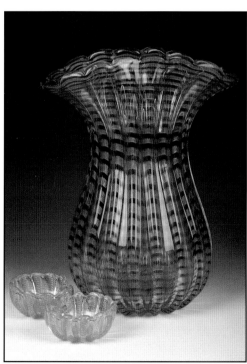

Barovier & Toso
Zebrati vase with two small *cordonato oro* bowls to show scale.

Zebrati detail.

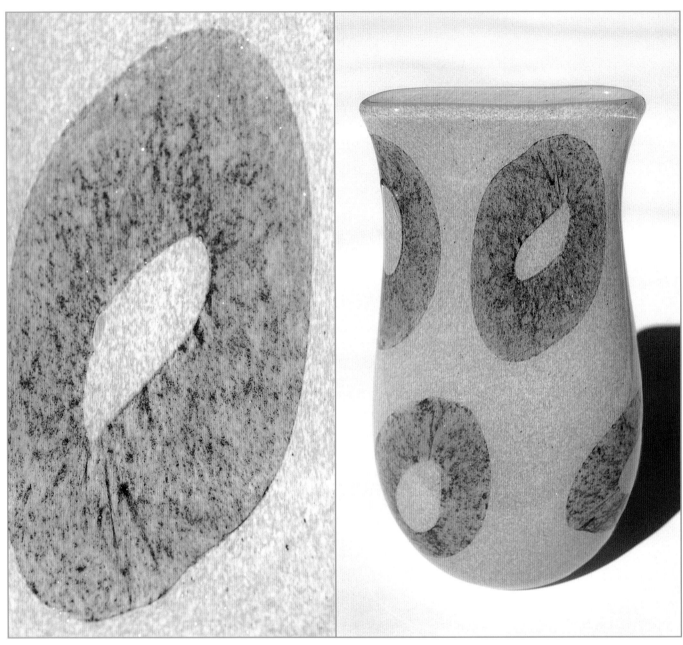

Detail.

Barovier & Toso
Opalescent internally textured celadon green glass vase with large turquoise circles, designed by Ercole Barovier.
Unmarked
Height 11-1/2 in; 29 cm.
$7,000-9,000
Courtesy of Michael Ellison

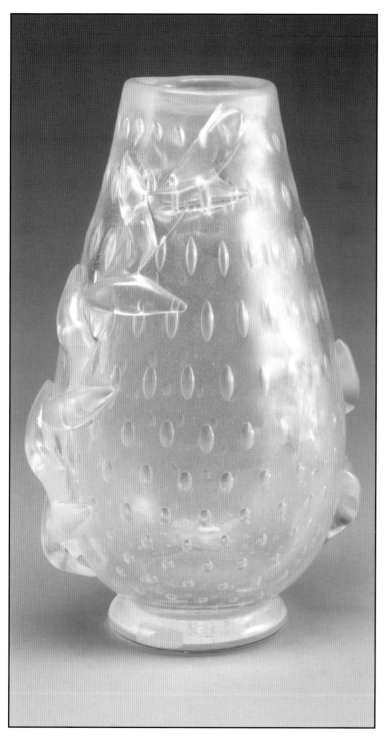

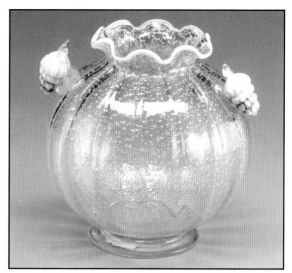

Barovier & Toso
Ribbed spherical vase of clear glass with mica inclusions and applied grape clusters at the shoulders.
Paper label
7 x 8 in; 18 x 20 cm
$1,200-1,600
Photo courtesy of Rago Modern Auctions

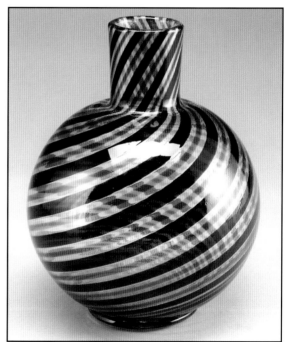

Barovier & Toso
Iridescent clear vase with controlled bubbles and applied leaf and vines, designed by Ercole Barovier, late 1930s.
Unmarked.
Height 11-1/2 in; 29 cm.
$3,000-3,500
Photo courtesy of Rago Modern Auctions

Barovier & Toso
Bulbous *striato* vase with cobalt, eggplant, and *aventurine* diagonal stripes.
Etched, Barovier E Toso/Murano.
Height 10 in; 25.5 cm.
$1,500-2,000
Photo courtesy of Rago Modern Auctions

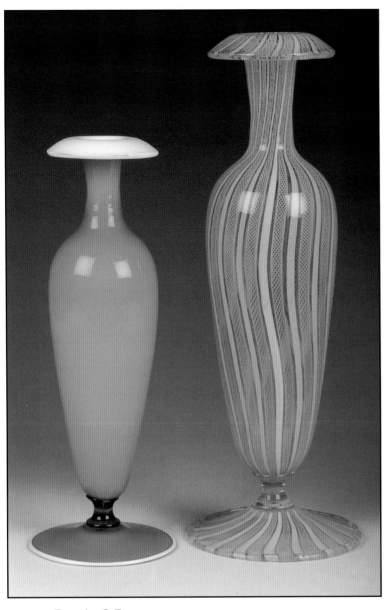

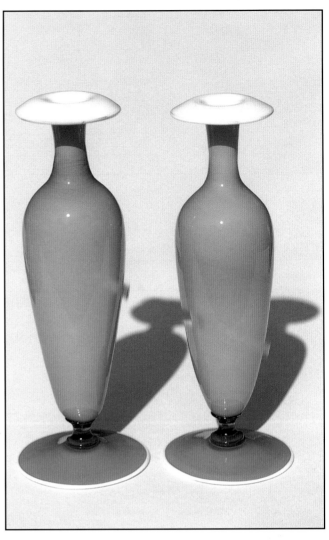

Barovier & Toso
Cased footed vases, *lattimo* glass encased in turquoise with
lattimo edge to foot.
Unmarked
Height 9-3/4 in; 25 cm.
$600-800 pair

Barovier & Toso
Footed filigree vases with folded rim, in blue and *lattimo*.
Unmarked
Height 12-1/4 in; 31 cm.
$1,000-1,200
Courtesy of Lorenzo Vigier

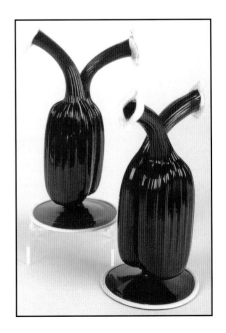

Red fluted double gourd vases, each with
applied white rim on V-neck and foot,
attributed to Salviati, early 20th century.
Unmarked
Height 6 in; 15 cm.
$150-200 each

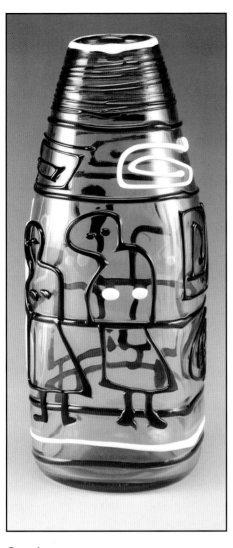

Cenedese
Clear glass vase with applied squeeze-bag figures in red, white, and blue, designed by Fulvio Bianconi.
Unmarked
Height 14 in; 35.5 cm.
$5,000-7,000
Photo courtesy of Rago Modern Auctions

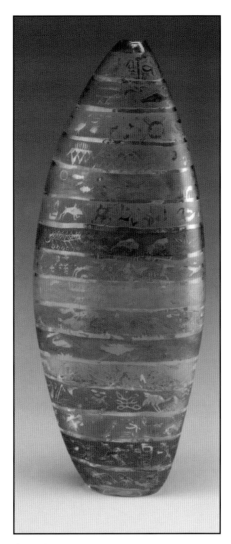

Cenedese
Large teardrop-shaped vase designed by Antonio Da Ros, with acid-cutback hieroglyphics enameled in purples, greens, blues, and grays by Giancarlo Begotti.
Incised, G. Begotti, A. Da Ros Cenedese.
Height 20 in; 51 cm.
$10,000-12,000
Photo courtesy of Rago Modern Auctions

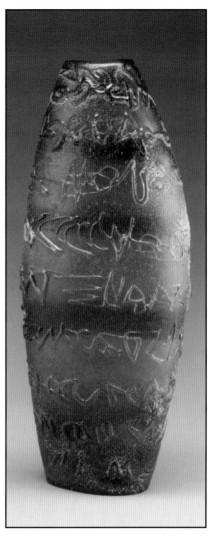

Cenedese
Large teardrop-shaped vase with striped blue and clear *scavo* ground, with applied trailing decoration.
Unmarked
Height 19 in; 48 cm.
$8,000-10,000
Photo courtesy of Rago Modern Auctions

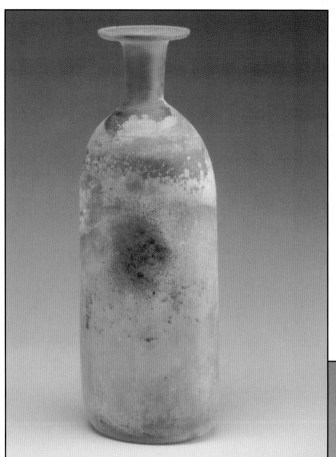

Cenedese
Bottle-vase of turquoise green *scavo* glass,
with narrow neck and flat flared rim.
Incised, Cenedese.
16-1/2 in; 42 cm.
$800-1,200
Photo courtesy of Rago Modern Auctions

Cenedese
Organic form vessel in blue *scavo* glass, with applied
leaf and vine and one hole, designed by Napoleone
Martinuzzi 1953-58.
Unmarked.
Height 11 in; 28 cm.
$12,000-16,000
Photo courtesy of Rago Modern Auctions

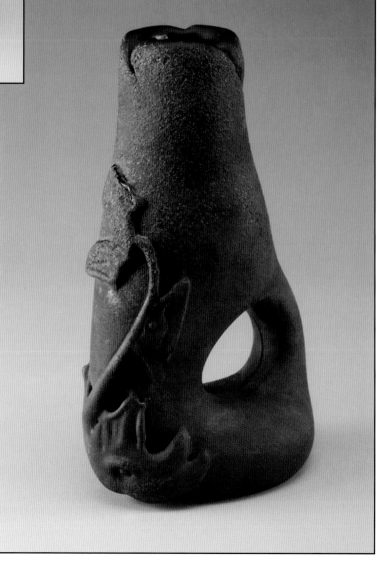

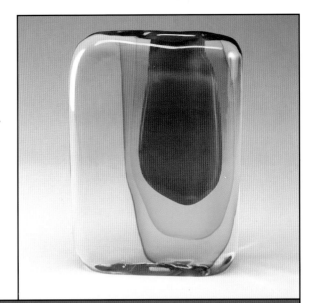

Cenedese
Sommerso bottle-vase of cased raspberry, turquoise, and clear glass.
Unmarked.
Height 14 in; 35.5 cm.
$500-700
Photo courtesy of Rago Modern Auctions

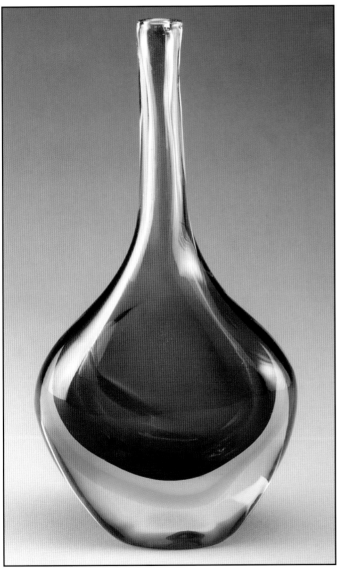

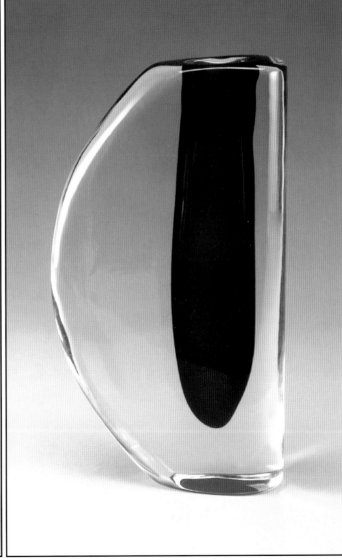

Cenedese
Sommerso Memento vase of flattened rectangular form in orange, green, blue, and clear cased glass, designed by Antonio Da Ros, mid 1950s.
Unmarked.
Height 10 in; 25.5 cm.
$1,500-2,000
Photo courtesy of Rago Modern Auctions

Cenedese
Sommerso vase of flattened rectangular form with one rounded side, in amethyst and clear cased glass, designed by Antonio Da Ros, mid 1950s.
Unmarked.
Height 12-1/2 in; 32 cm.
$1,000-1,200
Photo courtesy of Rago Modern Auctions

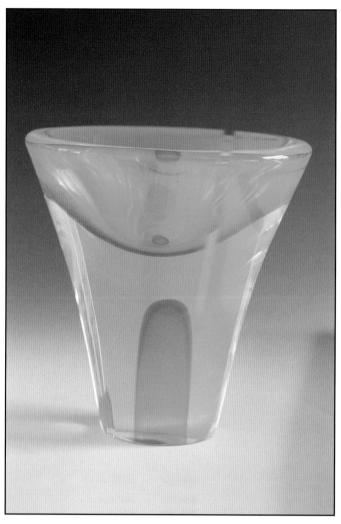

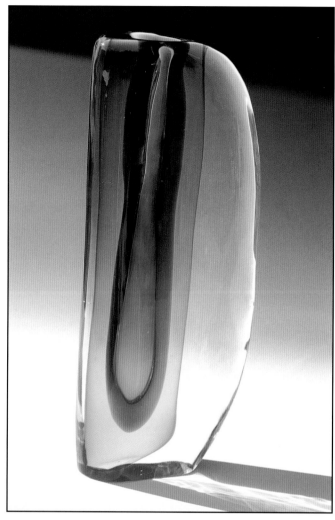

Cenedese
Sculptural *sommerso* vase in vaseline (shown under black light) with green top and blue base inclusion, designed by Antonio Da Ros.
Unmarked
Height 8 in; 20 cm.
$2,000-3,000
Courtesy of Lorenzo Vigier

Cenedese
Momento vase with one flat side and one bowed side, internal cobalt blue, turquoise, and clear outer layer, designed by Antonio Da Ros in 1963.
Unmarked
Height 14 in; 35.5 cm.
$1,200-1,600
Courtesy of Lorenzo Vigier

Opposite page:
Cenedese
Cylindrical *sommerso* vases: cobalt and turquoise; red and alexandrite with tall hollow base, pinched waist, and *sommerso* upper portion; vaseline and green with pinched waist and inclusion.
Unmarked
Heights 9-1/2, 12, and 8 in; 24, 30.5, and 20 cm.
$600-800, 700-900, 400-500

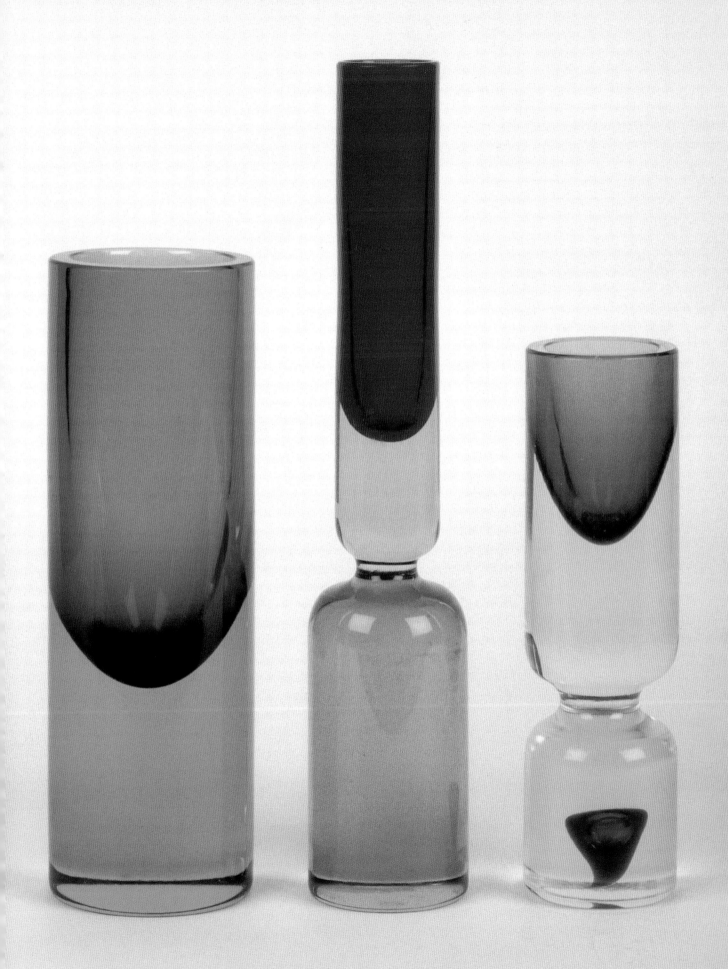

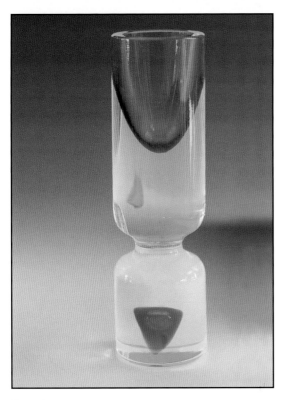

Cenedese
Vaseline vase shown under black light.

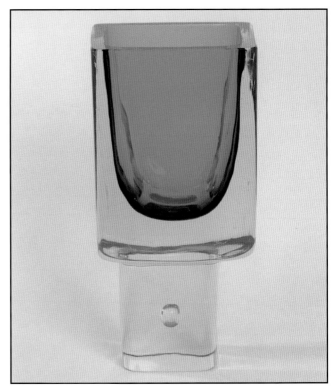

Cenedese
Heavy square *sommerso* vase with solid base and one
entrapped bubble; turquoise cased in vaseline glass, probably
designed by Antonio Da Ros.
Unmarked
Height 10-1/4 in; 26 cm.
$1,000-1,200
Collection of M. Lacis (Australia), photo courtesy of Geoff Clarke

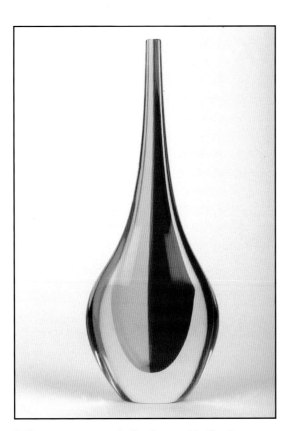

Tall *sommerso* vase, half yellow and half red,
encased in crystal.
Unmarked
Height 17-1/4 in; 44 cm.
$1,200-1,400

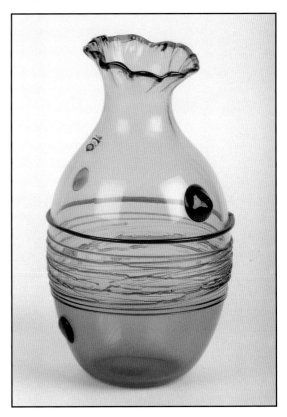

Cenedese
Bulbous vase with irregular rim, green bottom to
yellow, with applied threading and glass bits in red,
green, blue, and yellow.
Incised, Gino Cenedese 113/300 and foil label
Height 10-3/4 in; 27.5 cm.
$600-800

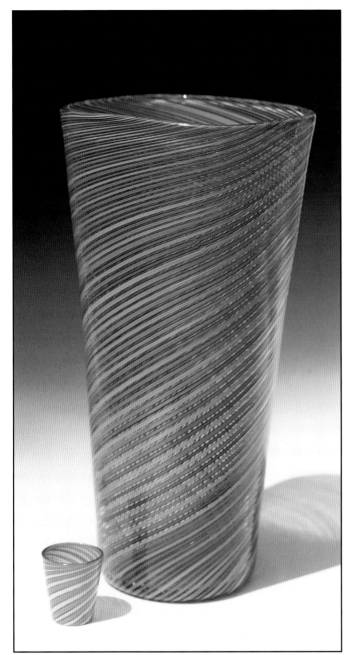

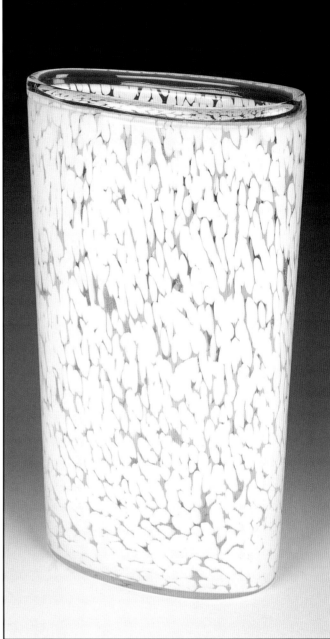

Cenedese
Mezza filigrana four-sided vase with pink, lavender, and light blue stripes, shown with small vase to show scale.
Incised, Cenedese.
Height 14-1/4 in; 36 cm.
$2,000-2,500

Top right:
Cenedese
Flattened cylinder vase in clear glass with internal *lattimo* spotty pattern, clear rim.
Incised, Cenedese.
Height 13-1/2 in; 34.5 cm.
$500-700

Detail.

Campanella
Heavy *sommerso* vase with molded textured sides and flat front and back, red in vaseline, in clear.
Unmarked
Height 5-1/4 in; 13.5 cm.
$100-150

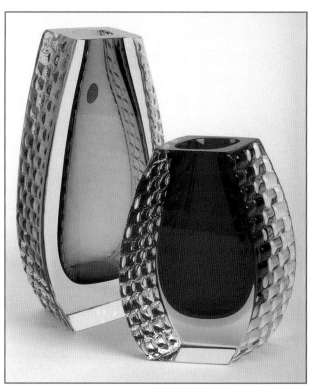

Campanella
Heavy *sommerso* vases in flattened teardrop form, lavender in clear and red in clear with textured sides.
Foil Label, Made in Murano Italy
Height 8-1/4 in; 21 cm. lavender.
$200-250, $100-150

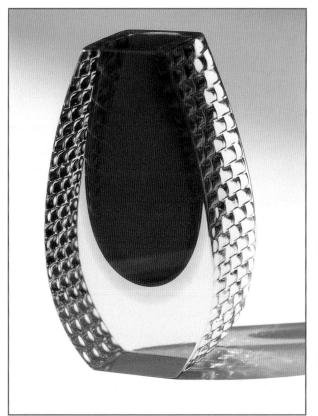

Campanella
Red *sommerso* in clear with textured sides.
Unmarked
Height 8-3/4 in; 22 cm.
$200-250

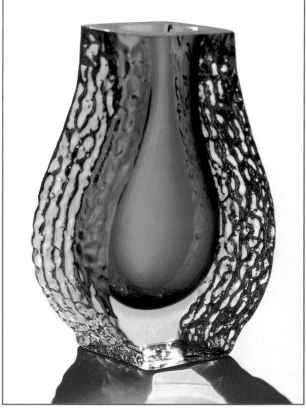

Campanella
Variation in shape with green *sommerso* inside crystal.
Unmarked
Height 8-1/4 in; 21 cm.
$200-250

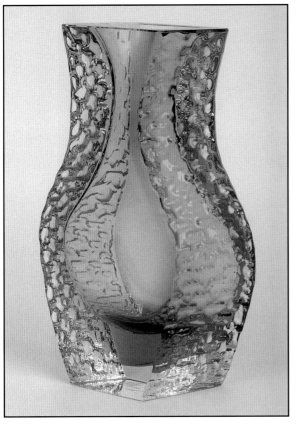

Campanella
Two-tone *sommerso* with teal on one side and amber
on the other.
Unmarked
Height 10-3/4 in; 27 cm.
$250-300

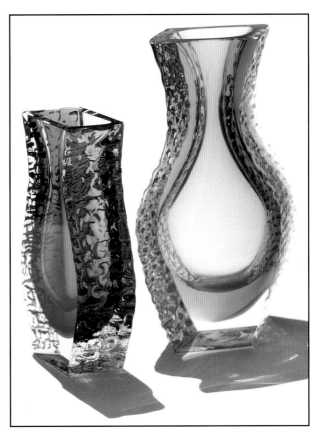

Campanella
Two-tone green and blue *sommerso*, shown with teal and
amber.
Unmarked
Height 8-1/2 in; 22 cm.
$200-250

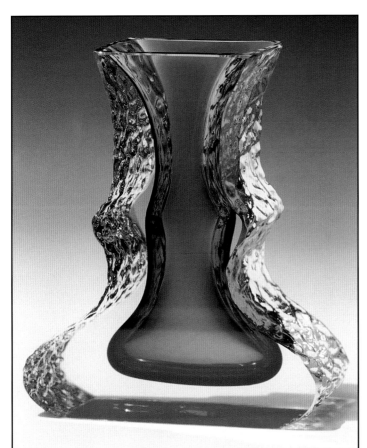

Murano Vetreria - G. Campanella & C.

Campanella
Heavy sculptural undulating form, gray
sommerso in crystal.
Label
Height 9-3/4 in. 25 cm.
$250-350

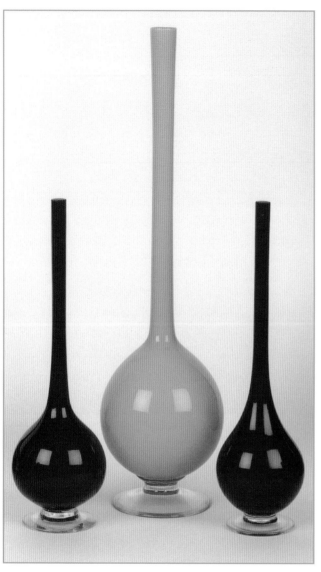

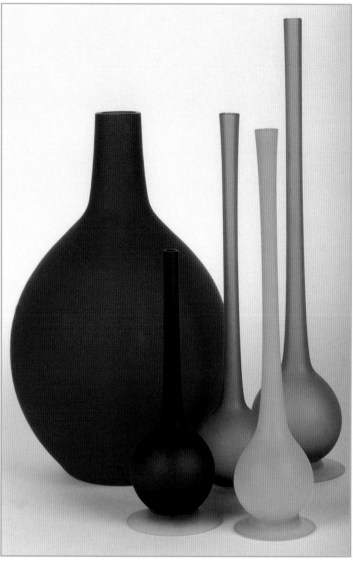

Carlo Moretti
Cased footed vase with elongated pencil neck, attributed to
Carlo Moretti, 1960s; *lattimo* interior cased in red, center
vase apple green, all with clear applied foot.
Unmarked
Height 11 in; 28 cm; 16-1/4 in; 31.5 cm.
$150-200 each

Carlo Moretti
Pencil neck *satinato* vases in varying heights, all with satin finish and
clear foot, designed by Carlo Moretti 1959-1966; with bulbous
orange *satinato* vase attributed to Moretti.
Paper labels, Rosenthal Netter.
Heights 10, 14, and 19 in; 25.5, 35.5, and 48 cm;
bulbous 14-1/2 in; 37 cm.
$100-200 each

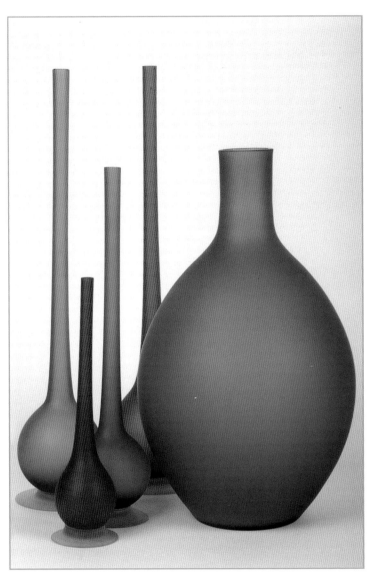

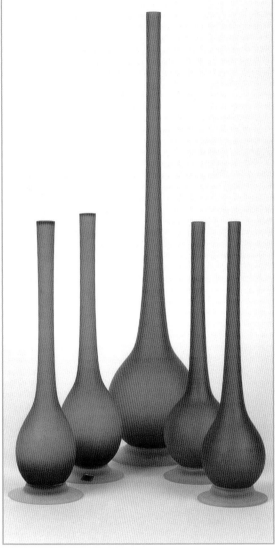

Carlo Moretti
Pencil neck *satinato* vases in varying heights, all with satin finish and clear foot, designed by Carlo Moretti 1959-1966; with bulbous turquoise *satinato* vase attributed to Moretti.
Paper labels, Rosenthal Netter.
Heights 10, 14, and 19 in; 25.5, 35.5, and 48 cm;
bulbous 14-1/2 in; 37 cm.
$100-200 each

Carlo Moretti
Pencil neck *satinato* vases in orange.

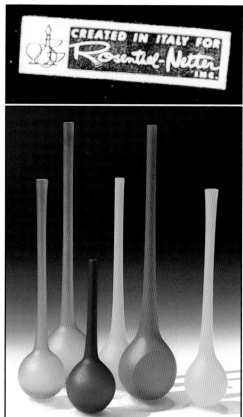

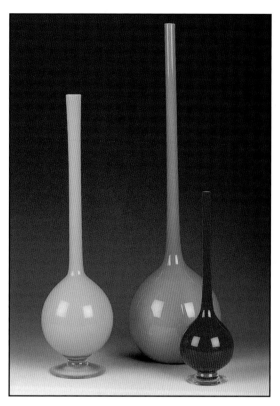

Carlo Moretti
Various cased pencil neck vases with regular glossy finish.

Carlo Moretti
Various colors and sizes of *satinato* vases

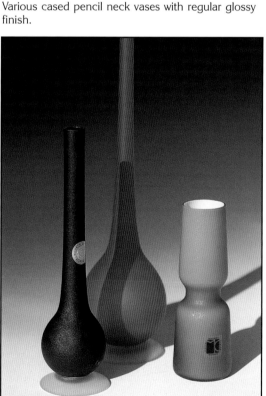

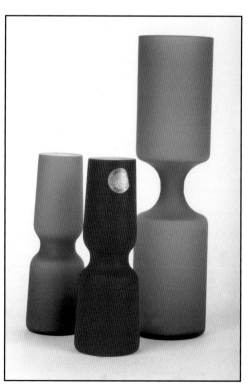

Carlo Moretti
Black *satinato* vase with old Moretti round gold label, orange *satinato*, and turquoise and white *bicolore satinato* vase.
Paper labels
Height of turquoise 7 in; 18 cm.
$100-150 each

Carlo Moretti
Hourglass form vase in mossy green *satinato*, shown with smaller vases in similar form.
Unmarked
Height 12 in; 30.5 cm.
$125-150

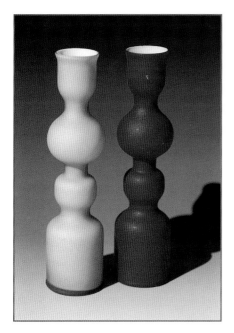

Carlo Moretti
Lavender and red cased *bicolore satinato* vases with four sections, ca. 1960s.
Gold label
Height 9-1/2 in; 24 cm.
$100-150 each

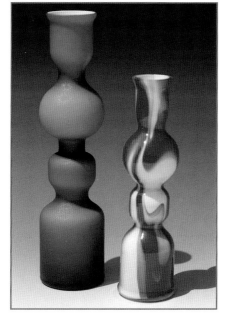

Carlo Moretti
Turquoise and *lattimo bicolore satinato* four-section vase with red and white marble vase, designed ca. 1970.
Red label
Height 9-1/2 and 7-1/2 in; 24 & 19 cm.
$100-150 each

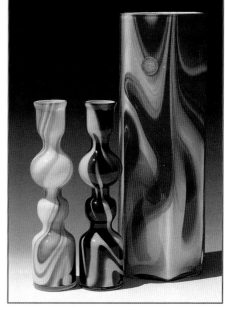

Carlo Moretti
Six-sided marble vase in red-orange and white, ca. 1960s, shown with two four-section marble vases in green and white and purple and white.
Gold label
Height 14 in; 35.5 cm.
$300-400

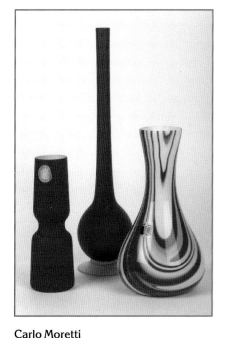

Carlo Moretti
Red *bicolore satinato,* red tall neck *satinato*, and red and white marble vase.
Heights 7, 9, and 14 in; 18, 23, and 35.5 cm.
Gold and black labels.
$100-150 each

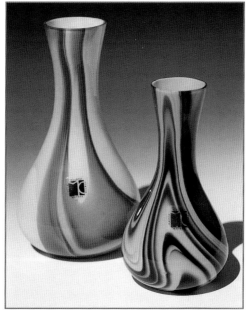

Carlo Moretti
Marble vases in orange and white and purple and white, ca. 1980s.
Heights 9 and 7-1/4 in; 23 and 18.5 cm.
Black label
$75-125 each

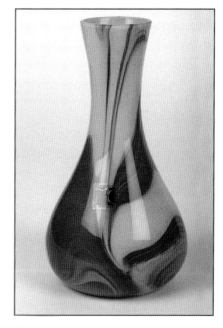

Carlo Moretti
Orange and yellow marble vase, ca. 1980s.
Height 9 in; 23 cm.
Black label
$100-150

Carlo Moretti
Murano Italia

Carlo Moretti Murano Italia

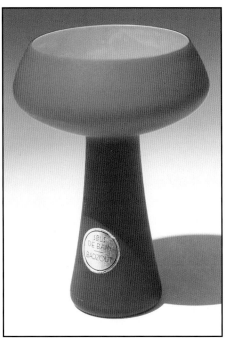

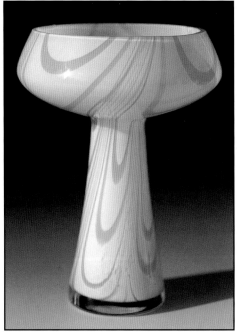

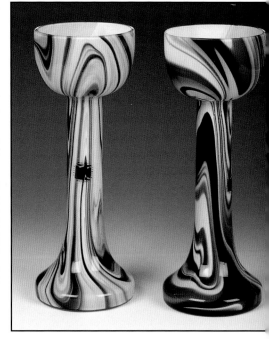

Carlo Moretti
Orange and white *bicolore satinato* vase with pedestal base and bowl top, 1960s.
Height 7-1/4 in; 18.5 cm.
Gold label
$100-150

Carlo Moretti
Cased marble pedestal bowl vase with green and turquoise swirls on white ground, ca. 1960s.
Height 7-1/4 in; 18.5 cm.
Gold label
$100-150

Carlo Moretti
Two chalice vases in green, purple, and white marble, ca. 1980s.
Black label
Height 9-3/4 in; 35 cm
$125-150 each

Carlo Moretti
Thick-walled cased dark red pillow vase with
marble insert.
Unmarked
Height 8-3/8 in; 21 cm.
$300-400

Marble detail.

Rim detail.

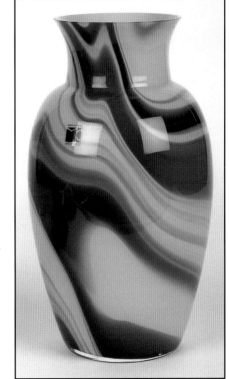

Carlo Moretti
Onde di mare marble vase in sea colors, 1990s.
Black label
Height 10-5/8 in; 27 cm.
$200-250

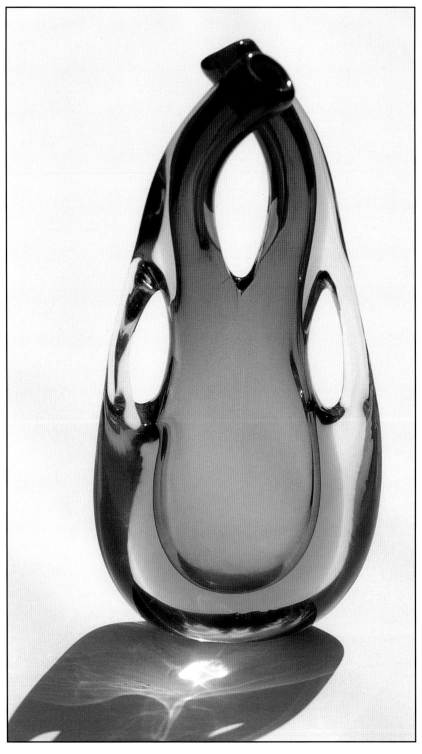

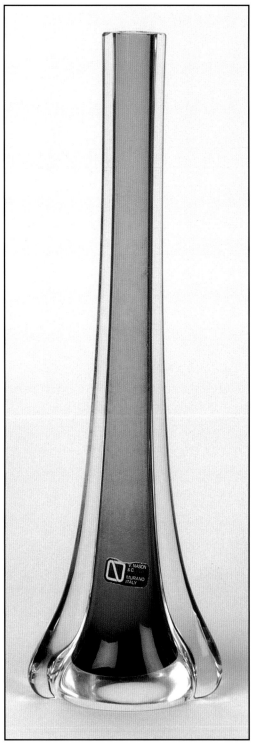

V. Nason
Double neck *sommerso* vase with two openings in the clear outer layer, raspberry interior.
Unmarked
Height 13 in; 33 cm.
$1,000-1,500
Courtesy of Michael Ellison

Nason & C.
Long-necked *sommerso* vase with gray interior.
Label, V. Nason & C. Murano Italy
Height 16 in; 40.5 cm.
$200-300

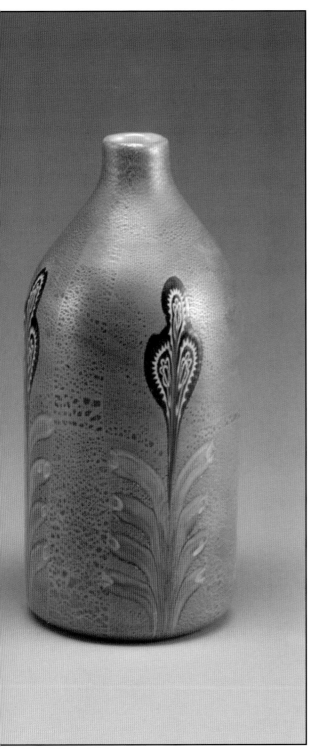

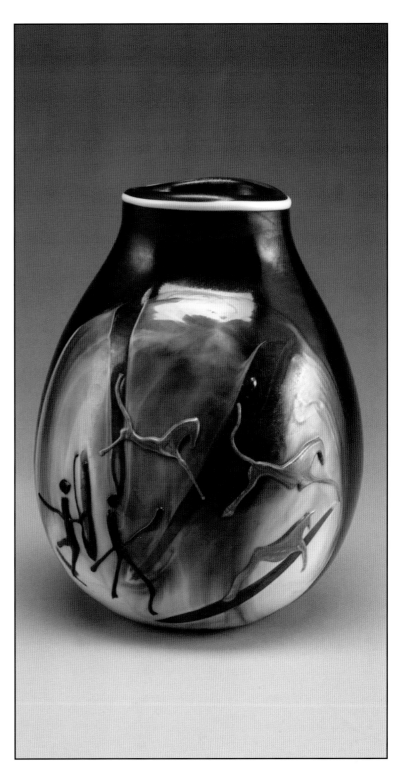

Ermanno Nason (attributed to)
Marquetry bottle-vase with inlaid flowers in blue with pink leaves, on gold foil ground, designed by Aldo Nason.
Unmarked
Height 10-1/2 in; 27 cm.
$4,000-5,000
Photo courtesy of Rago Modern Auctions

Ermanno Nason
Bulbous vase of fumed iridized glass with applied figural hunters and animals, designed by Fulvio Bianconi.
Unmarked.
Height 12 in; 30.5 cm.
$15,000-20,000
Photo courtesy of Rago Modern Auctions

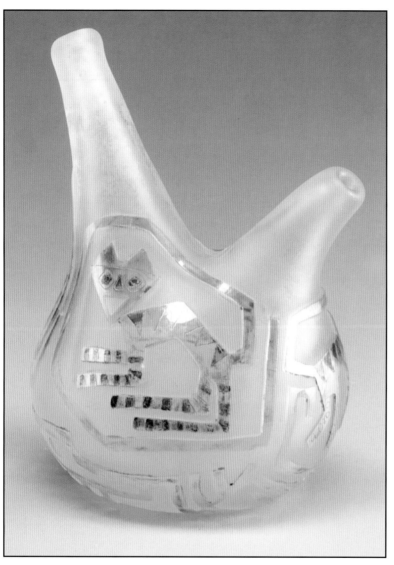

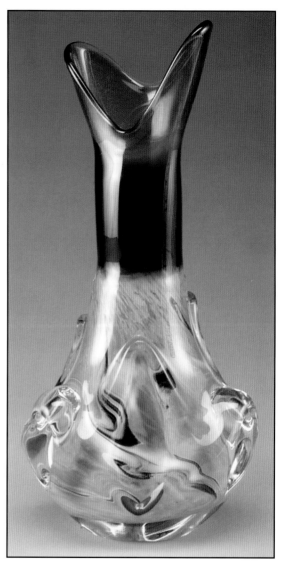

SALIR
Double spouted vase in clear acid-etched glass with primitive geometric animals.
Paper label, Pauly & C.
Height 9-1/2 in; 24 cm.
$3,500-4,500
Photo courtesy of Rago Modern Auctions

Salviati
Incalmo vase in green, amber, and clear glass with pulled surface decoration.
Unmarked.
Height 14-1/2 in; 37 cm.
$1,500-2,000
Photo courtesy of Rago Modern Auctions

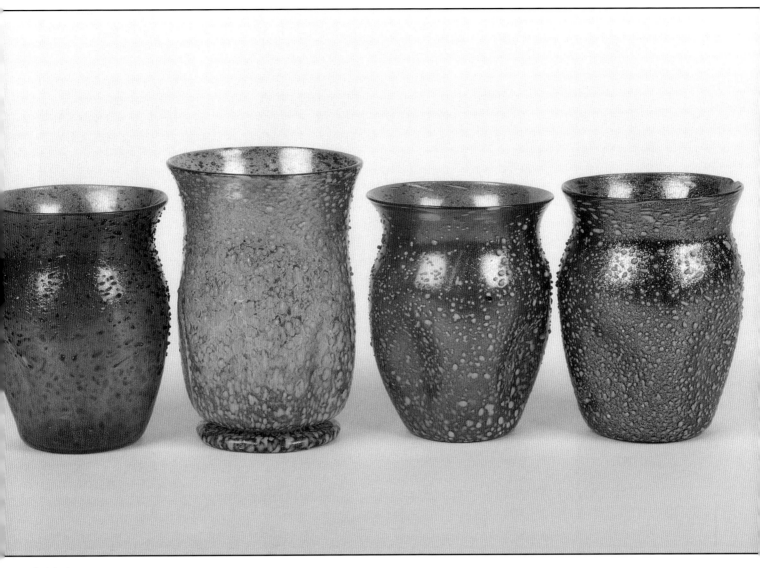

Salviati
Late 19th century *granzioli* vases with applied turquoise spots.
Unmarked
Heights 3-1/2 to 4 in; 9-10 cm.
$300-400 each
Courtesy of Lorenzo Vigier

Salviati
Late 19th century footed vase in Renaissance form with bumpy hollow stem, bowl of mottled multicolor and gold glass, with applied clear threading and prunts in the form of faces.
Unmarked
Height 10 in; 25.5 cm.
$600-800

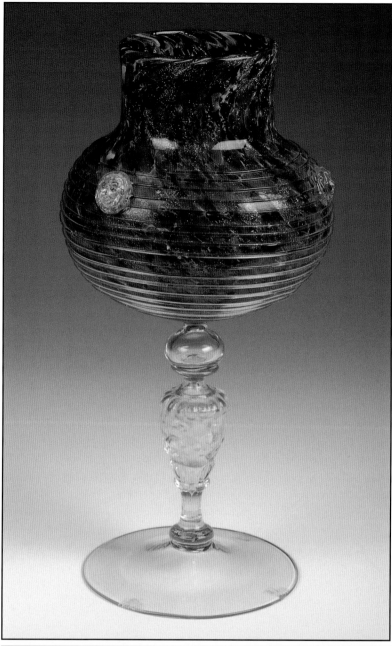

Detail of face.

56

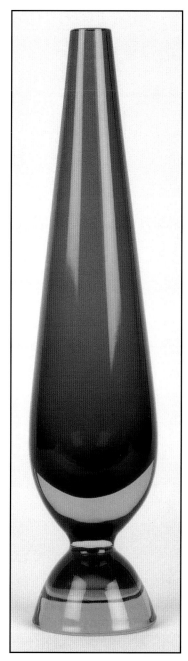

Salviati
Tall tapering gray and alexandrite
sommerso vase with alexandrite
paperweight base, attributed to
Salviati.
Unmarked
Height 15 in; 38 cm.
$1,000-1,500
Courtesy of Lorenzo Vigier

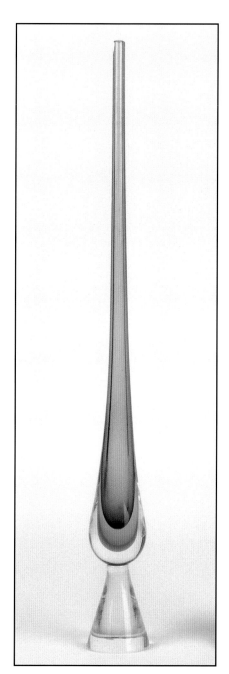

Salviati
Tall tapering *sommerso* vase with
raspberry pencil neck and turquoise
bottom, with clear paperweight base,
designed by Luciano Gaspari and
exhibited in the 1960 Biennale.
Unmarked
Height 20 in; 51 cm.
$1,000-1,500

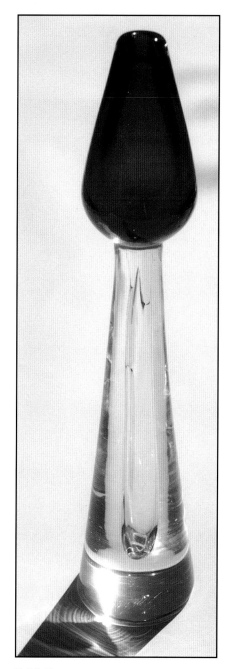

Salviati
Tulip form vase with heavy clear
elongated base, floriform top in red
sommerso with narrow opening,
designed by Luciano Gaspari.
Unmarked
Height 16-3.4 in; 42.5 cm.
$4,000-5,000
Courtesy of Michael Ellison

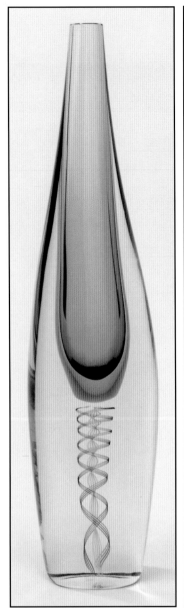 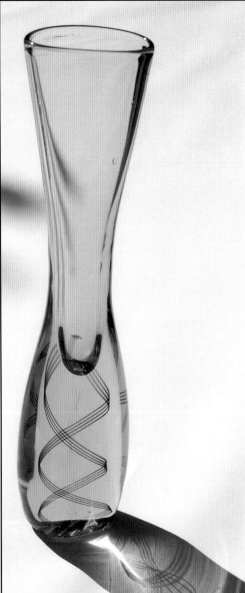 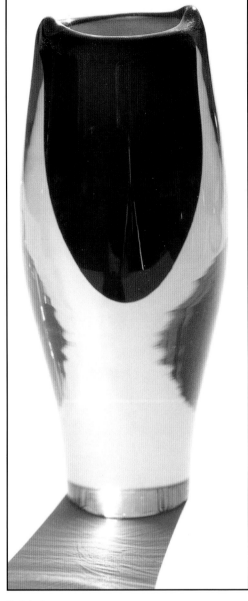

Salviati
Sommerso pinnacolo bottle
vase, heavy solid base with
internal spiral *filigrana*, green
interior encased in amber,
designed by Luciano Gaspari,
ca. 1960.
Unmarked
Height 18-1/2 in; 46.5 cm.
$4,000-5,000
*Collection of M. Lacis, photo
courtesy of Geoff Clarke*

Salviati
Turquoise *pinnacolo sommerso* vase with flared
top, heavy base enclosing twisted *filigrana*,
designed by Luciano Gaspari, ca. 1960.
Unmarked
Height 15-1/2 in; 39.5 cm.
$1,500-2,000
Courtesy of Lorenzo Vigier

Salviati
Heavy *sommerso* vase of dark amethyst
enclosed in light blue glass, designed by
Luciano Gaspari.
Unmarked
Height 7-3/4 in; 19.5 cm.
$400-500
Courtesy of Lorenzo Vigier

Opposite page:
Salviati
Graceful *sommerso pinnacolo* vases designed by Luciano
Gaspari: left, rose with heavy clear base and narrow neck; right
with cobalt interior and elongated heavy turquoise base.
Unmarked
Heights 19 & 21 in; 48.5 x 53.5 cm.
$2,000-3,000 each
Courtesy of Chuck Kaplan

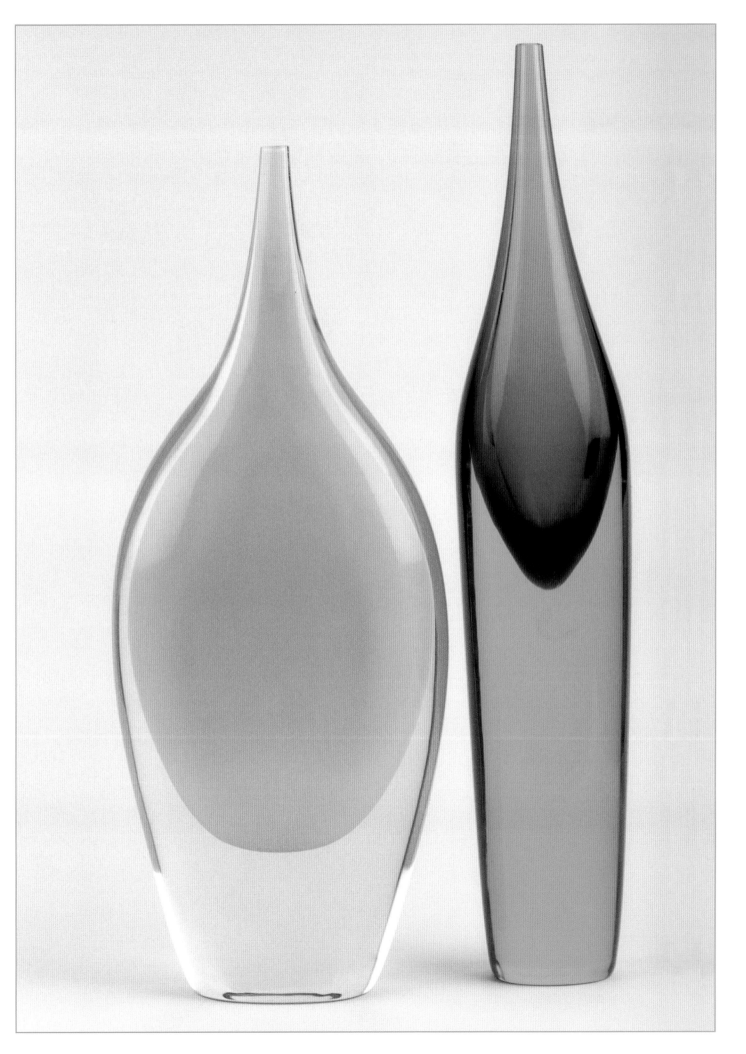

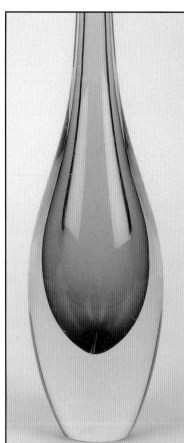

Salviati
Pink *sommerso* vase with deep heavy clear base,
atrributed to Luciano Gaspari for Salviati.
Unmarked
Height 9 in; 23 cm.
$300-400

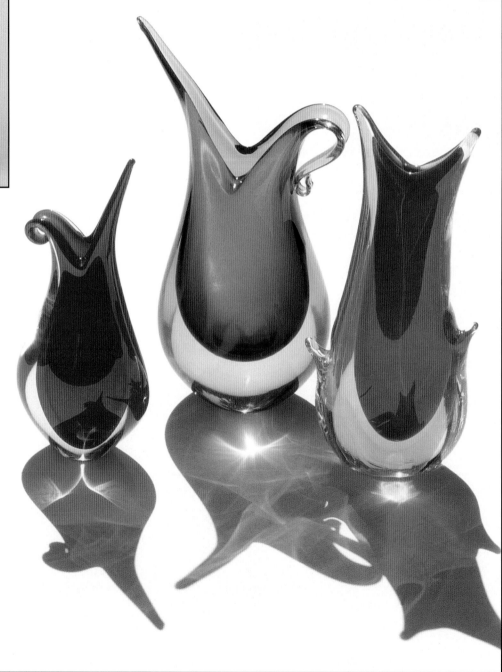

Seguso Vetri d'Arte
Amber *sommerso* vase with
pulled spout and handle,
attributed to Seguso Vetri
d'Arte, with two similar forms.
Unmarked
Heights 7-1/2 and 9 in; 19
and 23 cm.
$200-300 each
Courtesy of Lorenzo Vigier

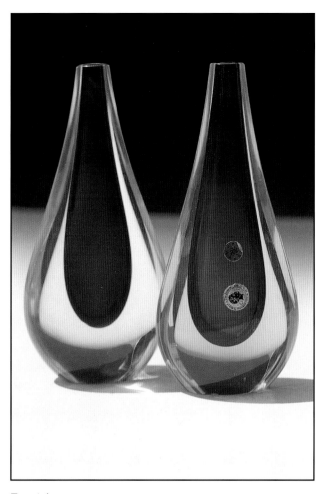

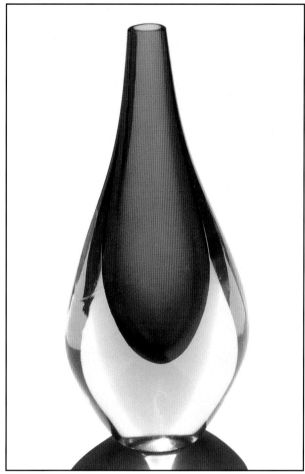

Top right:
Sommerso teardrop vase with raspberry encased in turquoise and clear glass, possibly by Seguso Vetri d'Arte.
Unmarked
Height 9 in; 23 cm.
$300-400
Courtesy of Lorenzo Vigier

Top left:
Galliano Ferro
Red and vaseline teardrop *sommerso* vases, in the style of Seguso Vetri d'Arte, by Galliano Ferro, ca. 1960s.
Labels, Murano, and head with GF and inscription.
Height 8-5/8 in; 21 cm.
$300-400 each

Right:
Two *sommerso* vases with red encased in vaseline, long necks, similar to Seguso Vetri d'Artc, shown with teardrop vase of higher quality.
Labels, Murano Glass and Made in Italy.
Height 12 in; 30.5 cm.
$100-150 each

Galliano
Ferro label

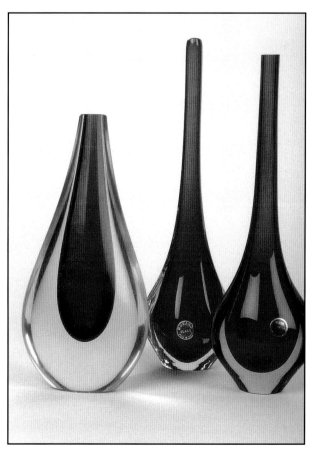

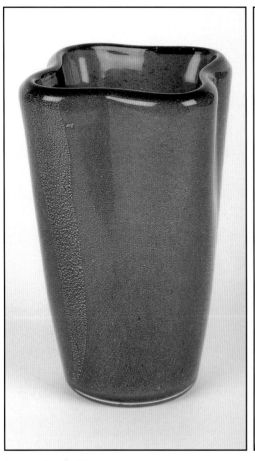

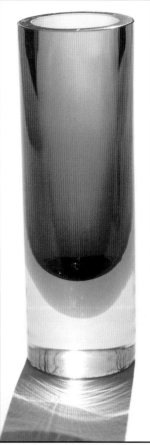

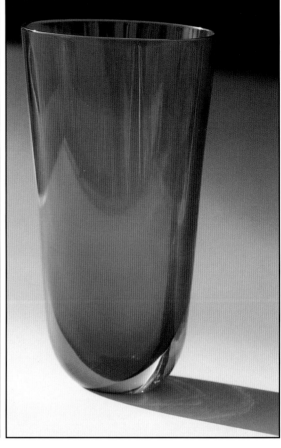

Seguso Vetri d'Arte
A *bollicine* vase of cylindrical from with pinched and squared rim, with an internal layer of green cased by a layer of frothy and tightly packed bubbles, covered with a layer of gold *aventurine,* all cased in clear glass, designed by Flavio Poli, ca. 1942.
Marked with illegible numbers
Height 6-1/4 in; 16 cm.
$1,000-1,200
Courtesy of Lorenzo Vigier

Cylindrical *sommerso* vase of rose, in amber, in clear, attributed to Seguso Vetri d'Arte.
Unmarked
Height 8 in; 20 cm.
$300-400
Courtesy of Lorenzo Vigier

Seguso Vetri d'Arte
Raspberry *sommerso* flattened cylindrical vase with rounded bottom and slightly flaring rim, designed by Flavio Poli, ca. 1958.
Unmarked
Height 12-1/2 in; 32 cm.
$1,500-2,000
Courtesy of Lorenzo Vigier

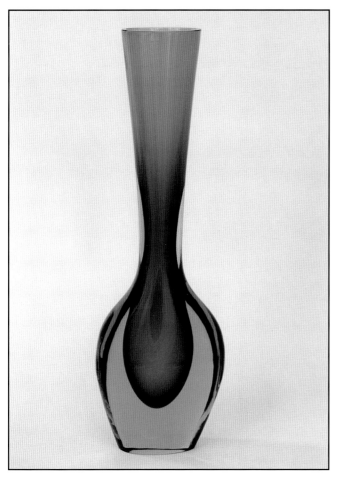

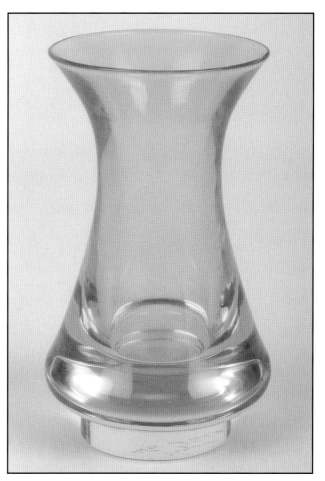

Seguso Vetri d'Arte
Tall *sommerso* vase in cobalt encased in turquoise, long tapered neck, attributed to Flavio Poli for Seguso Vetri d'Arte.
Unmarked
Height 19-1/4 in; 49 cm.
$1,000-1,200
Collection of J. Dilder (Australia), photo courtesy of Geoff Clarke

Seguso Vetri d'Arte
Yellow and pale blue *sommerso* vase, likely designed by Mario Pinzoni, ca. 1965.
Signed Seguso Vetri d'Arte
Height 5 in; 13 cm.
$150-200
Courtesy of Lorenzo Vigier

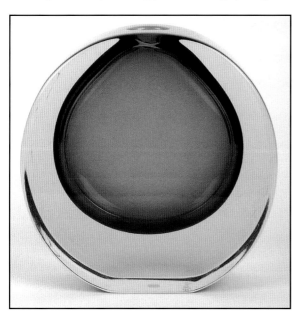

Seguso Vetri d'Arte
Sommerso vase of disk-like form, with an internal layer of transparent gray glass, heavily cased in light pink glass, designed by Maurizio Albarelli, ca. 1979.
Signed, S V D Albarelli 79
Height 6-1/2 in; 16.5 cm.
$600-800
Courtesy of Lorenzo Vigier

Seguso Vetri d'Arte

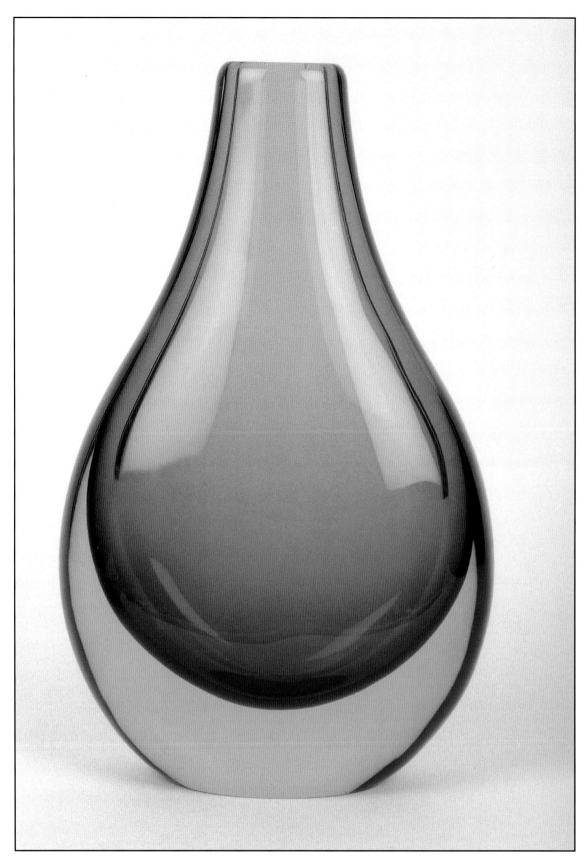

Seguso Vetri d'Arte
Sommerso vase of teardrop form flattened on two sides, with an internal layer of
transparent brown cased in amber glass, designed by Flavio Poli, ca. 1956.
Unmarked
Height 13 in; 33 cm.
$2,000-2,500
Courtesy of Lorenzo Vigier

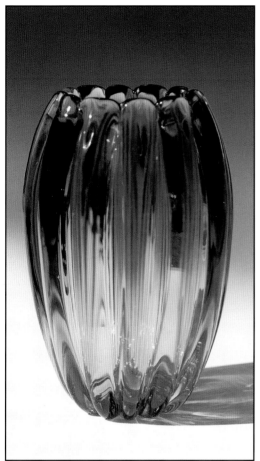
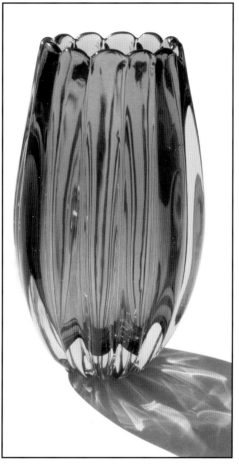
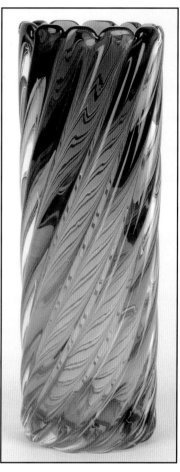

Seguso Vetri d'Arte
Fluted vase tapering slightly toward the base, with scalloped rim, in green to amber, attributed to Flavio Poli for Seguso Vetri d'Arte.
Unmarked
Height 9-1/4 in; 23.5 cm.
$500-700

Seguso Vetri d'Arte
Amber fluted vase tapering slightly toward the scalloped rim, attributed to Flavio Poli for Seguso Vetri d'Arte.
Unmarked
Height 12 in; 30.5 cm.
$1,600-1,800
Courtesy of Lorenzo Vigier

Seguso Vetri d'Arte
Sommerso vase of cylindrical form with external spiral ribs, with an internal layer of graded amber to gray glass cased in clear glass, attributed to Mario Pinzoni, ca. 1965.
Unmarked
Height 13 in; 33 cm.
$1,200-1,500
Courtesy of Lorenzo Vigier

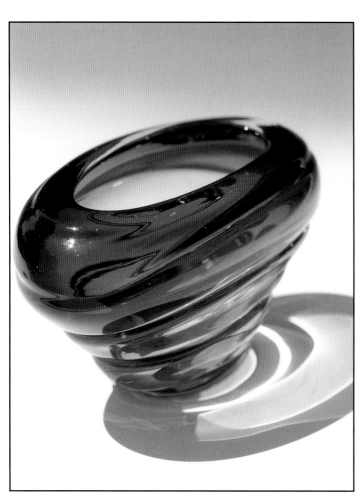

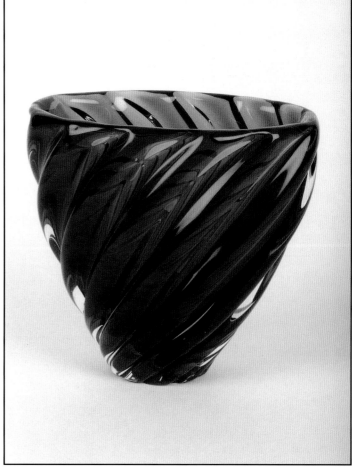

Heavy wide-shouldered vase in blue and purple, possibly by
Archimede Seguso.
Unmarked
5 x 9 in; 12.5 x 23 cm.
$300-400

Archimede Seguso
Sommerso vase in layers of purple, cranberry, and clear, with
diagonal ribbing.
Unmarked
Height 7 in; 18 cm.
$800-1,000
Courtesy of Lorenzo Vigier

Three 1990's versions of classic *sommerso* teardrop vase with
diagonal rim, bright raspberry encased in clear glass, designed by
Luigi Onesto after the original by Flavio Poli.
Oggetti import labels.
Heights 6 and 9-5/8 in; 15 and 24.5 cm.
$75-150 each
Courtesy of Michael Ellison

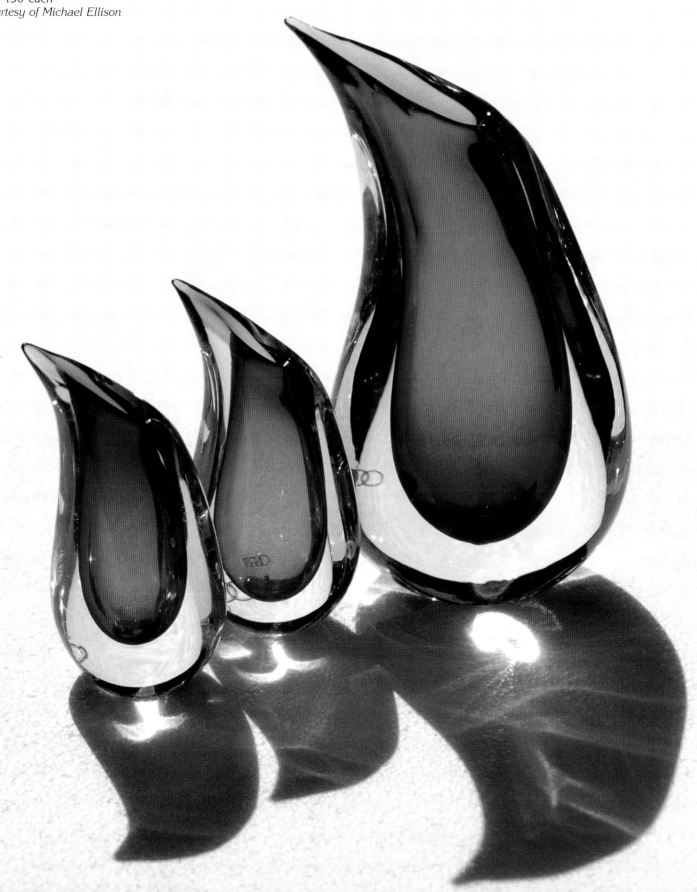

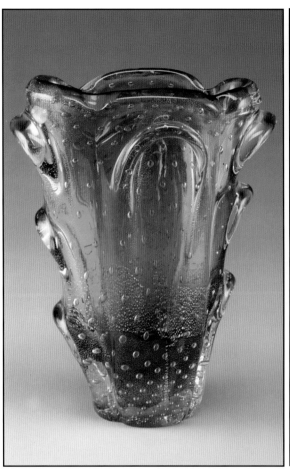

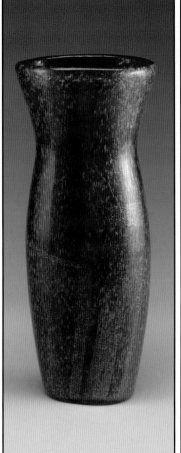

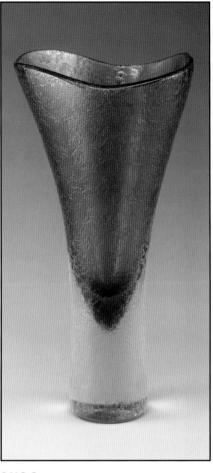

Seguso Vetri d'Arte
Green *bullicante* vase with gold patch inclusions
and pulled surface, 1938-40.
Unmarked.
Height 10 in; 25.5 cm.
$400-600
Photo courtesy of Rago Modern Auctions

Seguso Vetri d'Arte
A bollicinie balluster vase in red
and gold, designed by Flavio
Poli, ca. 1938.
Unmarked.
Height 14-1/2 in; 37 cm.
$2,500-3,500
*Photo courtesy of Rago Modern
Auctions*

S.V.C.C.
Flared *sommerso* vase in cranberry and
clear *corroso*, designed by Flavio Poli.
Unmarked.
Height 14 in; 35.5 cm.
$800-1,000
*Photo courtesy of Rago Modern
Auctions*

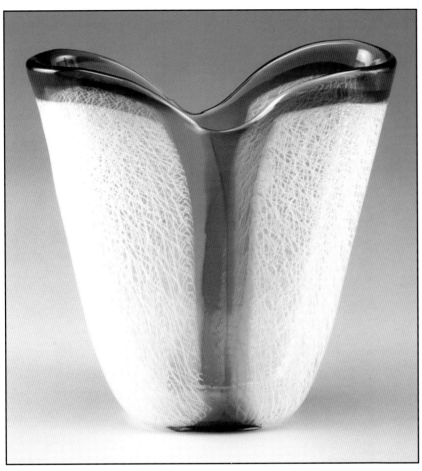

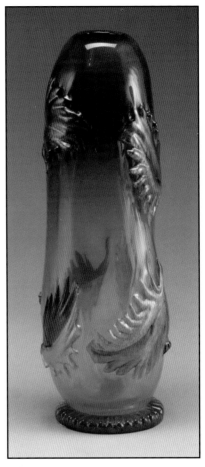

Archimede Seguso
White *merletto* flaring vase with green and amber band on rim and down center.
Unmarked
8 x 8 in; 20.5 x 20.5 cm.
$5,000-7,000
Photo courtesy of Rago Modern Auctions

Archimede Seguso
Green shaded vase with applied autumn leaves, ca. 1950.
Unmarked.
Height 14 in; 35.5 cm.
$3,500-4,500
Photo courtesy of Rago Modern Auctions

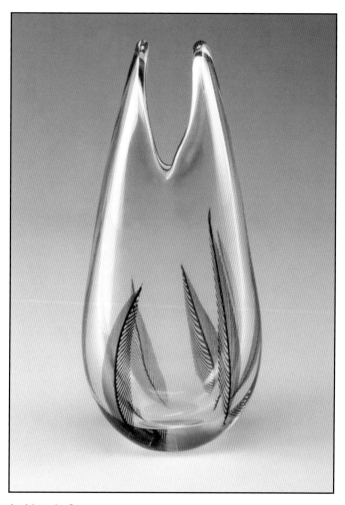

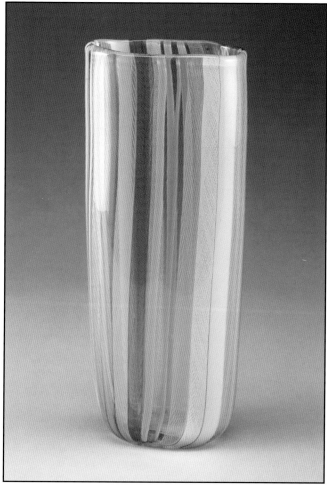

Archimede Seguso
A piume teardrop-shaped vase in amber with amethyst feathers, 1956.
Unmarked.
Height 10-1/2 in; 26.5 cm.
$4,000-6,000
Photo courtesy of Rago Modern Auctions

Archimede Seguso
Flattened ovoid vase with multi-colored *zanfirico* stripes.
Unmarked.
Height 11 in; 28 cm.
$600-800
Photo courtesy of Rago Modern Auctions

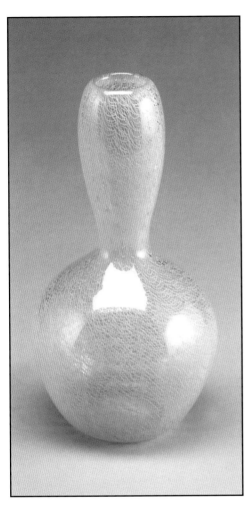

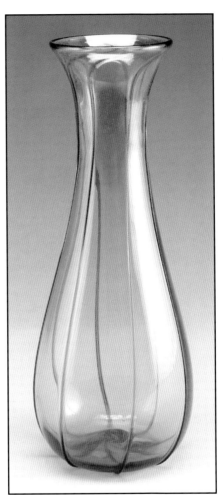

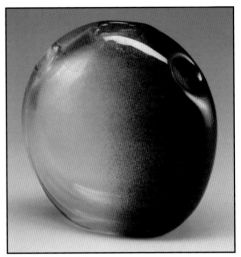

Archimede Seguso
Polveri pillow vase with three openings, in amethyst and gold, 1953.
Unmarked.
Height 9 in; 23 cm.
$1,500-2,000
Photo courtesy of Rago Modern Auctions

Archimede Seguso
Merletto gourd-shaped bottle-vase in blue and white.
Unmarked.
Height 8 in; 20.5 cm.
$3,000-4,000
Photo courtesy of Rago Modern Auctions

Archimede Seguso
Tear-drop form with flared rim in amber with applied green threads.
Unmarked.
Height 16 in; 40.5 cm.
$400-600
Photo courtesy of Rago Modern Auctions

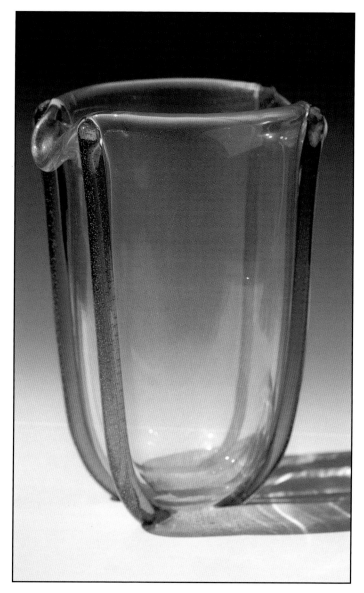
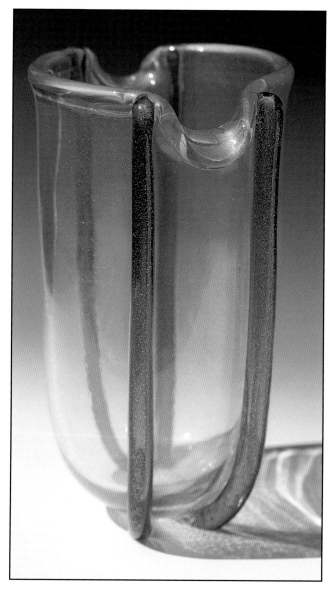

Archimede Seguso
Oro cordonati vase in clear with gold inclusions, rounded base, and two pulled spouts, with four applied green
ropes connecting the spouts to the base, designed by Archimede Seguso in 1949.
Unmarked
Height 11 in; 28 cm.
$2,500-3,500

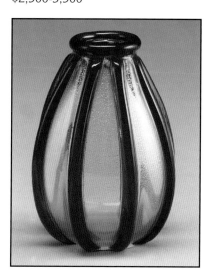

Archimede Seguso
Oro cordonati pear-shaped vase of clear and gold foil with
applied ruby rods and rim, 1949.
Signed, Archimede Seguso/Murano.
Height 4-1/2 in; 11 cm.
$1,500-2,000
Photo courtesy of Rago Modern Auctions

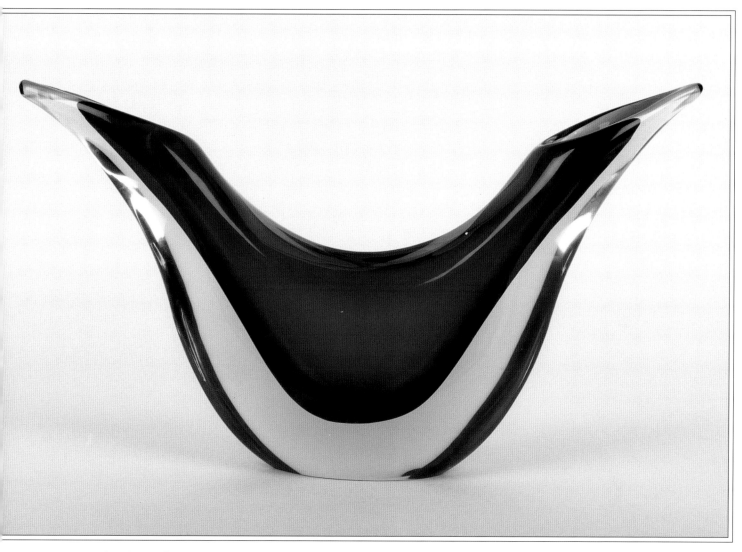

Archimede Seguso
Sommerso vase resembling horns with openings at each end, in cobalt blue cased in aquamarine
glass, designed by Archimede Seguso.
Labeled
Length 19 in; 48 cm.
$3,000-5,000
Courtesy of Lorenzo Vigier

Seguso Vetri d'Arte
Bullicante vase of lobed cylindrical form with clear
glass foot, with an internal layer of green covered by
a layer of gold foil, covered by layers of controlled
bubbles, cased in clear glass, designed by Flavio Poli,
ca. 1937, and likely executed by Archimede Seguso.
Unmarked
Height 9-1/4 in; 23.5 cm.
$16,000-18,000
Courtesy of Lorenzo Vigier

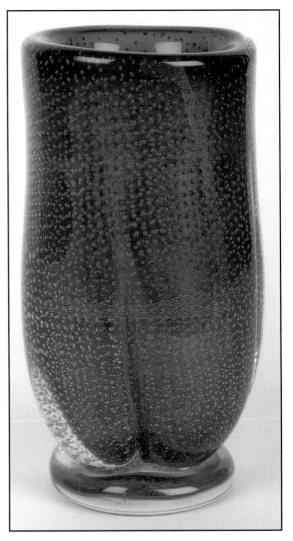

Detail.

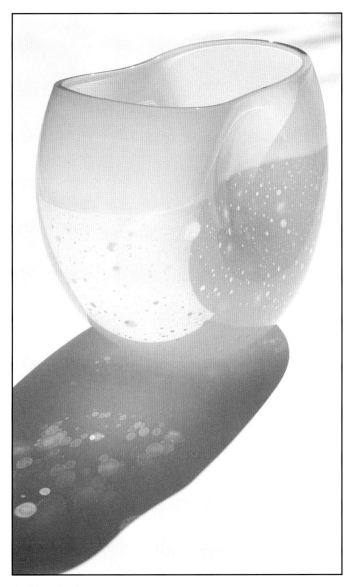

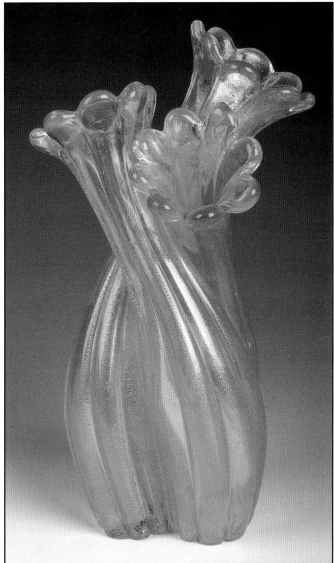

Archimede Seguso
Pillow form vase with dented sides, in *lattimo* and clear glass with internal pattern of bubbles in the bottom half, attributed to Archimede Seguso.
11 x 12 in; 28 x 30.5 cm.
$2,500-3,500
Courtesy of Michael Ellison

Archimede Seguso
Ritorto a coste vase designed by Archimede Seguso in 1950, with three fluted sections twisted together, clear glass with gold inclusions.
Unmarked
Height 9-3/4 in; 25 cm.
$1,200-1,600

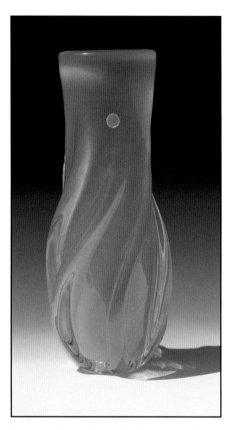

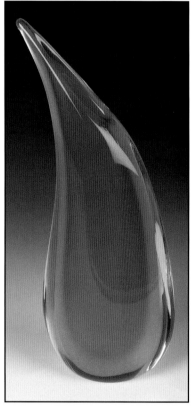

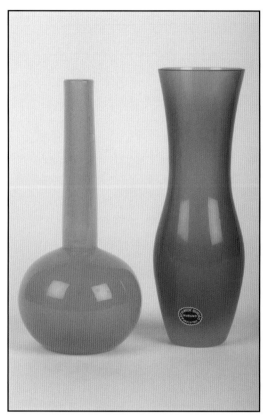

Cased pink opaline and clear vase with twisted form, in the style and color of Archimede Seguso.
Label, Made in Italy Murano
Height 13 in; 33 cm.
$500-700

Archimede Seguso
Teardrop *sommerso* vase with pulled spout-like rim, in pink *alabastro* cased in clear glass.
Unmarked
Height 11-1/4 in; 28.5 cm.
$400-500

Archimede Seguso
Alabastro rosa vase with bulbous base and narrow neck; with blue *alabastro* vase with flared rim.
Incised signature, Seguso Murano and paper label
Heights 8-1/4 and 8 in; 21 and 20 cm.
$400-600 and $250-350

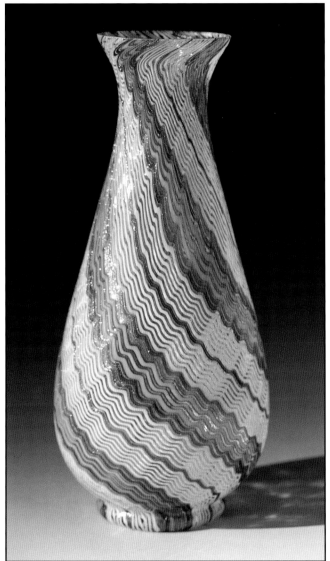

Aureliano Toso
Bulbous vase with molded foot, pinched neck and slightly
flared rim, with wavy *mezza filigrana* pattern typical of Dino
Martens for Aureliano Toso, in pink, white, and gold in clear
glass, model #6038 designed 1954.
Unmarked
Height 14-1/2 in; 37 cm.
$1,500-2,000

Detail.

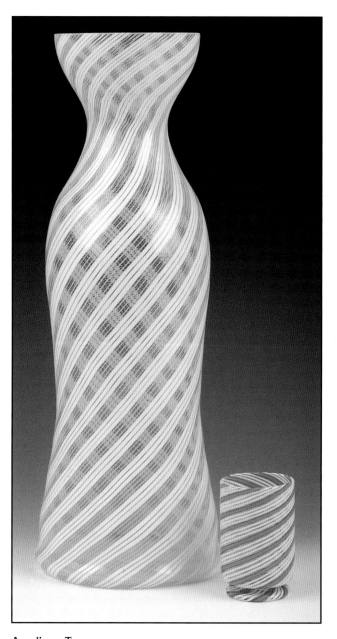

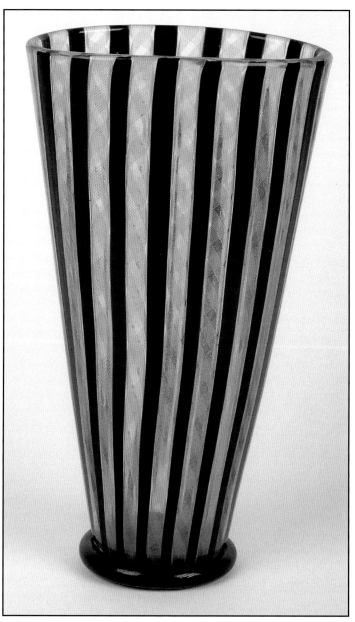

Aureliano Toso
Mezza filigrana vase in undulating form with flared rim, in
yellow and white on clear glass, model #6049 designed by
Dino Martens in 1954; shown with small vase to indicate
scale.
Unmarked
Height 15-1/2 in; 39.5 cm.
$2,000-2,500

Aureliano Toso
Tapering *a canne* vase in black and yellow fine filigree, model 3081
designed by Dino Martens in 1952.
Unmarked
Height 8-1/2 in; 21.5 cm.
$1,400-1,800

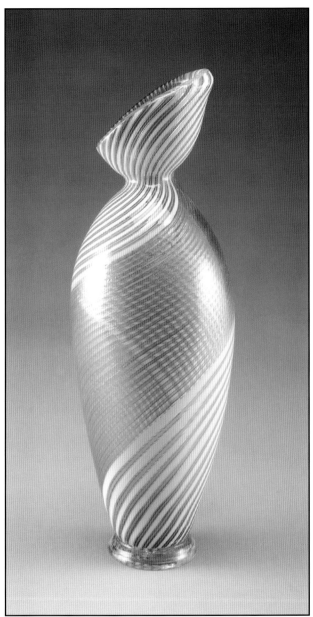

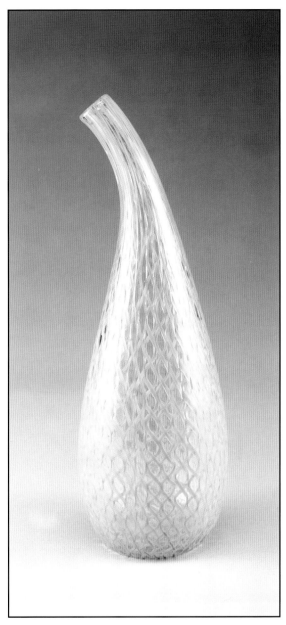

Aureliano Toso
Mezza filigrana bottle-base in pink and white, with pinched
neck and flared slanted rim, designed by Dino Martens.
Unmarked.
Height 13-1/4 in; 33.5 cm.
$2,000-3,000
Photo courtesy of Rago Modern Auctions

Aureliano Toso
Gourd-shaped bottle vase in robin's-egg blue twisted
filigree honeycomb *luminoso* pattern, designed by
Dino Martens.
Unmarked.
Height 12-1/2 in; 32 cm.
$3,000-4,000
Photo courtesy of Rago Modern Auctions

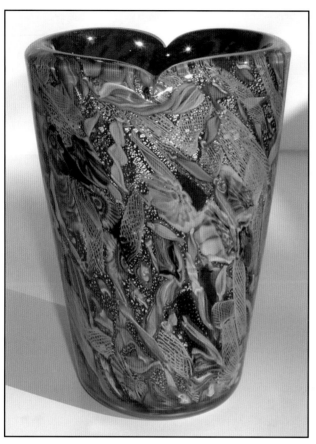

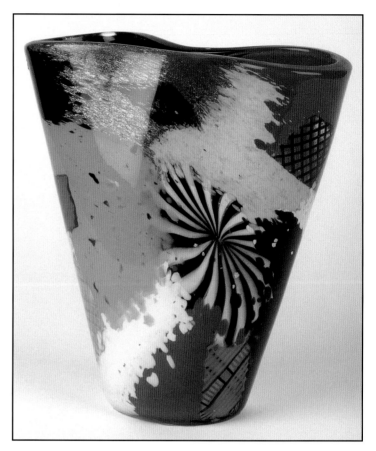

A.VE.M.
Cherry red interior surrounded by a layer containing multi-colored *filigrana*, *millefiori*, white *zanfirico*, and silver foil, 1950s.
Unmarked
Height 8 in; 20 cm.
$800-1,000
Photo courtesy of PlanetGlass.net

Aureliano Toso
Classic *Oriente* vase designed by Dino Martens in 1952 for Aureliano Toso, pinched flared design with patches of bright color, gold inclusions, and a black and white pinwheel motif.
Unmarked
Height 9 in; 23 cm.
$12,000-16,000

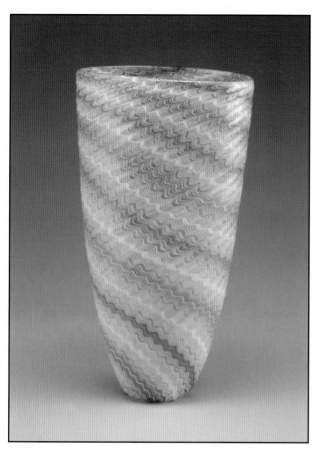

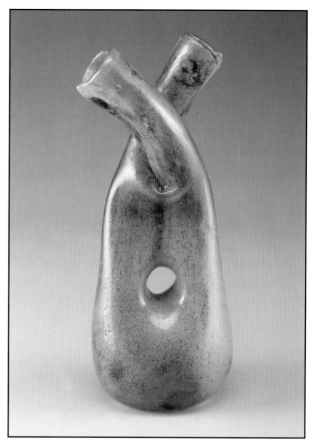

Aureliano Toso
Flaring multi-color *filigrana* pillow vase, designed by Dino Martens.
Unmarked.
Height 14 in; 35.5 cm.
$2,000-3,000
Photo courtesy of Rago Modern Auctions

Aureliano Toso
Double-spout vase with single hole, blue melted powers on surface, designed by Dino Martens, 1952.
Unmarked.
Height 11 in; 38 cm.
$2,000-3,000
Photo courtesy of Rago Modern Auctions

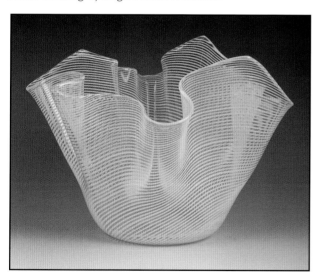

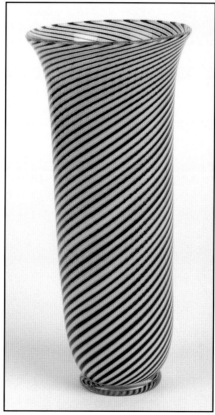

Aureliano Toso
Mezza filigrana in black and white, slightly flaring rim, on a clear applied base.
Unmarked
Height 10-1/4 in; 26 cm.
$600-800

Aureliano Toso
Fazoletto vase in clear glass with white *lattimo* threads, attributed to Aureliano Toso.
Unmarked
6-3/4 x 10 in; 17 x 25.5 cm.
$300-400

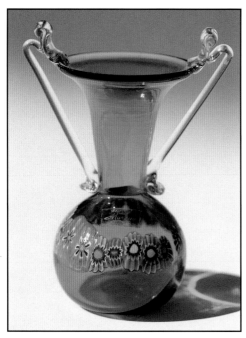

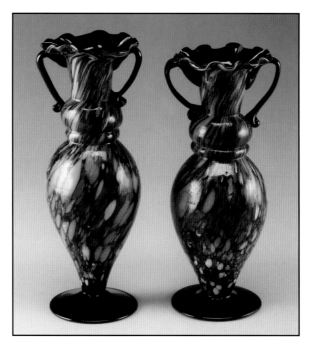

Light-weight turquoise vase with a band of
murrine around the bulbous lower portion,
applied clear handles, in the style of Fratelli
Toso.
Label, Made in Murano Italy
Height 5-1/2 in; 14 cm.
$100-150

Fratelli Toso
Pair of footed black *carnivale* urns with multicolor
spots, two black handles, 1920s.
Unmarked
10 and 10-1/2 in; 25.5 and 26.5 cm.
$2,000-3,000 pair
Photo courtesy of Rago Modern Auctions

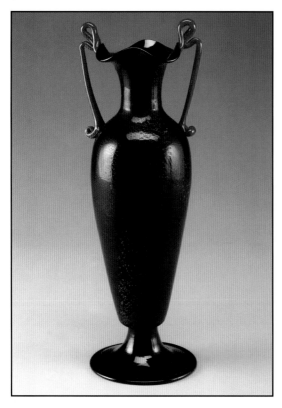

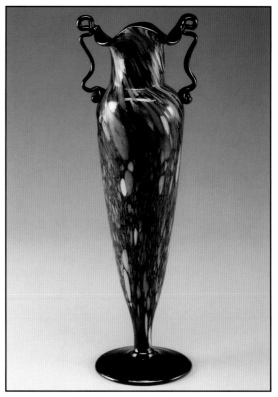

Fratelli Toso
Black *nero rosso* urn with two red handles, 1920s.
Unmarked
13-1/2 in; 34 cm.
$3,000-4,000
Photo courtesy of Rago Modern Auctions

Fratelli Toso
Footed black *carnivale* urn with multicolor spots, two
black handles, 1920s.
Unmarked, with original retail label from Naples, Italy.
Height 14 in; 35.5 cm.
$3,000-4,000
Photo courtesy of Rago Modern Auctions

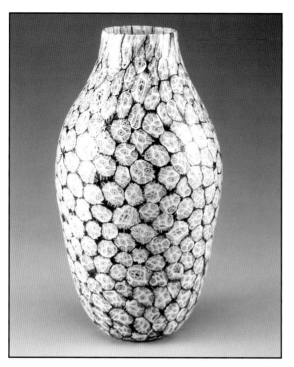

Fratelli Toso
Nerox terrazzo murrine vase in ovoid form in lavender, blue, red, and white.
Unmarked.
Height 12-1/2 in; 32 cm.
$8,000-12,000
Photo courtesy of Rago Modern Auctions

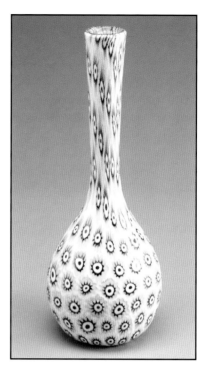

Fratelli Toso
Bottle-vase with primary colored *murrines* on a white ground.
Unmarked.
Height 11 in; 28 cm.
$1,200-1,800
Photo courtesy of Rago Modern Auctions

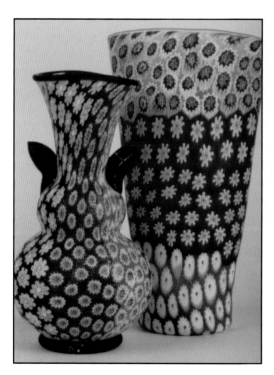

Fratelli Toso
Millefiori vases: left with two bulbous sections and flared top, in red, white, and blue *murrines*, applied blue rim, foot, and handles; right, pillow vase with flared top in same colors and style of *murrines*.
Unmarked
Height 9 and 11 in; 23 and 28 cm.
$600-800 each

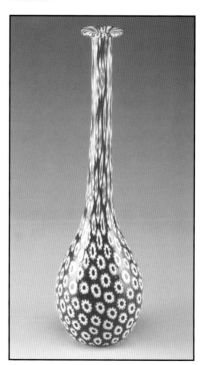

Fratelli Toso
Bulbous bottle-vase in red and white *millefiori*.
Unmarked.
Height 14 in; 35.5 cm.
$1,500-2,000

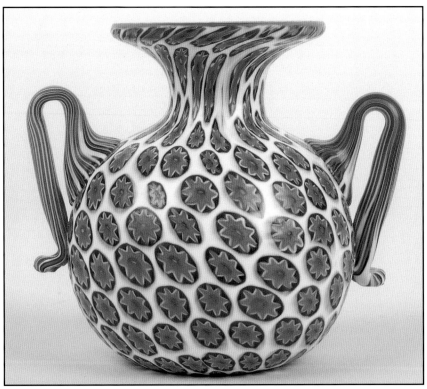

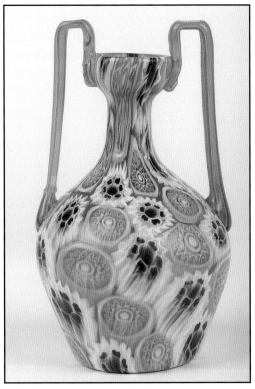

Fratelli Toso
Small *millefiori* urn with green, white, and blue *murrine*.
Unmarked
Height 4 in; 10 cm.
$300-400

Fratelli Toso
Small *millefiori* urn with green, red, white, and blue *murrine*.
Unmarked
Height 6 in; 15.5 cm.
$300-400

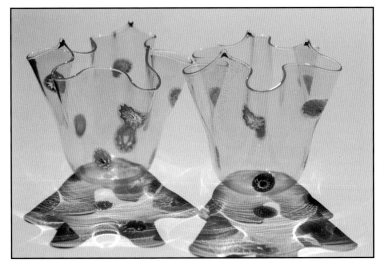

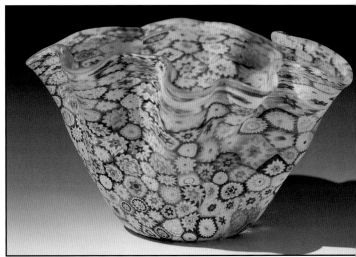

Fratelli Toso
Clear *fazoletto* vases with multicolor *murrine*.
Unmarked
Height 6 in; 15 cm.
$150-200 each

Fratelli Toso
Millefiori fazoletto vase with even undulating rim, rather than pulled points, with satin finish, ca. 1950s.
Unmarked
7-1/2 x 13 in; 19 x 33 cm.
$1,000-1,500

Detail.

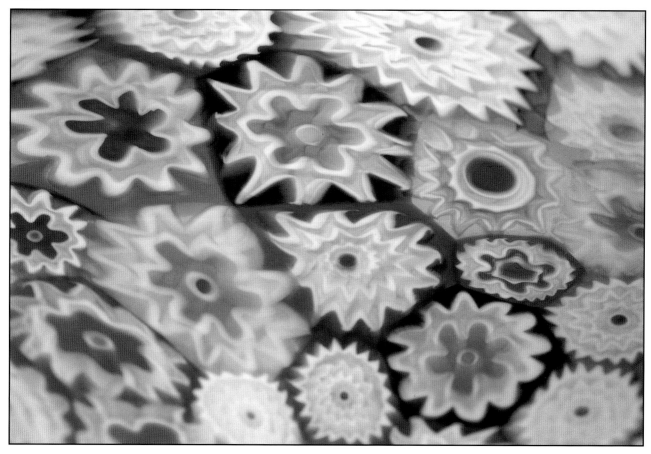

Detail.

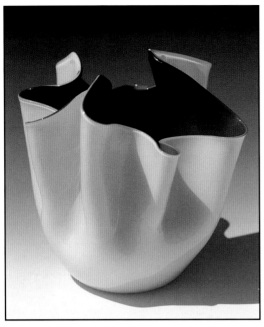

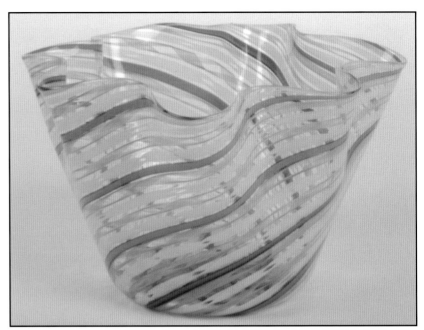

Fratelli Toso
Fazoletto with pulled points, purple cased in
lattimo.
Unmarked
Height 8-1/2 in; 21.5 cm.
$400-600

Fratelli Toso
Fazoletto vase with pink, white, and blue ribbons and filagree.
Paper label
Width 8-1/2 in; 22 cm.
$400-500

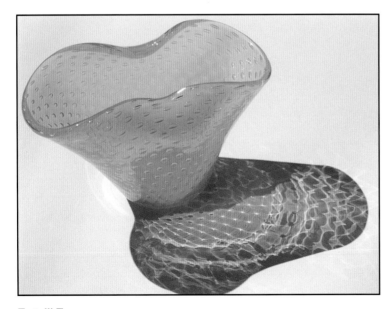

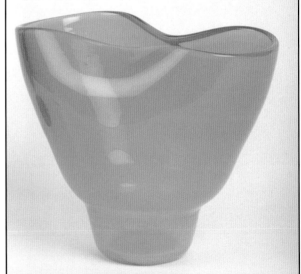

Fratelli Toso
Pale blue opalescent vase with large bubble pattern, pinched and flared
rim.
4-1/2 x 7-1/2 in; 11.5 x 19 cm.
Round foil label, Murano Glass Made in Italy
$250-350

Fratelli Toso
Light turquoise opalescent vase with pedestal base and
wide flared rim.
Unmarked
7-1/2 x 9-1/2 in; 19 x 23.5 cm.
$300-400

Detail.

Fratelli Toso
White opalescent vase with flared scalloped top and flat foot, with inclusions of pink ribbon bits, designed by Ermanno Toso.
Unmarked
Height 8 in; 20 cm.
$500-700
Courtesy of Lorenzo Vigier

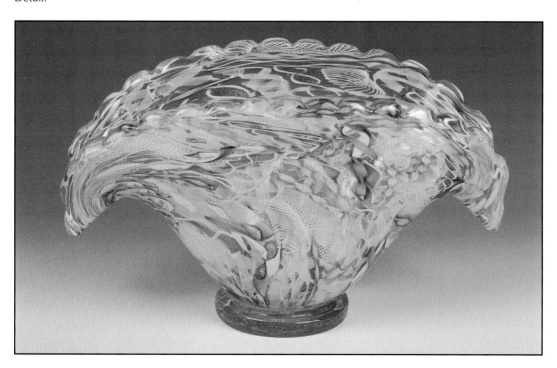

Fratelli Toso
Flared fan vase with scalloped rim and foot, internally decorated with pastel canes and *murrines*, similar to A.VE.M.
Unmarked
6-1/2 x 11 in; 16.5 x 28 cm.
$500-700
Courtesy of Lorenzo Vigier

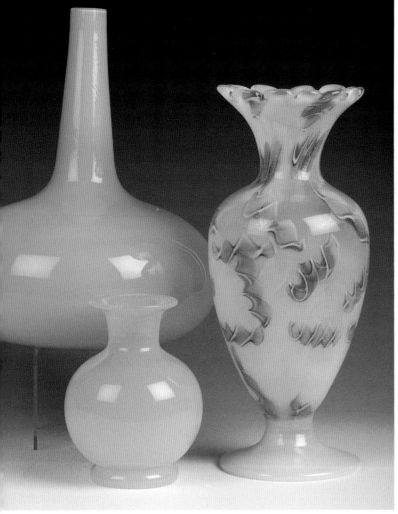

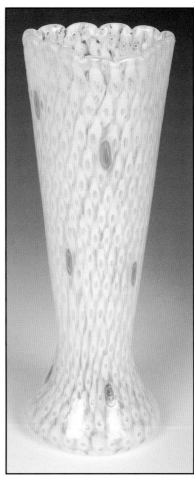

Fratelli Toso
Slender tapering vase with scalloped rim, a pattern of white cane slices with bubble and random turquoise *murrines*.
Round label, Murano Glass Made in Italy.
Height 9 in; 23 cm.
$400-600
Courtesy of Lorenzo Vigier

Fratelli Toso
Cased turquoise and white vase with wide bulbous bottom and long narrow neck.
Round label, Murano Glass Made in Italy.
Height 9-3/4 in; 25 cm.
$300-400

Archimede Seguso
Pink *alabastro* vase with globular base, round white foot, and flared rim.
Round label, Archimede Seguso Murano Made in Italy
Height 5 in; 12.5 cm.
$200-300

Fratelli Toso
White opalescent vase with large pink ribbon *murrine* inclusions, on round foot, pinched neck and flared scalloped rim.
Round label, Murano Glass Made in Italy
Height 10-1/2 in; 26.5 cm.
$700-900

Fratelli Toso
Cylindrical vase with diagonal bands of white, pink, and light blue with gold powders.
Unmarked
Height 10-1/2 in; 27 cm.
$300-400
Courtesy of Lorenzo Vigier

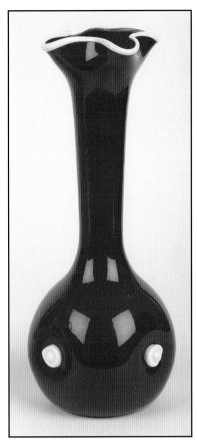

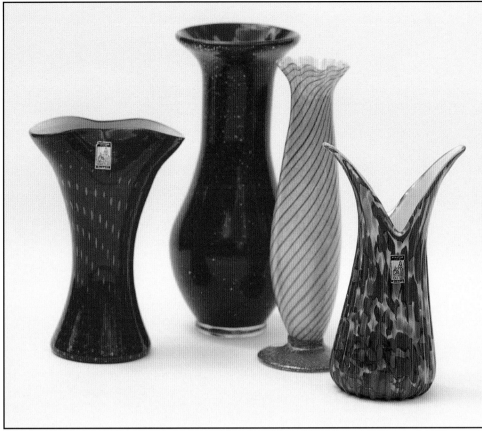

Fratelli Toso

Red vase with long neck and ruffled rim trimmed in *lattimo* glass, with *lattimo* canes in bulbous base, ca. 1960s, attributed to Fratelli Toso. Unmarked
Height 12-1/2 in; 32 cm.
$200-250

Fratelli Toso

Left: pinched and flared red-orange cased vase with regular bubble pattern, height 9 in; 23 cm. Right: Cased fluted vase with flared V-neck, mottled red-orange, browns, and white pattern, height 9-5/8 in; 24.5 cm. both with paper labels.
$250-350 each
Center left: unidentified red vase with clear foot and mica; center right white footed vase with orange diagonal stripe, height 11-3/4 in; 30 cm.
$75-100 each

Murano Glass Made in Italy export label used on Fratelli Toso items.

Castle export label used on Fratelli Toso and some other items.

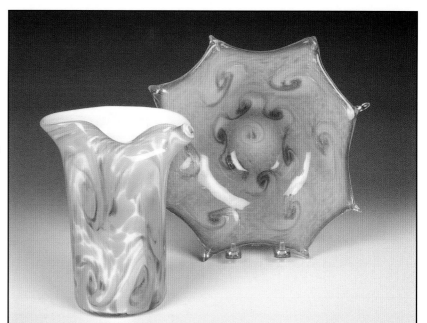

Fratelli Toso
"Starry night" swirled pattern on cased vase with turquoise ground.
Round label
Height 7-1/2 in; 19 cm
$300-400

"Starry night" plate with eight points, gold ground.
Unmarked
Diameter 11-1/4 in; 29 cm.
$150-200

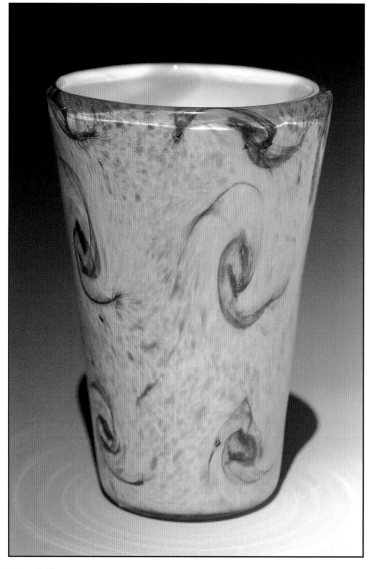

Fratelli Toso
Predominately white "starry night" beaker vase.
Unmarked
Height 10 in; 25.5 cm.
$700-900

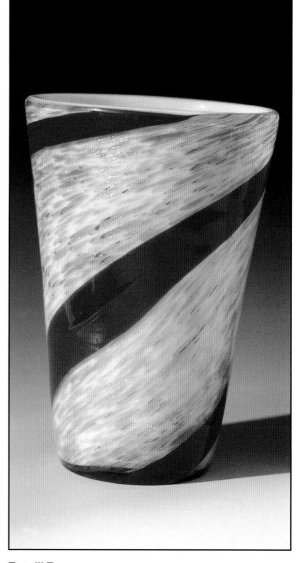

Fratelli Toso
White beaker vase with gold inclusions and broad diagonal red stripe.
Unmarked
Height 9-1/2 in; 24 cm.
$1,000-1500

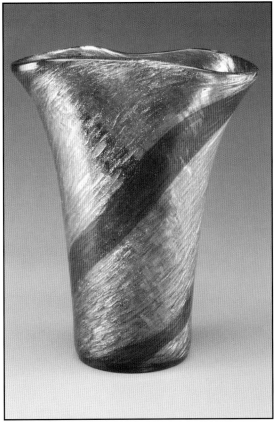

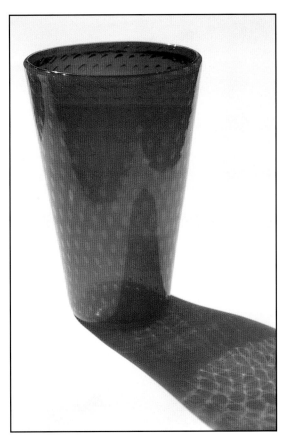

Fratelli Toso
Flaring pillow vase in *aventurine* glass with wide red-orange bands.
Unmarked.
Height 11 in; 28 cm.
$1,500-2,000
Photo courtesy of Rago Modern Auctions

Fratelli Toso
Red opalescent beaker vase with large bubble pattern.
Unmarked
Height 10 in; 25.5 cm.
$600-800

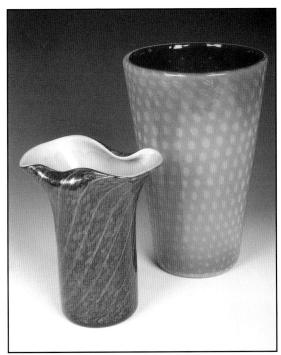

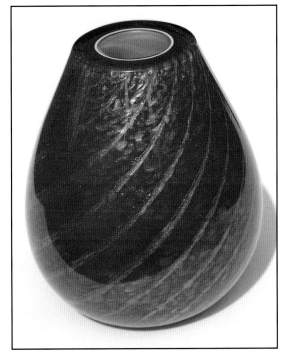

Fratelli Toso
Cased opalescent vase with red interior and bubble pattern, shown with pinched cased vase with gold stripe.
Label, Murano Glass Made in Italy
Height 10 in; 25.5 cm.
$600-800

Fratelli Toso
Thick-walled cased pear-shaped vase in red-orange with gold stripe.
Castle label
Height 7 in; 18 cm.
$400-600

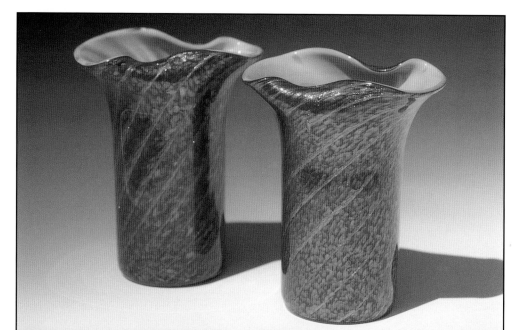

Fratelli Toso
Red-orange on white cased vases
with pinched rim and gold stripes.
Label, Murano Glass Made in Italy
Height 7 in; 18 cm.
$250-350 each

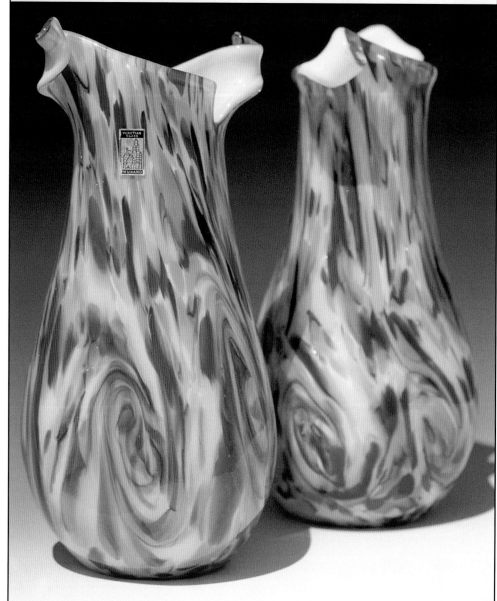

Fratelli Toso
Apparenzia vases, each in multi-
colored swirled confetti pattern
over white, with cut and twisted
rim.
Castle label
Heights 12-3/4 in; 31.5 cm.
$1,500-1,800 each

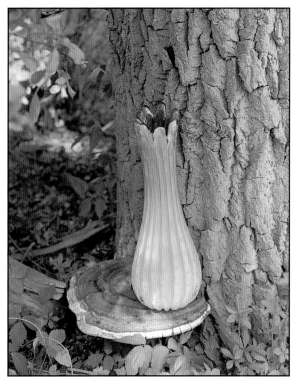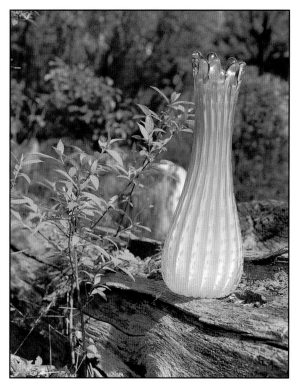

Fratelli Toso
Fluted ribbed organic-form vase with irregular rim, in white opalescent with bubbles cased over green.
Label, Murano Glass Made in Italy
Height 16 in; 40.5 cm.
$1,500-2,000
Courtesy of Lorenzo Vigier

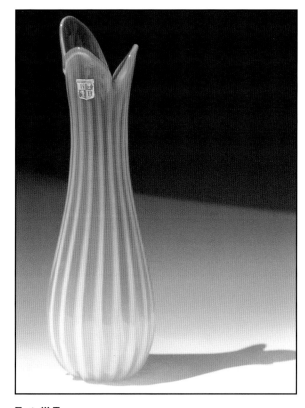

Fratelli Toso
Fluted ribbed organic-form vase with irregular rim, in white opalescent cased over red-orange.
Label, Murano Glass Made in Italy and KB export label
Height 16 in; 40.5 cm.
$1,500-2,000

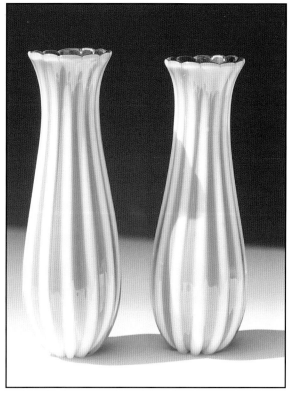

Fratelli Toso
Fluted ribbed organic-form vase, in white opalescent with scalloped rim, cased over burgundy.
Unmarked
Height 16-1/8 in; 41 cm.
$1,500-2,000

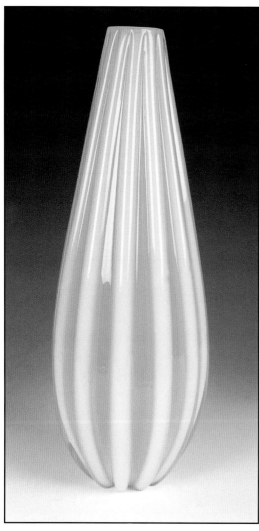

Fratelli Toso
Fluted ribbed organic-form vase, in white opalescent with even rim, cased over turquoise.
Unmarked
Height 16-1/2 in; 42 cm.
$1,500-2,000

Fratelli Toso
Fluted ribbed melon form vase in white opalescent over pink, shown with tall turquoise vase.
Unmarked
Height 9-1/2 in; 23.5 cm.
$1,500-2,000

Detail of bottom.

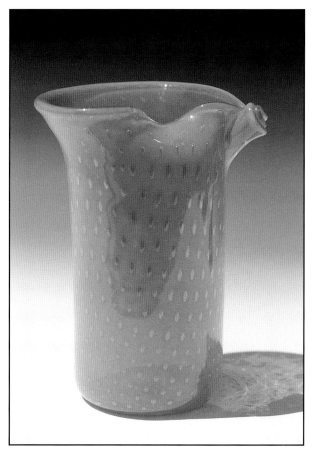

Fratelli Toso
Beaker vase in white opalescent cased over pink.
Unmarked
Height 7-1/2 in. 19 cm.
$500-700

Fratelli Toso
Cylindrical vase with twisted rim, white opalescent with bubbles cased over pink.
Unmarked
Height 7-1/2 in; 19 cm.
$600-800

Fratelli Toso
Pink opalescent vase with elongated bubbles, sides of rim pulled like ears.
Unmarked
Height 9 in; 23 cm.
$600-800

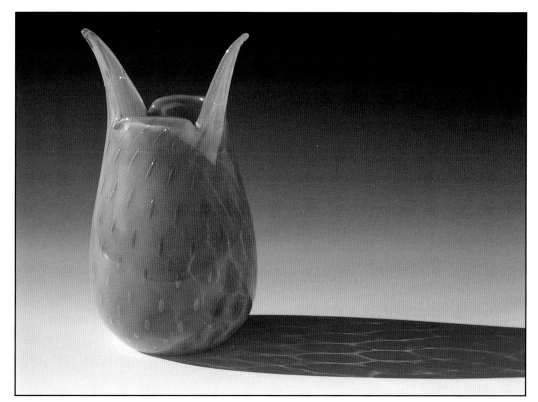

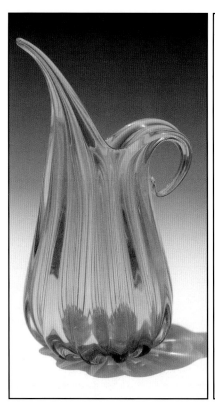

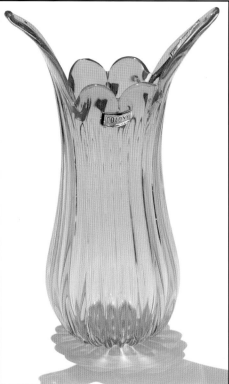

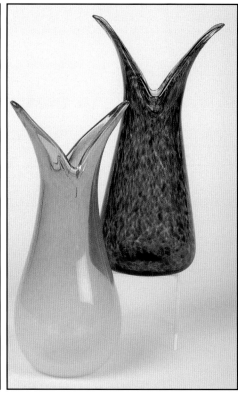

Fluted vase in green and amber with
pulled rim to form spout and handle.
Unmarked
Height 9 in; 23 cm.
$300-400

Fratelli Toso
Fluted vase in green and amber with both
sides pulled like ears.
Colony and Indiana Glass export/import
labels, plus round Murano Glass Made in Italy
$400-500

Fratelli Toso
Two vases with pulled V-necks: pink opales-
cent; with purple, green, and gold
Label, Murano Glass Made in Italy
Heights 10 and 9-1/2 in; 25.5 and 24 cm.
$300-400 each

Fratelli Toso
White opalescent
vases with
turquoise stripes,
rim pulled and
curled like ears.
Label, Murano
Glass Made in
Italy
Heights 9 in; 23
cm.
$500-700 each

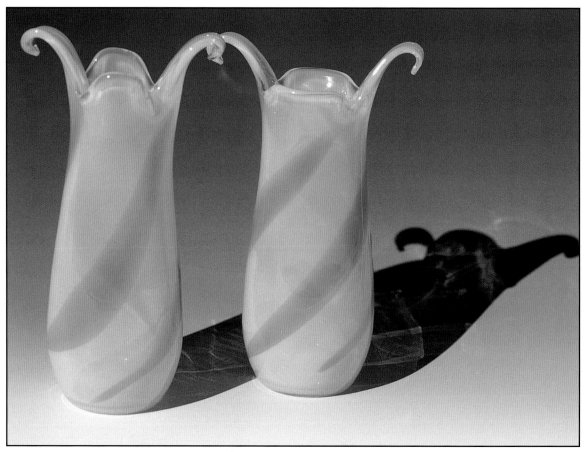

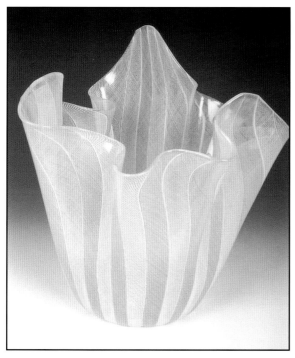

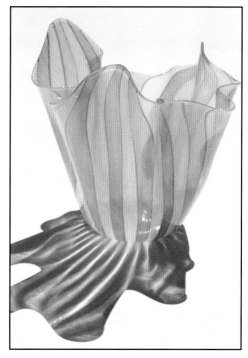

Venini

Fazzoletto vase in pink and white *zanfirico,* designed by
Fulvio Bianconi in 1949.
Acid stamp, Venini/Murano/Italia
Height 11-1/2 in; 29 cm.
$3,000-4,000

Fazzoletto shown in different lighting.

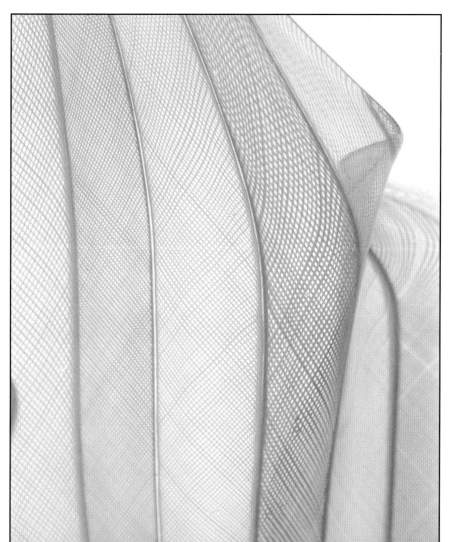

Detail.

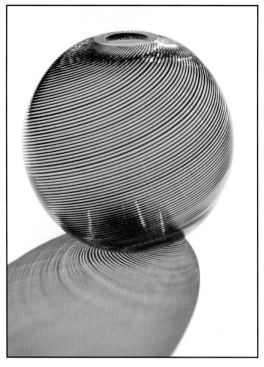

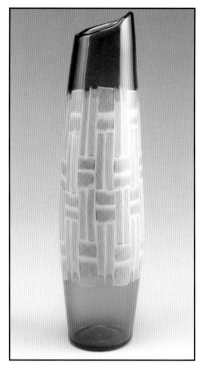

Venini
Round *mezza filigrana* vase with purple filigree on clear, designed by Carlo Scarpa in 1934. This example is from the 1970s.
Signed, Venini/Italia
Height 5-1/2 in; 14 cm.
$400-500

Venini
Cylindrical *mosaico zanforico* technique vase with slanted rim, in turquoise with white *lattimo* technique in a mosaic pattern, designed by Paolo Venini in 1949.
Acid stamp, Venini/Murano/Italia
13-1/2 in; 34 cm.
$7,000-9,000
Photo courtesy of Rago Modern Auctions

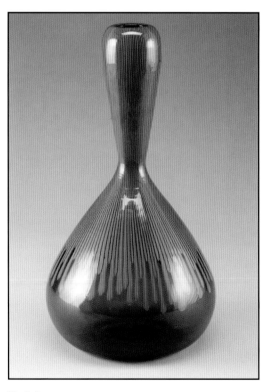

Venini
Cannette gourd-shaped bottle-vase of smoky glass with coral linear canes, designed by Ludovico Diaz de Santillana in 1963.
Height 12 in; 30.5 cm.
Acid stamp, Venini/Murano/Italia
$2,500-3,500
Photo courtesy of Rago Modern Auctions

Venini
Flared cylindrical vase of clear glass with white swirls.
Height 8-1/2 in; 22 cm.
Acid stamp, Venini/Murano/Italia
$1,800-2,200
Photo courtesy of Rago Modern Auctions

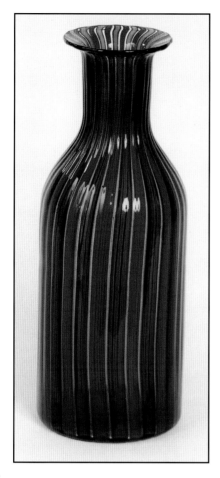

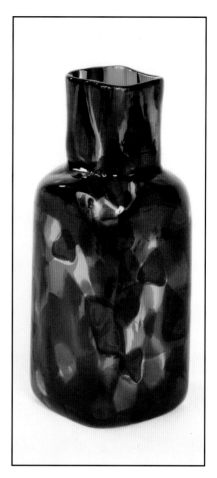

Venini
Bottle-vase with vertical red and blue stripes, attributed to Venini.
Height 10-1/2 in; 26.5 cm.
$700-900
Collection of M. Lacis (Australia), photo courtesy of Geoff Clarke

Venini
Square *pezzato* bottle vase with patches of red, blue, and green designed by Fulvio Bianconi, ca. 1951-1952.
Acid stamp, Venini/Murano/Italy and paper label
Height 9 in; 22.5 cm.
$2,000-3,000
Collection of M. Lacis, photo courtesy of Geoff Clarke

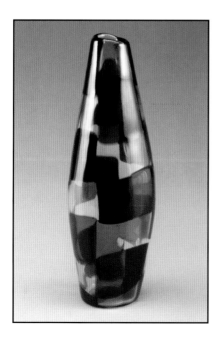

Paper label

Venini
Cigar-shaped *pezzato* vase in clear and earth tones, designed by Fulvio Bianconi, ca. 1951-1952.
Acid stamp, Venini/Murano/Italia
Height 10-1/2 in; 26.5 cm.
$5,000-7,000
Photo courtesy of Rago Modern Auctions

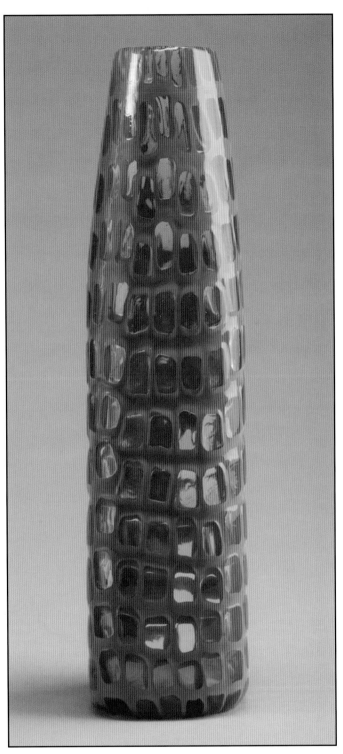

Venini
Four-sided red and clear *occhi* (technique) vase with pattern of "eyes" designed by Tobia Scarpa in 1960.
Paper label plus acid stamp, Venini/Murano/Italia
12-1/2 in; 32 cm.
$10,000-15,000
Photo courtesy of Rago Modern Auctions

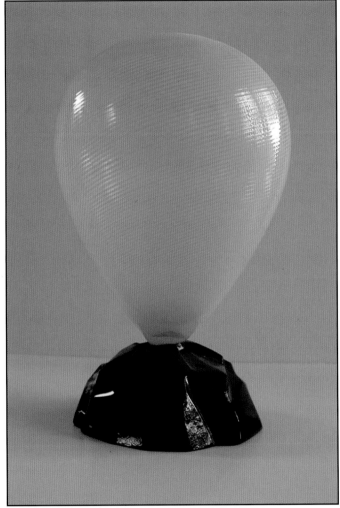

Venini
Simira vase with blown yellow *mezza filigrana* balloon-form body mounted on solid glass rock-like green base, designed by architect Alessandro Mendini in 1988.
Signed, Venini 88
Height 12 in; 31 cm.
$1,500-2,500
Photo courtesy of PlanetGlass.net

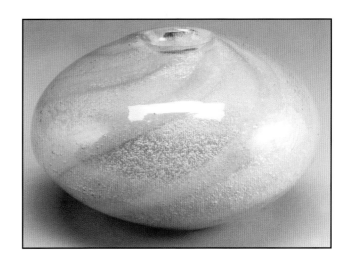

Venini
Squat *sommerso a bollicine* vase with tiny
opening, mint-green swirls in bubbly glass,
designed by Carlo Scarpa, ca. 1934-35.
Acid stamp, Venini/Murano/Italia
5-1/2 x 9 in; 14 x 23 cm.
$10,000-15,000
Photo courtesy of Rago Modern Auctions

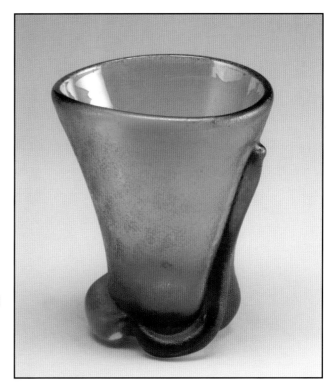

Venini
Emerald green flaring *corroso a relievi* (technique)
vase with applied snake-like relief at base and up one
side, designed by Carlo Scarpa in 1936 and presented
at Venice Biennale of the same year.
Acid stamp, Venini/Murano/Made in Italy
Height 7-1/2 in; 19 cm.
$2,000-3,000
Photo courtesy of Rago Modern Auctions

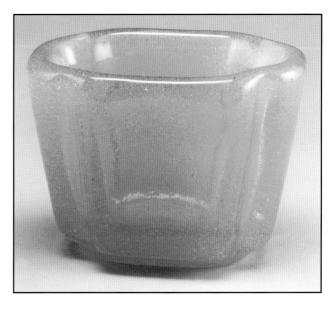

Venini
Green *sommerso a bollicine* (technique) faceted
vase, designed by Carlo Scarpa, ca. 1934-1936.
Unmarked
4-1/2 x 5-1/2 in; 11.5 x 14 cm.
$1,500-2,000
Photo courtesy of Rago Modern Auctions

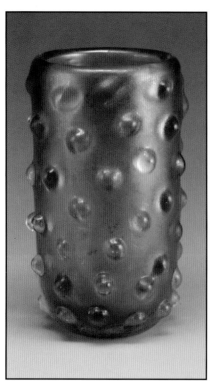

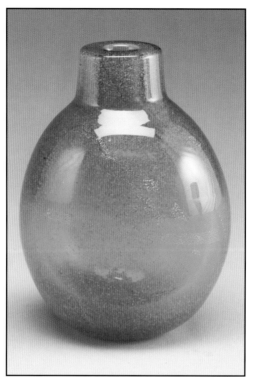

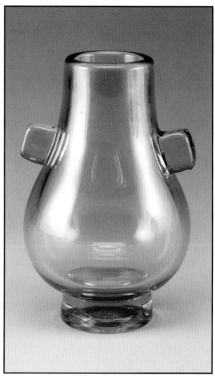

Venini
Pink *corroso a bugne* (technique) vase with hobnail, designed by Carlo Scarpa in 1936.
Acid stamp, Venini/Murano/Italia
12 in; 30.5 cm.
$8,000-10,000
Photo courtesy of Rago Modern Auctions

Venini
Green and gold *sommerso a bollicine* (technique) ovoid bottle-vase designed by Carlo Scarpa in 1934.
Acid stamp, Venini/Murano/Made in Italy
Height 8-1/2 in; 22 cm.
$4,000-6,000
Photo courtesy of Rago Modern Auctions

Venini
Bulbous amber vase with lug handles and slightly fumed surface, designed by Carlo Scarpa ca. 1934-1940. It is difficult to date this piece because Scarpa did this form in 1934 in *bollicine*, but the surface of this example suggests late 1930s.
Height 9-3/4 in; 25 cm.
Acid stamp, Venini/Murano/Italia.
$3,500-4,000
Photo courtesy of Rago Modern Auctions

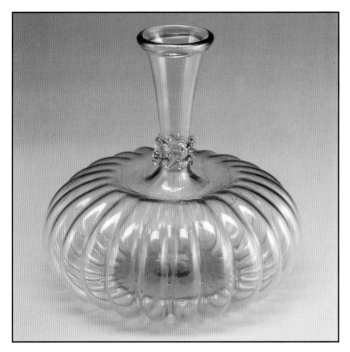

Venini
Rare ribbed gourd-shaped *soffiati* bottle-vase in blue, designed by Vittorio Zecchin in 1925.
10 x 9 in; 25.5 x 23 cm.
Acid stamp, Venini/Murano
$3,000-5,000
Photo courtesy of Rago Modern Auctions

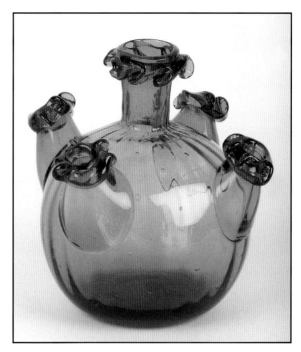

Venini
Five-spouted soffiato vase in brown with applied decoration, designed by Vittorio Zecchin, ca. early 1920s.
Unmarked
Height 6 in; 15 cm.
$1,000-1,500
Courtesy of Lorenzo Vigier

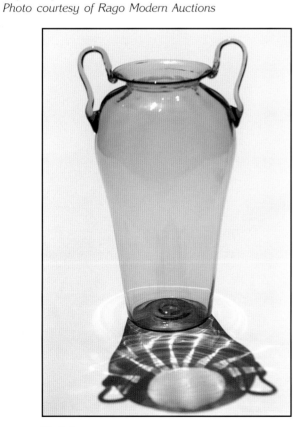

Venini
Light blue transparent two-handled vase or ewer, attributed to Vittorio Zecchin for Venini ca. 1925.
Height 11 in.
$1,000-1,500

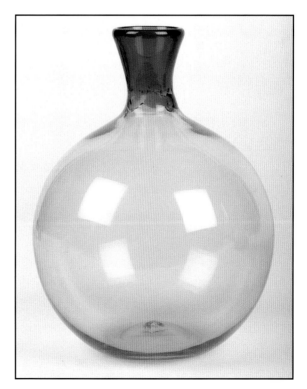

Venini
Balloon-shape pale and deep green *incalmo* vase, ca. 1970s.
Diamond point, Venini Italia
Height 5-1/2 in; 14 cm.
$250-350

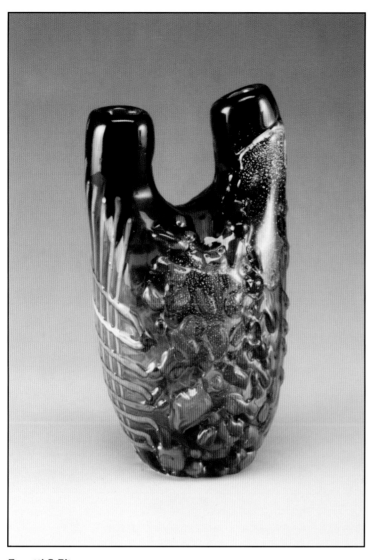

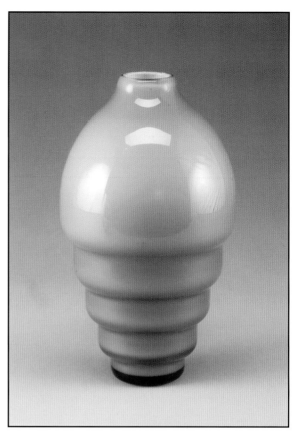

Zecchin & Martinuzzi Vetri Artistica e Mosaici
Green glass in graduated tiers, attributed to Napoleone Martinuzzi, ca. 1932.
Paper label, Made in Italy.
Height 11 in; 28 cm.
$2,500-3,000
Photo courtesy of Rago Modern Auctions

Zanetti & Pitau
Double spouted bulbous vase of green with applied cross-hatching and red blobs.
Unmarked
Height 11-1/2 in; 29 cm.
$4,000-6,000
Photo courtesy of Rago Modern Auctions

Vistosi
Three-piece set of block vases in smoky glass with blue and green *murrines*, designed by Fulvio Bianconi, ca. 1962.
Unmarked.
9-1/2, 6-3/4 and 2-3/4 in; 24, 17, and 7 cm.
$1,500-2,000 set
Photo courtesy of Rago Modern Auctions

Detail.

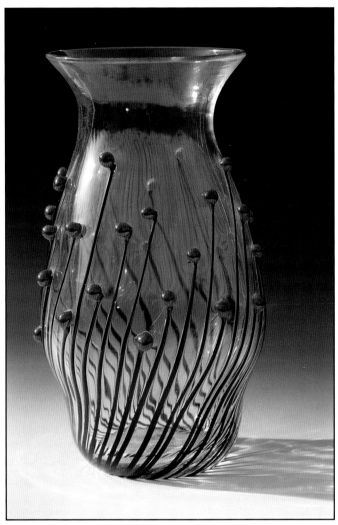

Zanetti
Clear glass vase with applied black stems and red berries,
designed by Licio Zanetti, ca. 1960.
Incised, Zanetti, L
Height 14-1/4 in; 37 cm.
$3,000-4,000

Alberto Dona
Flattened vase with partition and double rim, black and white narrow stripes cased over white interior, with orange outer stripes, 2000. Lino Tagliapietra originally designed and made this model.
Signed, Alberto Dona
Height 14-3/3 in; 37.5 cm.
$3,000-4,000
Courtesy of Chuck Kaplan

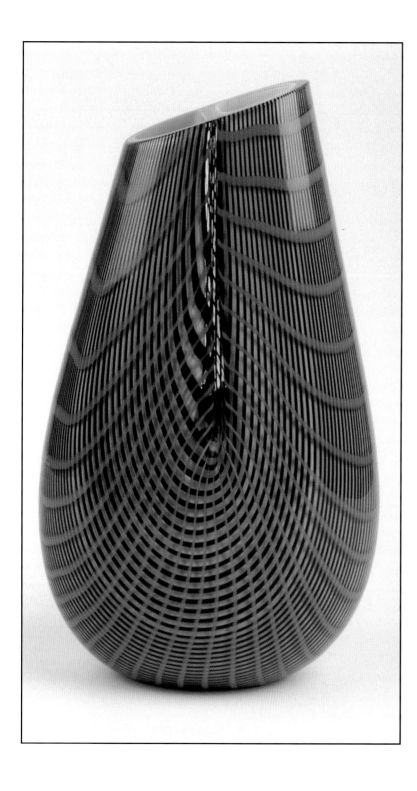

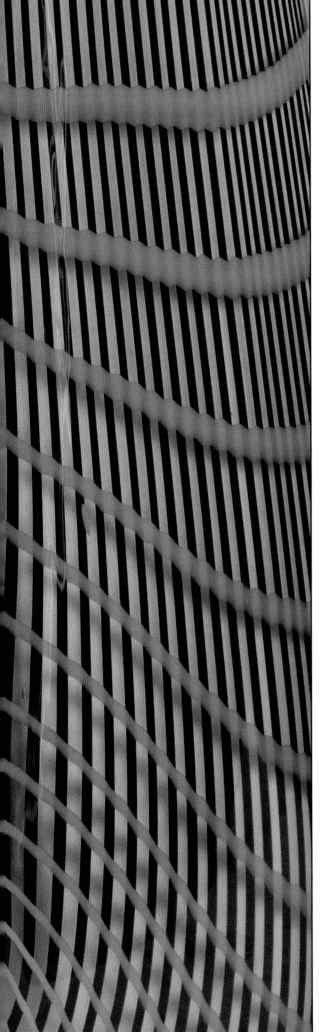

Detail.

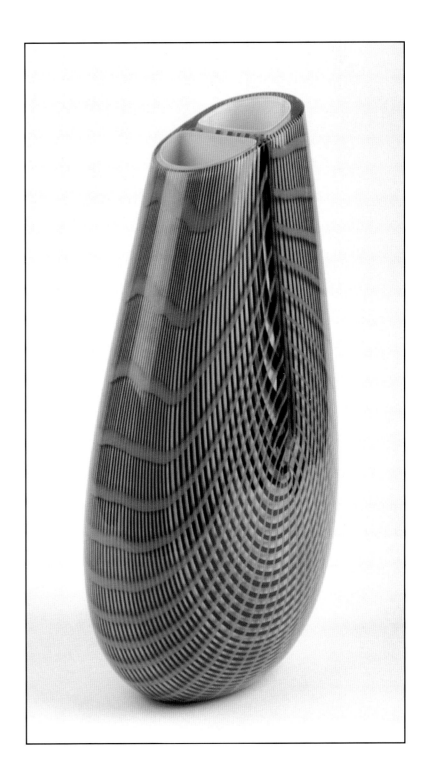

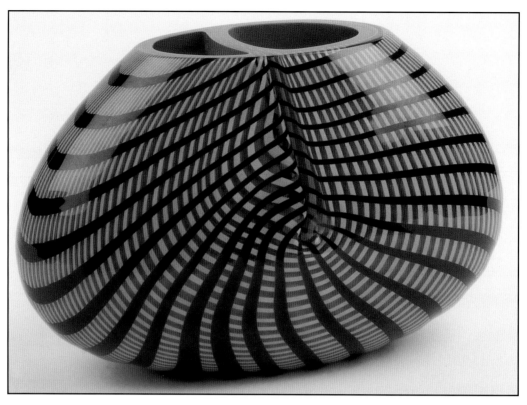

Alberto Dona
Flattened squat vase with partition and double rim, red and yellow narrow stripes cased over clear and red, with black outer stripes, made in 2000 after a Lino Tagliapietra design.
Signed Alberto Dona
7-1/2 x 12-1/2 in; 19 x 32 cm.
$3,000-4,000
Courtesy of Chuck Kaplan

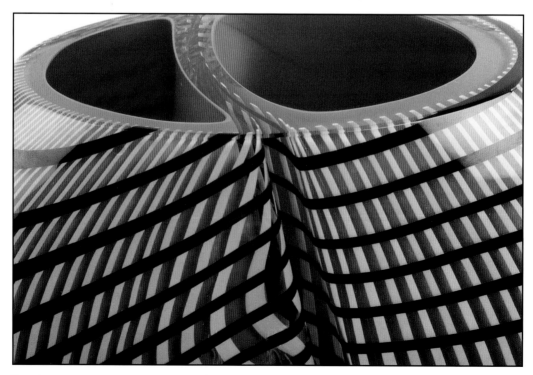

Detail.

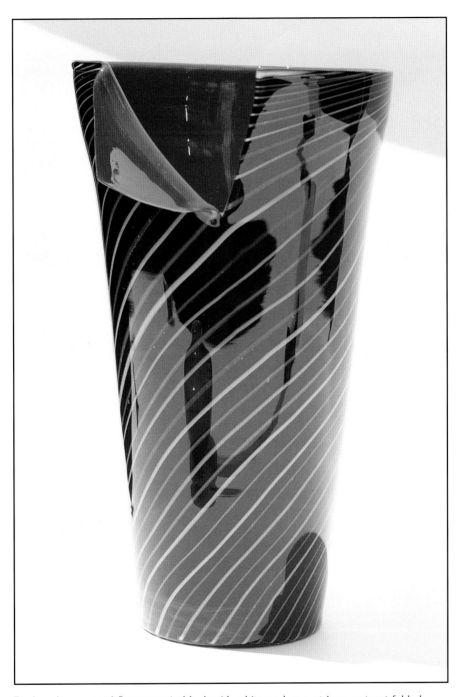

Beaker-shape cased floor vase in black with white and gray stripes, cut-out folded section to expose red interior.
Unmarked
Height 19 in; 48 cm.
$2,000-2,500

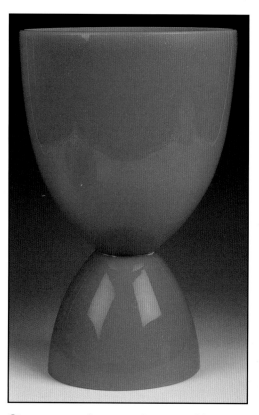

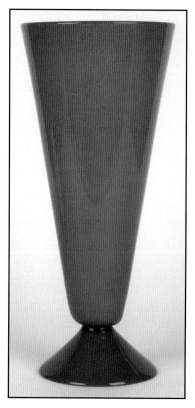

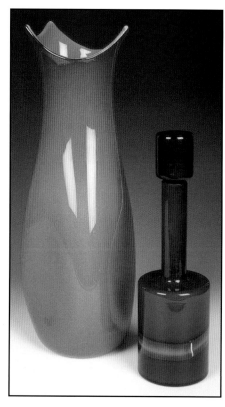

Giant egg-cup shape vase in opaque blue.
Label remnant
Height 12 in; 30.5 cm.
$200-300

Tapered vase with foot, in bright
orange.
Unmarked
Height 14 in; 35.5 cm.
$200-250

Pinched vase with irregular three-point
rim, in bright orange, shown with *a fasce*
decanter.
Unmarked
Height 16-1/2 in; 42 cm.
$300-400

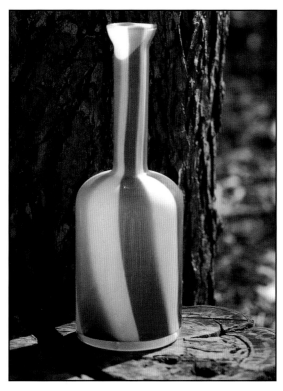

Cased white bottle vase with blue and orange
vertical stripes.
Raymor label
Height 10-1/2 in; 26.5 cm.
$100-150

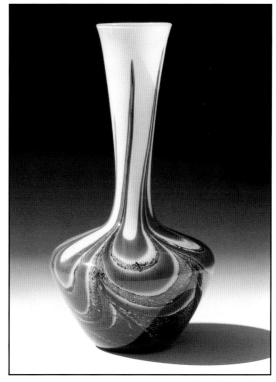

White vase with wide bottom and long narrow neck,
black and orange swirl design.
Unmarked
Height 12 in; 30.5 cm.
$100-150

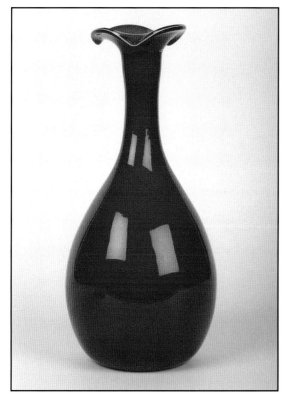

Red-orange cased vase with bulbous bottom, long
neck, and ruffled rim.
Unmarked
Height 13-3/4 in; 35 cm.
$100-150

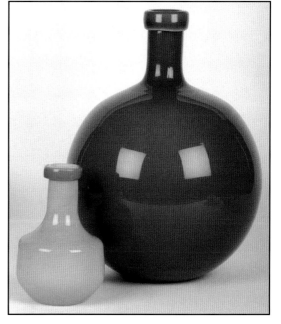

Heavy cased globular vase with gray folded collar
over narrow neck, gray interior, purple and clear
outer layers, shown with similar Swedish Boda vase
designed by Erik Hoglund.
Label, Made in Italy
Height 15-1/4 in; 39 cm.
$500-700

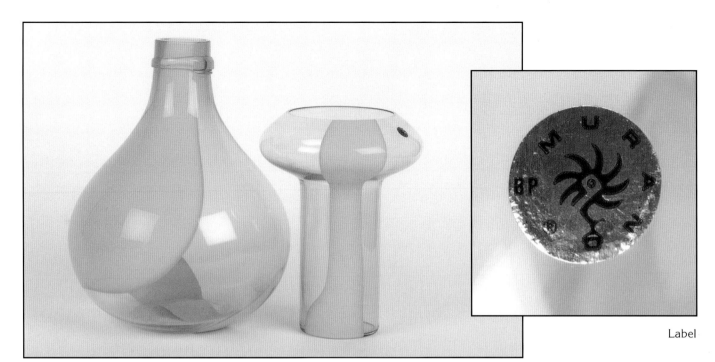

Label

Large bulbous smoky vase with large chrome yellow splash, with matching cylindrical vase with bulbous top, likely by La Murrina, imported by Raymor.
Export label
Height 13 in; 33 cm. and 9-1/2 in; 24 cm.
$150-300 each
Courtesy of Lorenzo Vigier

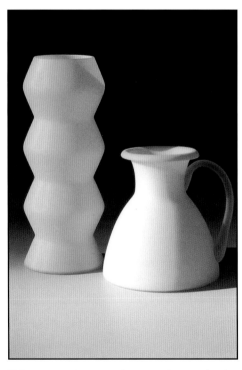

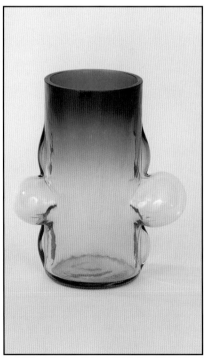

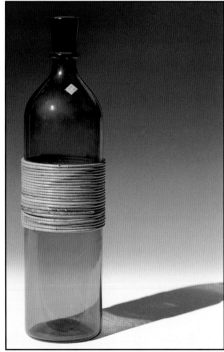

Yellow over white cased vase with satin finish, in '60s zig-zag form, shown with pitcher in reversed color combination.
Unmarked
Height 12-1/4 in; 31 cm.
$150-200

VeArt
Cylindrical vase in blue and clear with two protruding bubbles, possibly designed by Toni Zuccheri (worked for VeArt in the 1970s) and produced later.
Label, VeArt Handcrafted Made in Italy, initials T.Z. 1989
Height 8-3/4 in; 22 cm
$300-400
Collection of M. Lacis, photo courtesy of Geoff Clarke.

Blue bottle wrapped in bamboo strip.
Label, Made in Italy
Height 15-1/2 in; 39.5 cm.
$75-100

Yellow and white *filigrana* footed vase, probably missing a cover. Designs like this often indicate that a cover was to be placed over the extended rim. Decanters missing stoppers can also be mistaken for bottle vases, because neither the loose-fitting stopper nor neck interior has been ground.

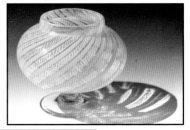

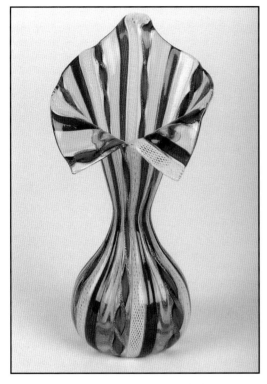

Filigrana vase in primary colors and white, rim is floriform cut and pulled rim.
Unmarked
Height 7-1/4 in; 18 cm.
$200-300

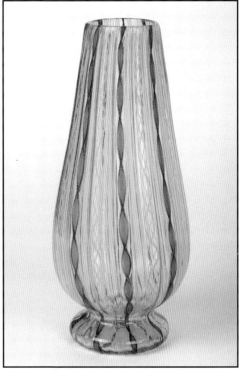

Filigrana vase in brown, yellow, and white, with molded foot.
Unmarked
Height 9-3/4 in; 24.5 cm.
$400-500

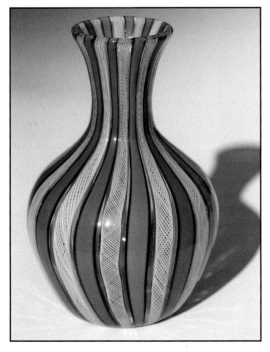

Blue and white *filigrana* vase with bulbous base and flared rim.
Unmarked
Height 6-1/4 in; 16 cm.
$200-300

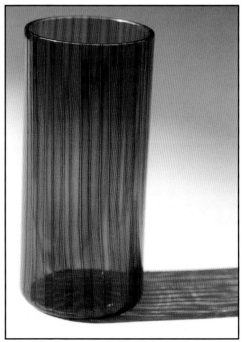

Blue and orange *a canne* cylindrical vase in the style of Venini or Moretti.
Unmarked
Height 8-5/8 in; 21.5 cm.
$300-400

113

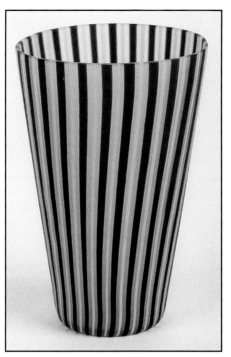

Left:
Black and white *a canne* flared beaker vase with satin finish.
Unmarked
Height 5-1/8 in; 13 cm.
$150-200

Right:
Cylindrical vase of white encased in clear glass, with orange and red abstract shapes, possibly by A.VE.M.
Unmarked
Height 12-1/8 in; 31 cm.
$200-300

Tall cylindrical and slightly bulbous vases in teal, red, and yellow-green with *lattimo* diagonal stripe.
Paper labels
Heights 18-1/2 to 19-1/2 in; 47 to 49.5 cm.
$150-250 each

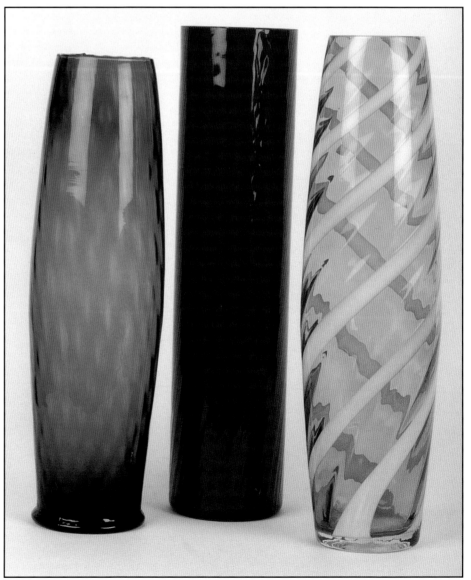

Decanters, Covered Jars

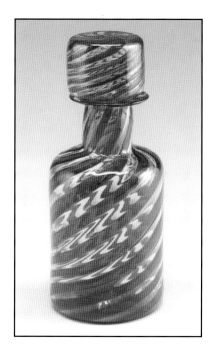

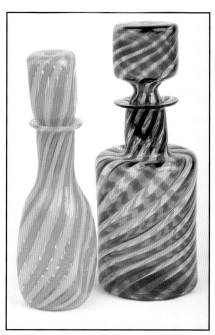

Left:
Barovier & Toso
Striato stoppered bottle with red and yellow diagonal stripes or canes.
Unmarked
Height 9-1/2 in; 24 cm.
$400-600
Photo courtesy of Rago Modern Auctions

Right:
Barovier & Toso
Right: blue and yellow striped cylindrical bottle with matching cylindrical stopper, with (left) yellow and turquoise squared bottle in the same style, possible also Barovier & Toso.
Unmarked
Heights 9-1/2 in; 24 cm.
$400-600; $300-400

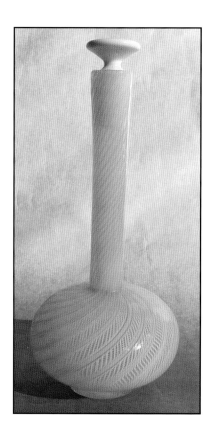

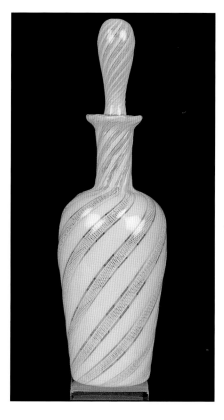

Left:
Yellow and white *filigrana* bottle with *lattimo* stopper and applied clear base.
Import labels
Height 9 in; 23 cm.
$200-300
Photo courtesy of PlanetGlass.net

Right:
High-shouldered cylindrical bottle with yellow diagonal stripe and white *filigrana*, with matching inverted teardrop stopper.
Unmarked
Height 9 in; 23 cm.
$300-350

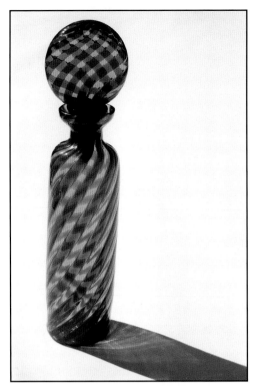

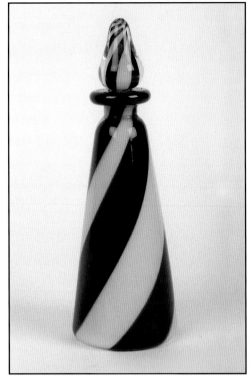

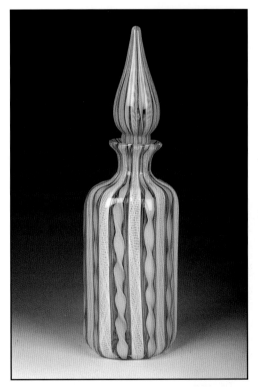

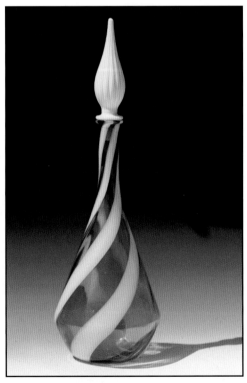

Top left:
Lime green and amethyst diagonal striped cylindrical bottle with matching oversized round stopper.
Unmarked
Height 11-1/2 in; 29 cm.
$400-600
Courtesy of Lorenzo Vigier

Bottom left:
Six-sided green and white *filigrana* bottle with matching teardrop stopper.
Unmarked
Height 12-1/2 in; 32 cm.
$400-500

Top right:
Archimede Seguso
A Fasce bottle of conical form with stopper, internally decorated with spiraling bands of amethyst and opaline white glass, cased in clear glass, designed by Archimede Seguso.
Label
Height 9 in; 23 cm.
$600-800
Courtesy of Lorenzo Vigier

Bottom right:
Alrose
Light purple bottle with wide white stripes and fluted *lattimo* teardrop stopper.
Unmarked
Height 22-3/8 in; 57 cm.
$300-350

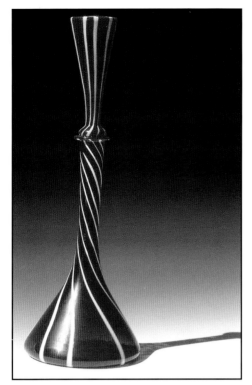

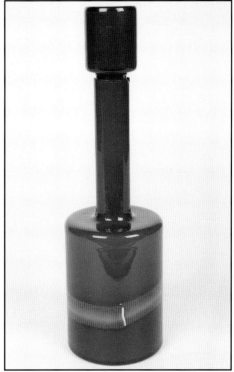

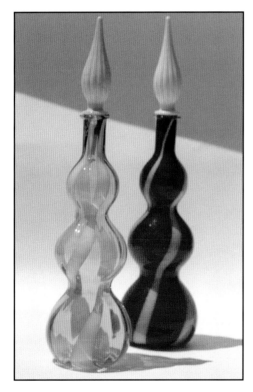

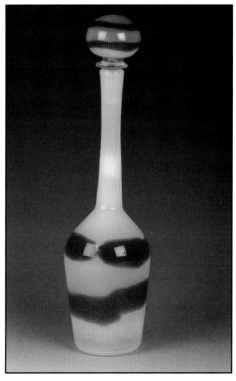

Top left:
Alrose
Red inverted funnel-shaped decanter with oversized flat-top stopper, each with white stripes.
Unmarked
Height 22-1/2 in; 57 cm.
$400-500

Bottom left:
Alrose
Two gurgle bottles with three tapering bulbous sections, one lime green, one cherry red, each with wide white stripes and fluted *lattimo* teardrop stopper.
Unmarked
Height 23 in; 58.5 cm.
$400-500 each

Top right:
Vistosi
Vistosi *a fasce* decanter in bright blue with orange band, cylindrical shaped base, long neck, and stopper.
Unmarked
Height 12 in; 30.5 cm.
$800-1,000
Courtesy of Lorenzo Vigier

Bottom right:
A.VE.M.
White opalescent decanter with long neck, pink bands on bottle and round stopper, attributed to A.VE.M.
Unmarked
Height 14 in; 35.5 cm.
$700-900

117

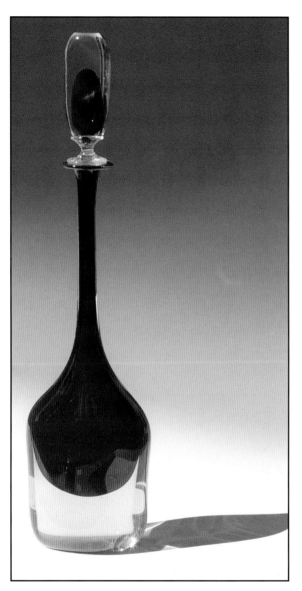

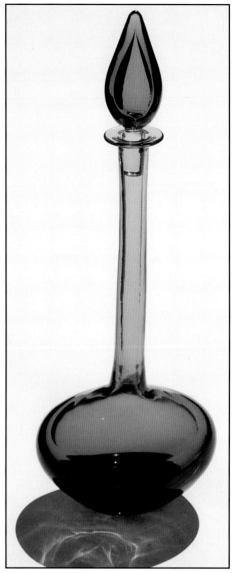

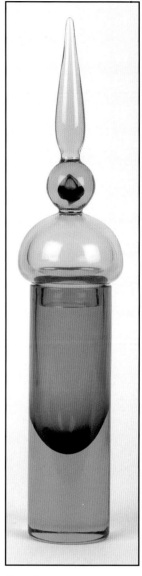

Cenedese
Sommerso decanter of cherry red encased in vaseline, with long thin neck and *sommerso* stopper.
Unmarked
Height 19-1/2 in; 49 cm.
$2,000-3,000

Seguso Vetri d'Arte
Sommerso decanter in leaf green and amber, wide base, long thin neck, and teardrop or flame stopper, designed by Mario Pinzoni, ca. 1965.
Unmarked
Height 18 in; 46 cm.
$1,200-1,600

Cenedese
Sommerso cylindrical decanter in cobalt and turquoise, with ornate dome and ball cover with tall finial.
Unmarked
Height 19 in; 48 cm.
$2,000-3,000

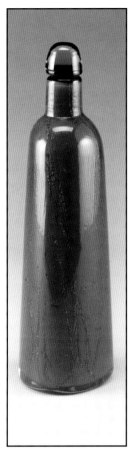

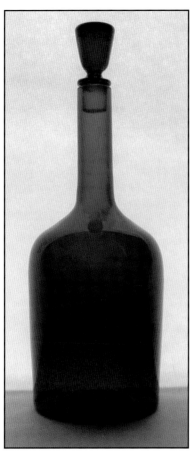

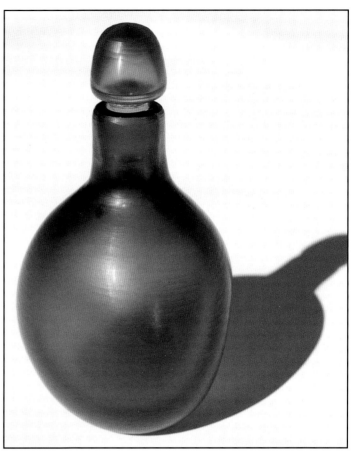

Venini
Giada bottle in olive
green with copper
inclusions, designed by
Toni Zuccheri in 1964.
Acid stamp, Venini/
Murano/Italia
Height 12 in; 30.5 cm.
$2,000-2,500
*Photo courtesy of
Rago Modern Auctions*

Venini
Cobalt and emerald green incalmo
decanter, designed by Gio Ponti,
ca.1949.
Signed, Venina/Murano/Italia
$700-900
Photo courtesy of PlanetGlass.net

Venini
Cobalt, clear, and yellow *sommerso inciso* bottle with mushroom
stopper, designed by Paolo Venini in 1950.
Acid stamp, Venini/Murano/Italia
Height 8 in; 20 cm.
$1,500-2,000
Courtesy of Michael Ellison

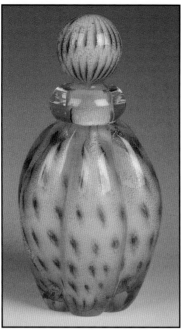

Archimede Seguso
Fluted gourd-shaped cased bottle in white with gold and brick-red dots, clear collar and round stopper.
Label, Archimede Seguso
Height 6-1/8 in; 15.5 cm.
$300-400

Barovier & Toso
Cordonato oro decanter with disc foot and diagonal swirl repeated on the stopper, ca. 1950.
Unmarked
Height 7-1/2 in; 19 cm.
$500-600

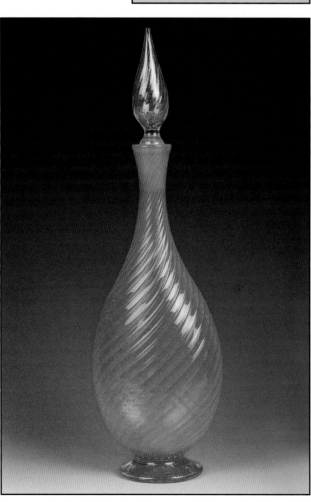

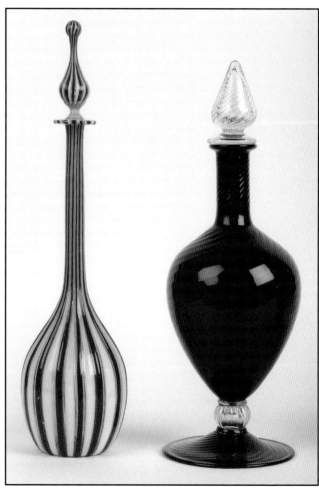

Galliano Ferro
Decanter in pink optic swirl flattened bulbous form, applied clear foot and flame stopper.
Label, G.F. Made in Italy Murano
Height 15-3/4 in; 40 cm.
$800-1,000

Fratelli Toso
Red and white *a canne* decanter, attributed to Fratelli Toso, late 19th or early 20th century.
Unmarked
Height 16-1/2 in; 42 cm.
$1,000-1,500

Salviati
Red footed decanter with optic swirl, clear and gold ball above the foot, and clear stopper.
Label, Made in Italy, Salviati & C.
Height 15 in; 38 cm.
$500-700

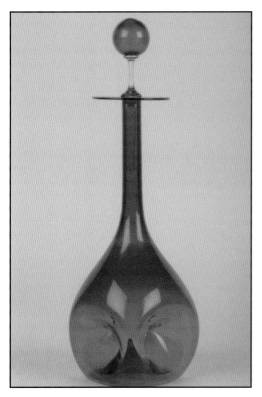

Fratelli Toso
Decanter with indented bottom and sides, the globular stopper with an exaggerated disk-like rim, designed by Ermanno Toso c. 1960.
Unmarked
Height 15-1/2 in; 39 cm
$1000-1,250
Courtesy of Lorenzo Vigier

Stopper

Fratelli Toso
Tall slender sensual decanter in shades of rose with gold foil and flame stopper.
Label, Murano Glass Made in Italy
Height 31 in; 79 cm.
$4,000-5,000

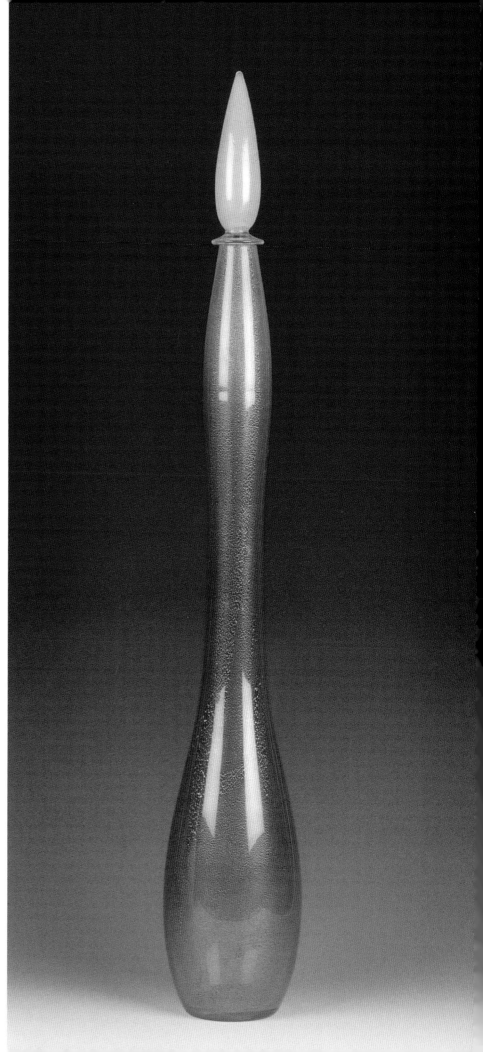

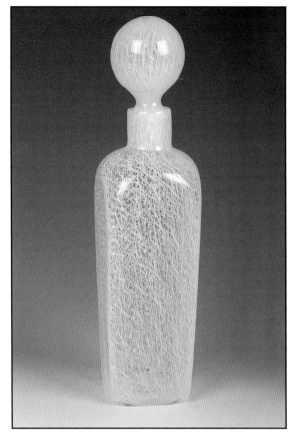

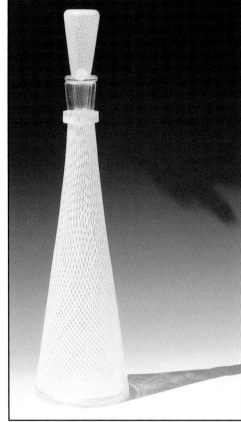

Archimede Seguso
Merletto bottle with squared body and globular stopper in clear glass, internally decorated with fine white strands of canes, which create a patterned lacework design, designed by Archimede Seguso, ca. 1952. Labeled
Height 8 in; 20 cm.
$1,000-1,500
Courtesy of Lorenzo Vigier

Fratelli Toso
Tapered cylindrical decanter with white filigree net pattern, surface, and matching stopper in same form as bottle.
Label, Murano Glass Made in Italy
Height 17-3/4 in; 45 cm.
$1500-2,000

Detail.

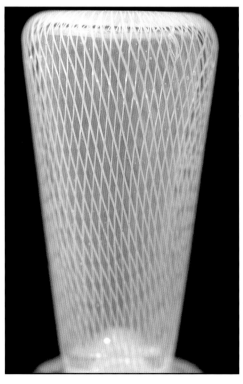

Detail.

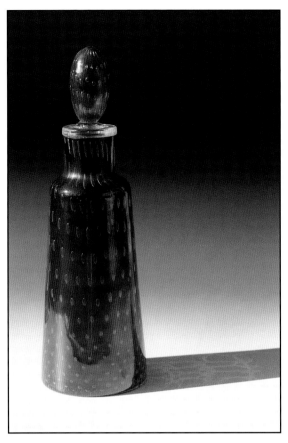

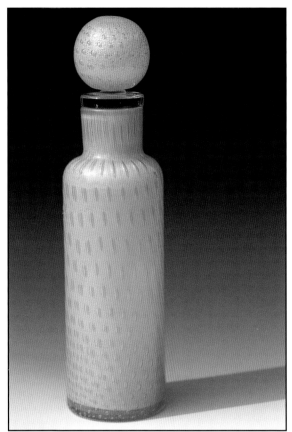

Fratelli Toso
Tapered cylindrical decanter in raspberry with internal bubble pattern, iridized surface, and matching egg-shaped stopper.
Label, Murano Glass Made in Italy
Height 15-1/2 in; 39.5 cm.
$700-900

Fratelli Toso
Cased cylindrical decanter in pastel blue with bubble pattern and matching globular stopper.
Unmarked
Height 14-3/4 in; 37.5 cm.
$700-900

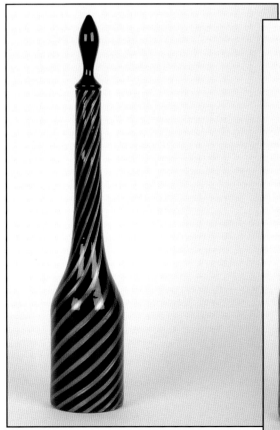

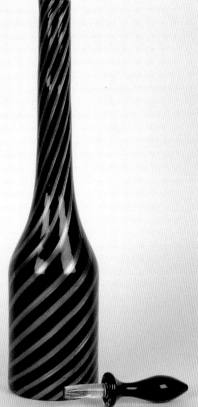

Fratelli Toso
Cylindrical decanter in black and gold *a canne*, with long neck and black stopper.
Label, Murano Glass Made in Italy
Height 19 in; 48 cm.
$1,500-2,000

Decanter with stopper out to show clear portion.

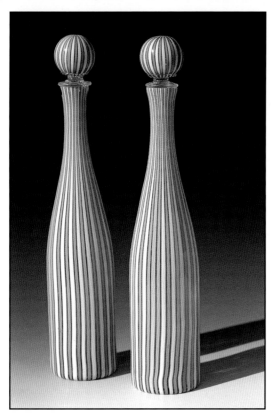

Fratelli Toso
Cylindrical decanters in light blue and white *a
canne,* with matching globular stoppers.
Label, Murano Glass Made in Italy
Height 17-3/4 in; 45 cm.
$1,200-1,600 each

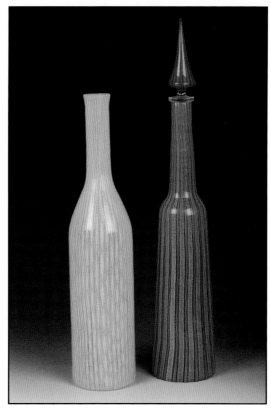

Fratelli Toso
Tapered cylindrical decanter with orange *canne*
and white filigree, matching flame stopper, shown
with similar bottle which is probably a decanter
missing the stopper.
Label, Murano Glass Made in Italy
Height 19-1/4 in; 49 cm.
$1,400-1,800

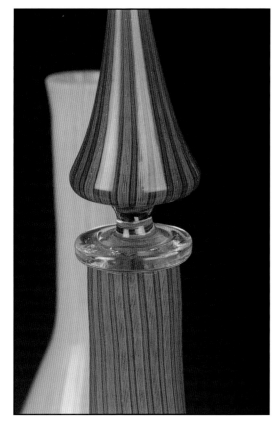

Detail.

Detail.

Opposite page:
Fratelli Toso
Decanter shapes: left,
pink and blue vertical
canes, elongated bell-
shape decanter with
stopper in same form,
reversed.
Label, Murano Glass
Made in Italy
Height 17 in; 43 cm.
$1,200-1,400

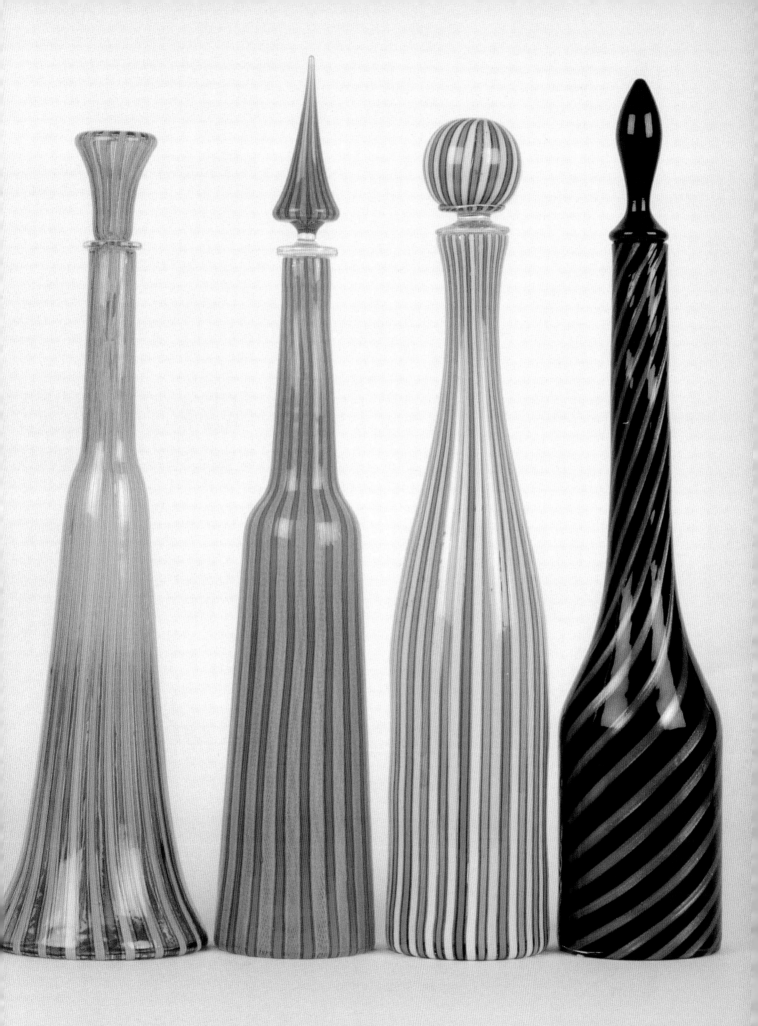

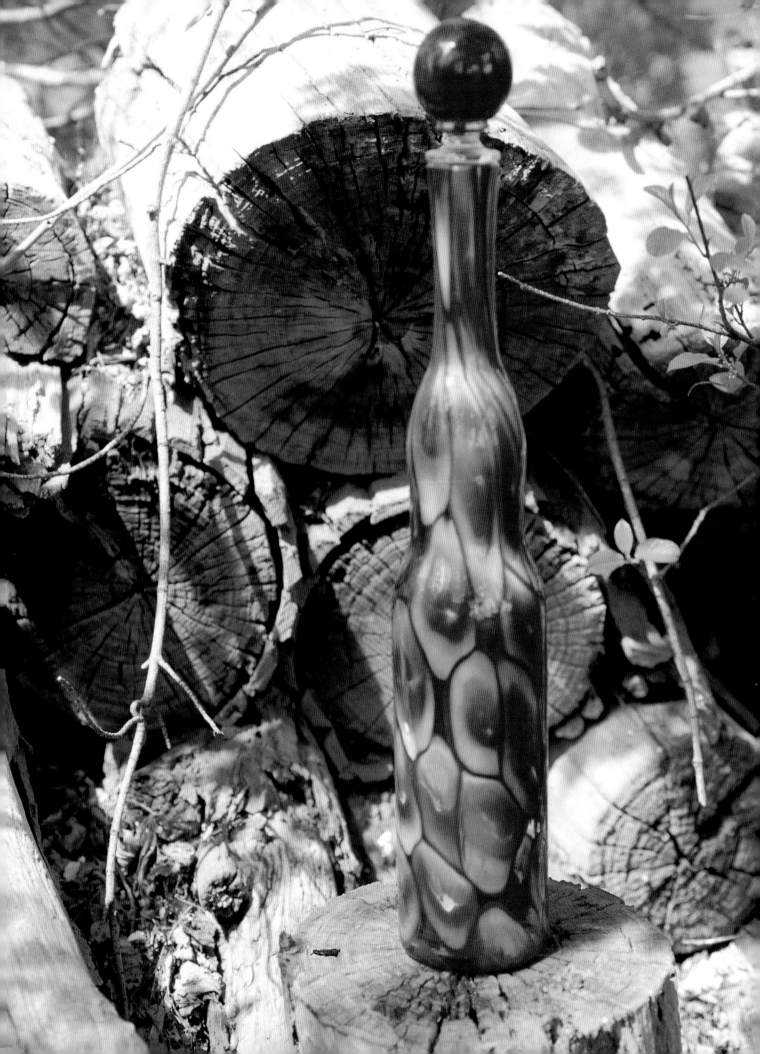

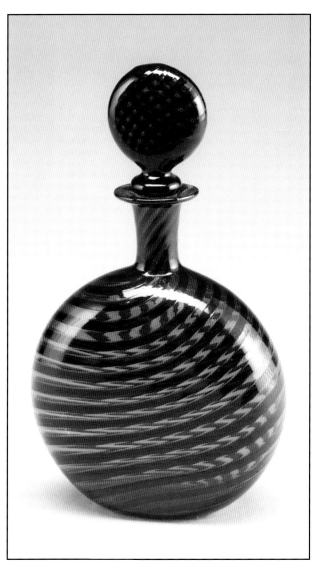 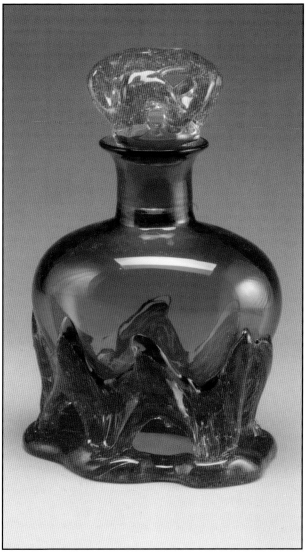

Fratelli Toso (attributed to)
A *spirale* stoppered bottle with red and cobalt stripes on body and stopper.
Unmarked
Height 8 in; 20 cm.
$700-900
Photo courtesy of Rago Modern Auctions

Pino Signoretto
Stoppered bottle in teal with applied organic red base and red stopper.
Inscribed script signature.
Height 13-1/2 in; 34 cm.
$1,000-1,500
Photo courtesy of Rago Modern Auctions

Opposite page:
Fratelli Toso
Decanter with orange patches of glass resembling cells, solid orange globular stopper, designed by Ermanno Toso, ca. 1960. A version of this decanter was also produced in a technique which used *nero* or black oxide glass to collect patches, hence the name *Nerox*.
Unmarked
Height 19-1/2 in; 50 cm
$2,000-3,000
Courtesy of Lorenzo Vigier

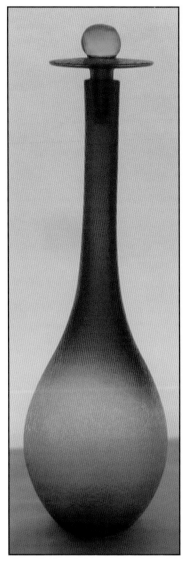

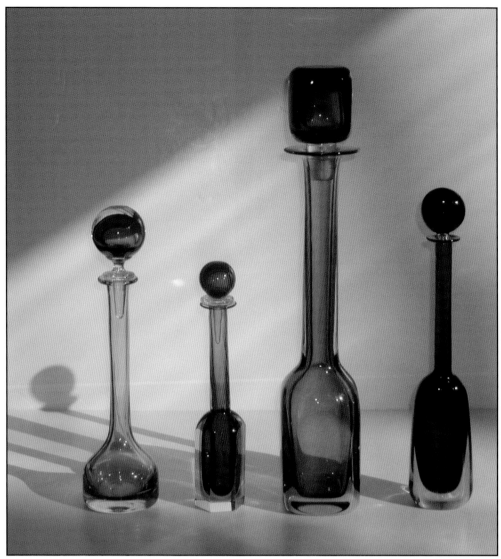

Seguso Vetri d'Arte
Bright green fading to watermelon red with acid incuced *corroso* finish, with purple and green saucer shaped stoper, attribited to Flavio Poli for Seguso Vetri d'Arte.
Unmarked
Height 13-3/4 in; 35 cm
$500-700
Photo courtesy of PlanetGlass.net

Four *sommerso* decanters, all unsigned, left to right:

Green cased in pale lavender.
Height 15-1/2 in; 39.5 cm.
$400-500

Faceted bottom, amethyst cased in sky blue, in clear.
Height 12-1/2 in; 32 cm.
$200-300

Archimede Seguso
Amber cased in yellow glass.
Height 22-1/2 in; 57 cm.
$700-900

Cranberry glass cased in pale lavender.
Height 16-1/4 in; 41.5 cm.
$500-700
Photo courtesy of PlanetGlass.net

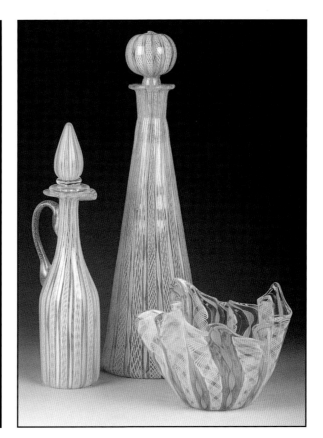

Barbini
Renaissance style covered footed vase with three rounded sections decreasing in size toward the foot, in white with gold powder.
Unmarked
Height 13 in; 33 cm.
$300-400

Pastel ribbon with white *filigrana* cruet with flame stopper and decanter with round stopper (shown with *filigrana* bowl).
Unmarked
Heights 11 & 14-1/2 in; 28 & 37 cm.
$200-250; $300-400

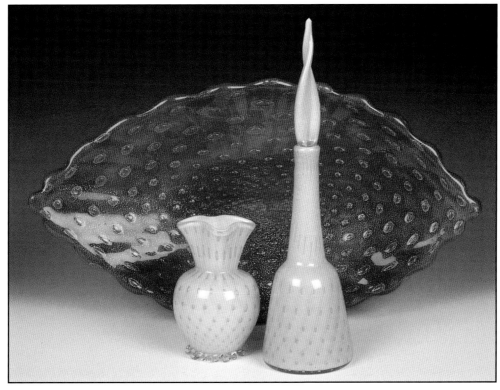

Barbini
White cased decanter with bubble pattern and long twisted flame stopper (shown with vase and platter also by Barbini).
Unmarked
Height 14 in; 35.5 cm.
$250-350

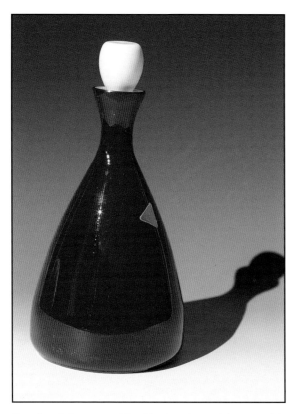

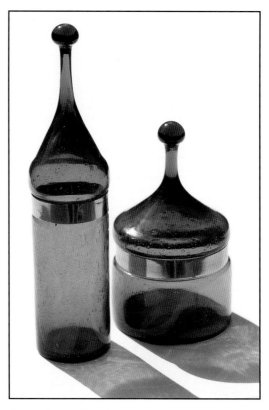

Cased red decanter with white interior and heavy solid stopper.
Labels, Made in Italy, and Raymor
Height 12 in; 30-1/2 in.
$100-200

Covered jars of bubbly amber glass, the base with metal band, and covers with round finial.
Raymor labels.
Heights 13 & 8-1/2 in; 33 & 21.5 cm.
$100-150 each

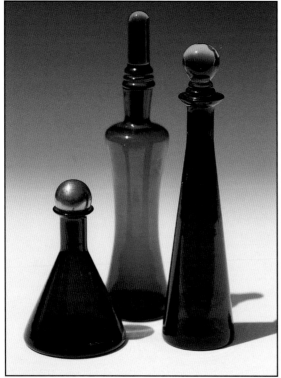

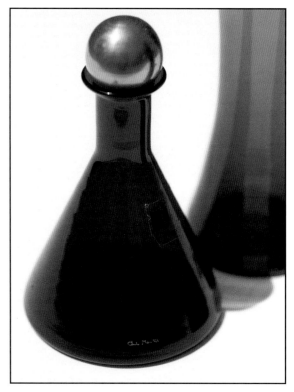

Carlo Moretti
Cobalt perfume or oil bottles with festive multi-colored stoppers.
Incised, Carlo Moretti.
Heights 4-1/2, 8-1/2 and 8 in; 11, 21.5, and 20 cm.
$100-150 each

Detail.

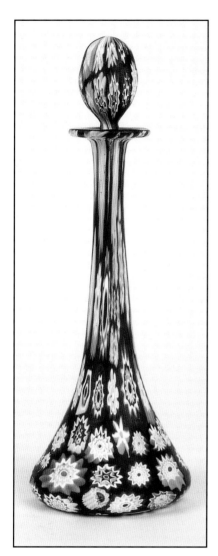

Fratelli Toso
Millefiori decanter in cobalt with multi-color *millefiori* canes, and satin or matte finish, c. 1950s.
Height 11 in.
$500-600

Fratelli Toso
Decanter in clear glass with translucent yellow and blue vertical bands.
Foil label
Height 10 in; 25 cm
$400-500
Photo courtesy of PlanetGlass.net

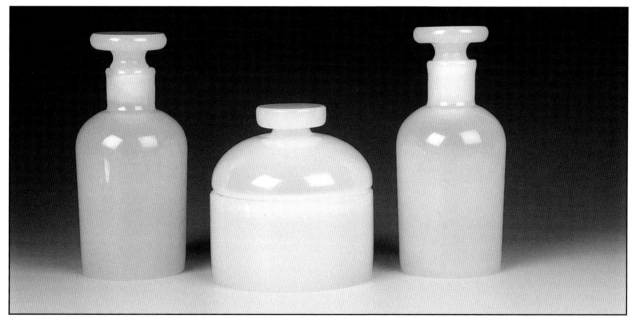

Cenedese
Three white *alabastro* dresser jars, two with stoppers, center with domed lid.
Label, Cenedese Glass
Heights 5-3/4 and 4 in; 14.5 and 10 cm.
$100-150 each

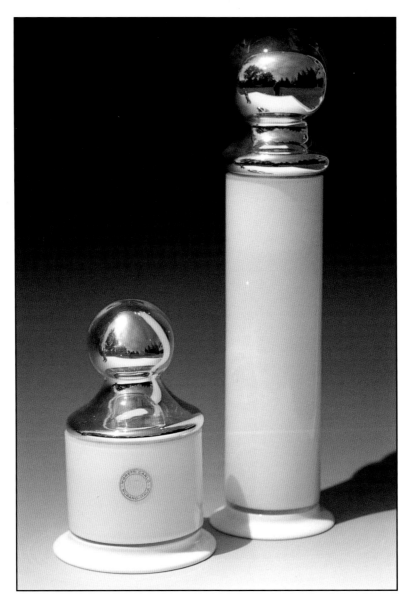

Carlo Moretti
White cylindrical jars with mirrored glass (coated on interior) covers, ca. 1960s. Old labels.
Heights 7 and 14-1/2 in; 17.5 and 37 cm.
$200-250 each

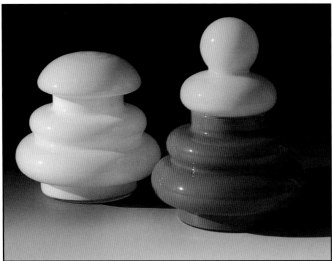

Typically 1960s tiered covered jars, one all white, the other orange with large yellow top.
Unmarked
Heights 8 and 11 in; 20 and 28 cm.
$100-200 each

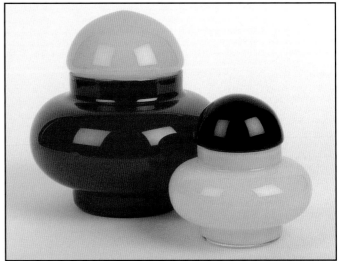

1960s covered jars: large in orange with domed yellow top, small in yellow with cobalt top.
Unmarked
Heights 8 and 5-1/2 in; 20 and 14 cm.
$100-150 each

Carlo Moretti
Footed covered *satinato* jars, each with rounded cover and finial, in three sizes and colors, ca. 1960s.
Unmarked
Heights 13, 14, and 17 in; 33, 35.5, and 43 cm.
$100-200 each

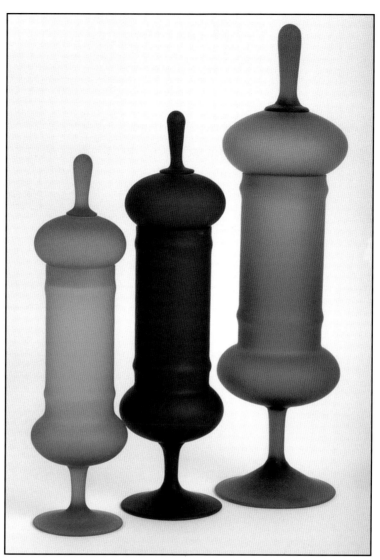

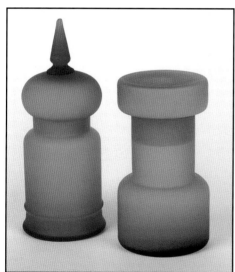

Carlo Moretti
Turquoise *satinato* Byzantine-form covered jar, and green and white *bicolore satinato* jar with flat cover, ca. 1960s.
Unmarked
Heights 9 and 6-3/4 in; 23 and 17 cm.
$50-75 each

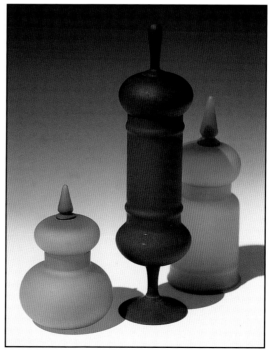

Carlo Moretti
Green *satinato* Byzantine-form jar, shown with other Moretti designs.
Unmarked
Height 6-1/4 in; 16 cm.
$50-75

133

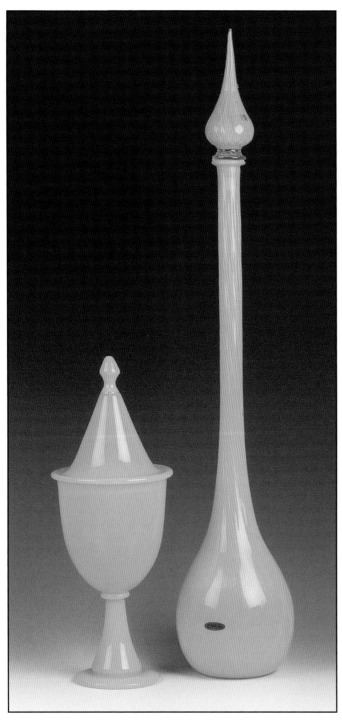

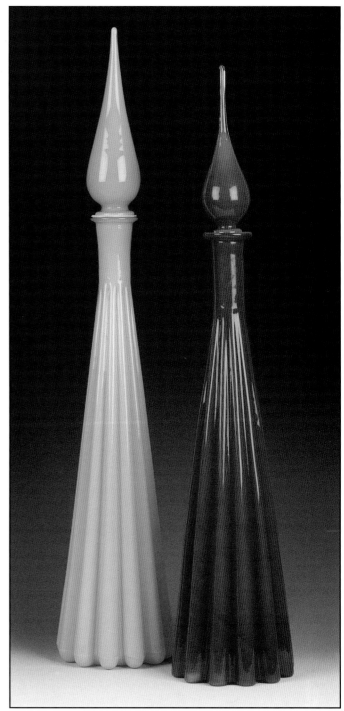

Yellow footed covered jar with yellow bottle-vase with extreme
long neck and flame stopper.
Label, Made in Italy
Heights 16-1/2 and 33 in; 42 and 84 cm.
$200-300 each

Cased persimmon-orange and light turquoise fluted decanters
with teardrop stopper.
Center label, Tuscany Made in Italy
26-1/2 and 28-1/2 in; 67 and 72-1/2 cm.
$250-350 each

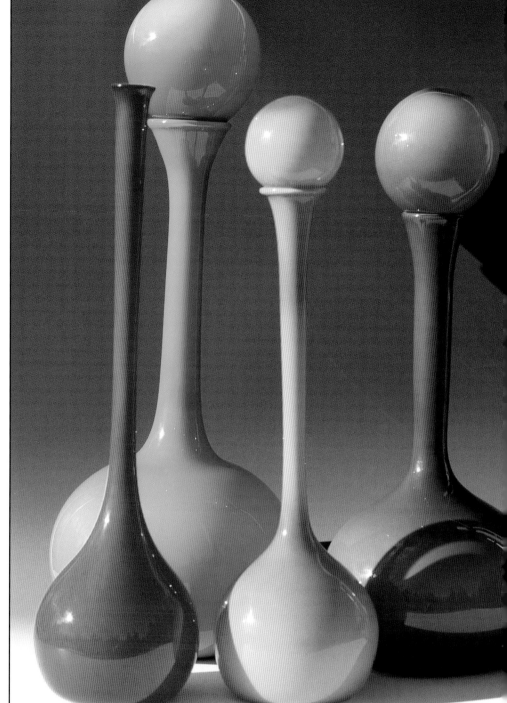

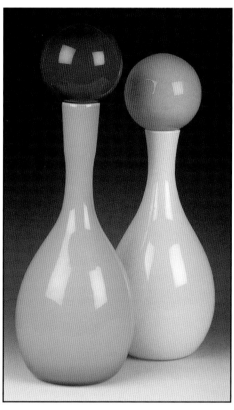

Blue bottle decanter with plum ball stopper, and white with chrome yellow stopper.
Unmarked
Heights 18 and 16 in; 40.5 and 46 cm.
$200-250 each

Extreme 1960s decanters with large bubble stoppers: green, gold, and purple, shown with orange vase.
Heights 25-5./8, 31, 25-1/2, and 26 in; 65, 79, 65, and 66 cm.
vase $200-250; decanters $300-500 each

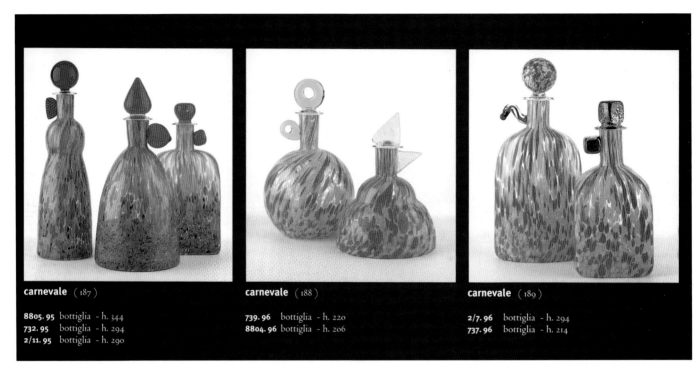

carnevale (187)

8805. 95 bottiglia - h. 344
732. 95 bottiglia - h. 294
2/11. 95 bottiglia - h. 290

carnevale (188)

739. 96 bottiglia - h. 220
8804. 96 bottiglia - h. 206

carnevale (189)

2/7. 96 bottiglia - h. 294
737. 96 bottiglia - h. 214

onde di mare (183)

8804. 70 bottiglia - h. 206
8805. 70 bottiglia - h. 344

onde di mare (184)

739. 70 bottiglia - h. 220
732. 70 bottiglia - h. 290

Carlo Moretti designs.
Photos by Sergio Sutto, courtesy of Carlo Moretti

superbe (165)

3994. A B C bottiglie collezione - h. 400

superbe (166)

3994. D E F bottiglie collezione - h. 400

superbe (167)

3995. A B C bottiglie collezione - h. 400

superbe (173)

3995. D E F bottiglie collezione - h. 400

rosso e nero (174)

2981. 24 vaso - h. 235
2980. 24 vaso - h. 255

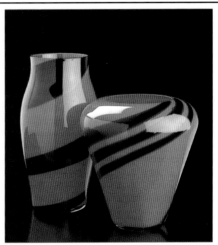

rosso e nero (175)

2982. 24 vaso - h. 255
2978. 24 vaso - h. 195

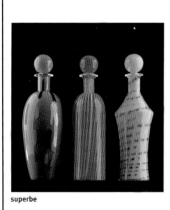

superbe

3997. A - B - C bottiglie da collezione - h. 400

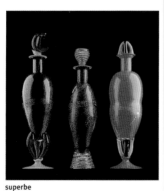

superbe

3997. D - E - F bottiglie da collezione - h. 410

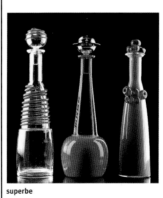

superbe

3996. A - B - C bottiglie da collezione - h. 440

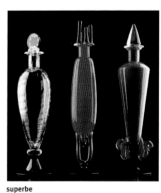

superbe

3996. D - E - F bottiglie da collezione - h. 440

Carlo Moretti designs
Photos by Sergio Sutto, courtesy of Carlo Moretti

137

Plates, Bowls, Ashtrays

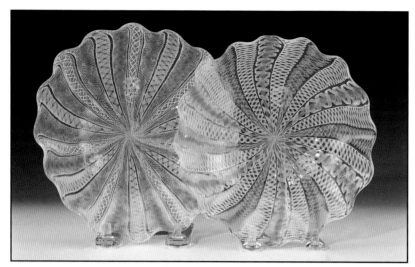

Salviati
Plates with different filigree techniques in gold, yellow, and white, each with three raspberry feet of clear glass, ca. 1900.
Unmarked
Diameter 6-5/8 in; 17 cm.
$200-300 each

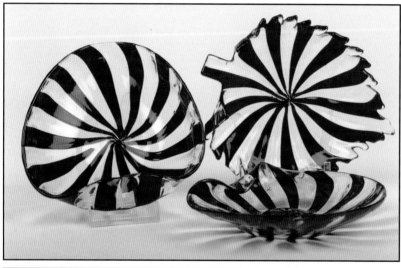

Three bowls with red and clear stripes radiating from the centers: one in leaf shape, two with folded edge.
Unmarked
Ave. 5-1/4 in; 13.5 cm.
$75-100 each

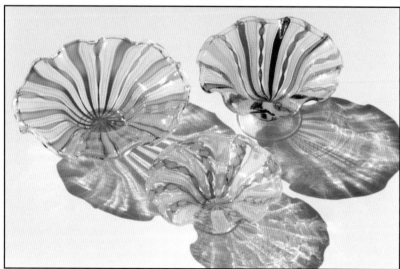

Salviati
Three mid-century footed ruffled bowls with multicolored filigree.
Label, Salviati & Co. Venice Made in Italy
Diameters 4-1/2, 5-1/2, and 6-1/2 in; 11, 14, & 16.5 cm.
$100-150 each

Right:
Salviati
Ruffled plate, usually
used as an underplate
for a fingerbowl, in
gold and white
filigree, late 19th or
early 20th century.
Unmarked
Diameter 6-1/2 in;
16.5 cm.
$150-200

Far right:
Salviati
Blue and white filigree
plate, attributed to
Salviati.
Unmarked
Diameter 13 in; 33
cm.
$400-500

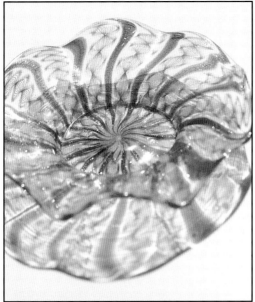

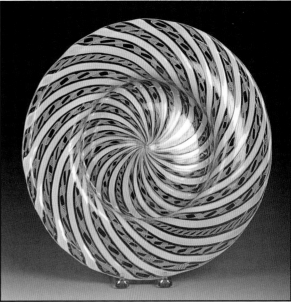

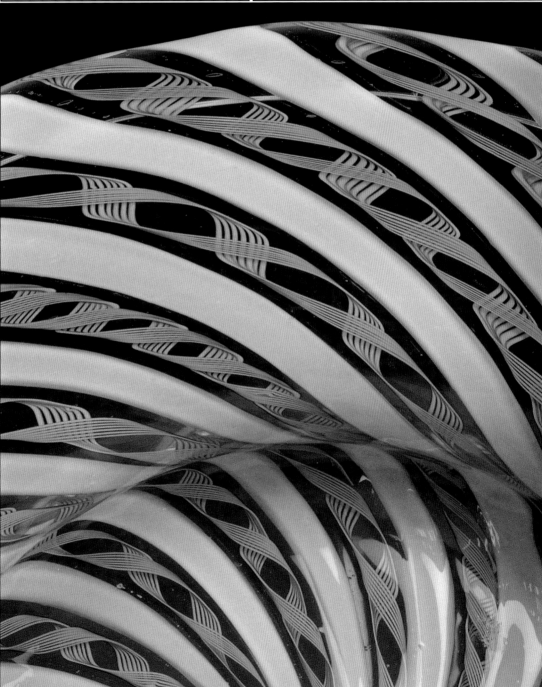

Detail.

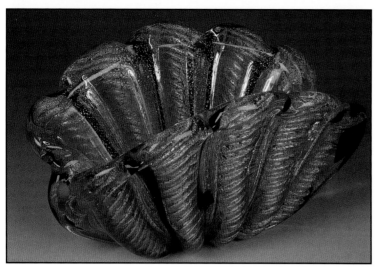
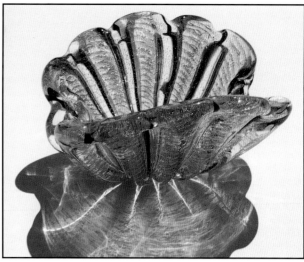

Barovier & Toso
Cordonato oro fluted bowl in clam-like form, clear glass with gold inclusions, designed by Ercole Barovier in 1950.
Unmarked
Length 7 in; 16.5 cm.
$300-400

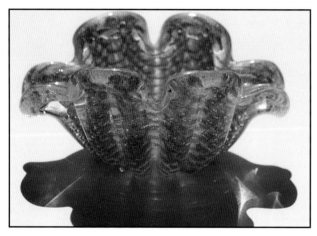

Barovier & Toso
Cordonato oro fluted bowl with scalloped top in pinkish glass with gold inclusions, Ercole Barovier, 1950.
Unmarked
Length 7-1/4 in; 18.5 cm.
$300-400

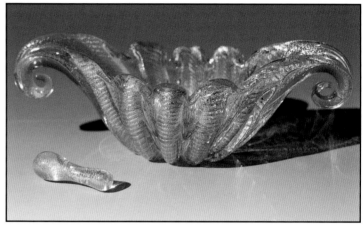

Barovier & Toso
Cordonato oro fluted bowl or mortar with scalloped top and scrolled ends, in clear glass with gold inclusions, with glass pestle, designed by Ercole Barovier, 1950.
Unmarked
Length 9-3/4 in; 25 cm.
$400-600

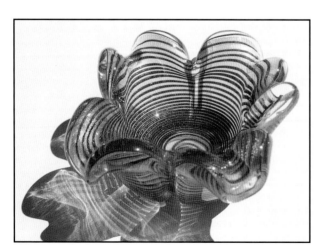

Barovier & Toso
Zebrati floriform bowl with gold inclusions and reddish stripes.
Unmarked
Diameter 7 in; 18 cm.
$300-400

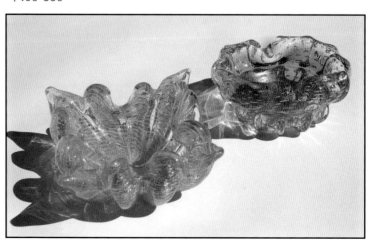

Barovier & Toso
Cordonato oro floriform bowl and scalloped bowl with pink glass with gold inclusions.
Label
Length 7-1/4 and 5-1/2 in; 18.5 and 14 cm.
$300-400; $200-250
Courtesy of Lorenzo Vigier

Cenedese
Round geode bowl in clear with yellow interior.
Unmarked
Diameter 8 in; 20 cm.
$250-300

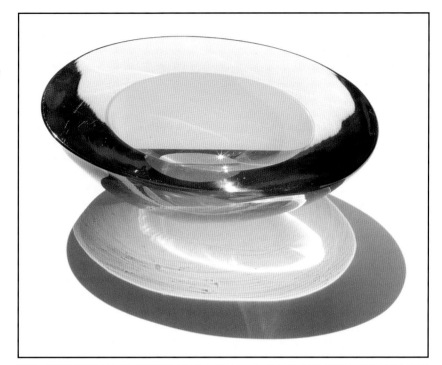

Cenedese
Geode bowls in blue and clear and yellow and clear.
Unmarked
Length 7-1/2 in; 19 cm.
$250-300 each
Courtesy of Lorenzo Vigier

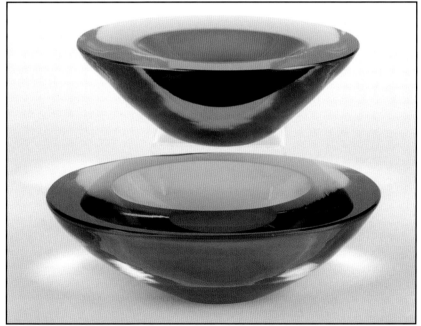

Cenedese
Elongated *sommerso* bowl in turquoise and clear, designed by Antonio Da Ros, 1960s.
Unmarked
Width 13 in; 33 cm.
$1,000-1,200
Courtesy of Lorenzo Vigier

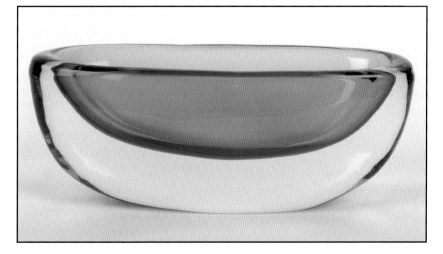

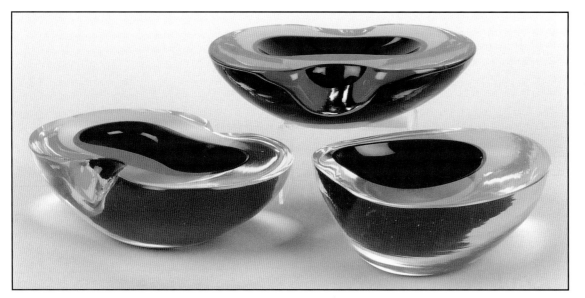

Cenedese
Freeform geode bowls, top in alexandrite and red, bottom in vaseline and red, designed by Antonio Da Ros, 1960s.
Unmarked
6-1/2 to 7-1/4 in; 16.5 to 18.5 cm.
$300-350 each
Courtesy of Lorenzo Vigier

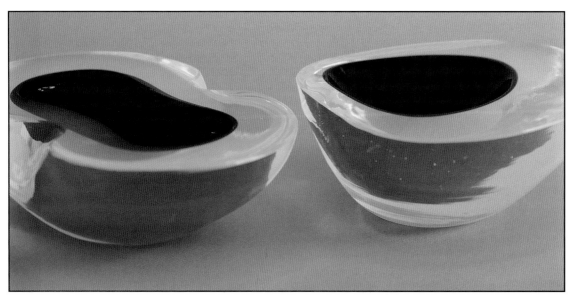

Cenedese
Geode bowls under black light.

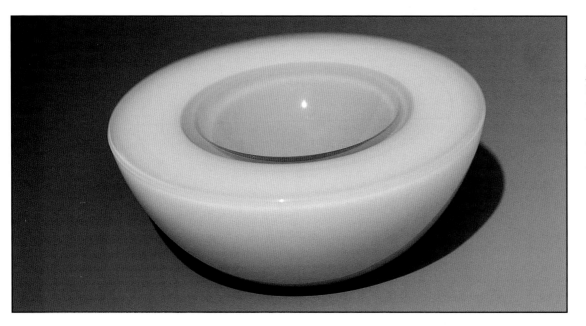

Archimede Seguso
Alabastro cased geode bowl in white with yellow center, designed by Archimede Seguso in 1958.
Unmarked
Diameter 5-1/2 in; 14 cm.
$250-350

Archimede Seguso
Alabastro cased geode bowl in white
with red center, designed by
Archimede Seguso in 1958.
Unmarked
Diameter 5-1/2 in; 14 cm.
$250-350
Courtesy of Michael Ellison

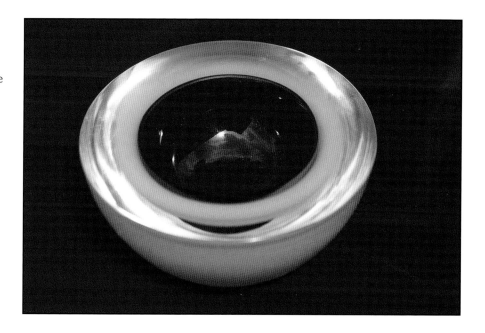

S.V.d'A Albarelli

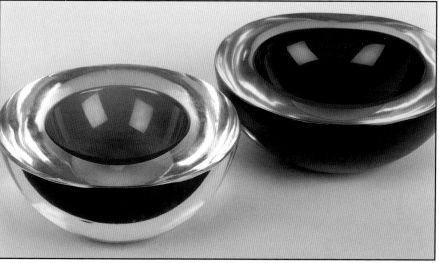

Seguso Vetri d'Arte
Sommerso geode bowl, with an internal
layer of transparent gray glass, heavily
cased in light pink glass, designed by
Maurizio Albarelli, late 1970s.
Signed, S.V.d'A Albarelli
Diameter 5-1/2 in; 14 cm.
$250-350
Courtesy of Lorenzo Vigier

Archimede Seguso
Sommerso geode bowl in cobalt and
turquoise.
Diameter 6-1/4 in; 16 cm.
$250-350

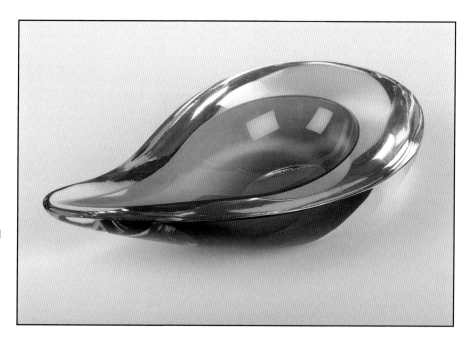

Seguso Vetri d'Arte
Sommerso teardrop bowl, with an internal
layer of transparent gray glass, heavily cased
in light pink glass, designed by Maurizio
Albarelli, ca. 1979.
Signed, S V d Albarelli 79
Length 9-3/4 in; 24.8 cm.
$400-500
Courtesy of Lorenzo Vigier

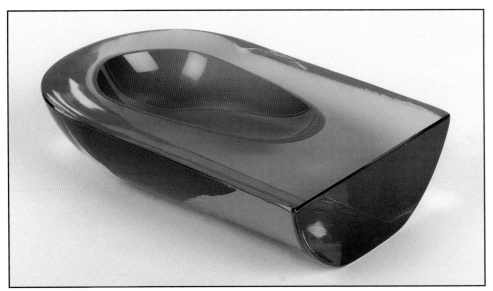

Seguso Vetri d'Arte
Sommerso bowl of complex geometric form and partially rounded underside, with an ovoid layer of transparent chestnut glass heavily cased in amber glass, designed by Maurizio Albarelli, late 1970s.
Signed, S.V.d'A Albarelli 9?1
Length 7 in; 17.8 cm.
$400-500
Courtesy of Lorenzo Vigier

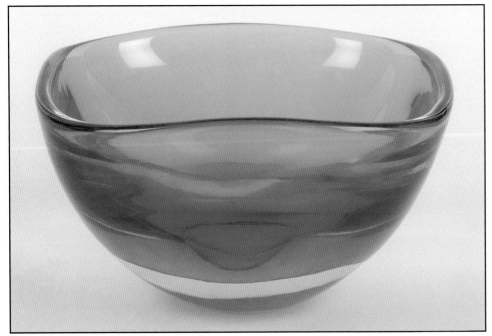

Seguso Vetri d'Arte
Sommerso bowl with square sides, in green and yellow.
Width 5-3/4 in; 14.5 cm.
$300-350
Courtesy of Lorenzo Vigier

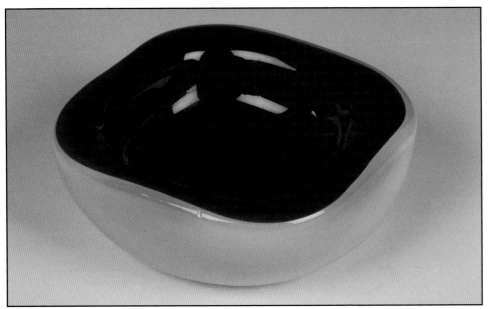

Archimede Seguso
Square geode type bowl in deep red cased in white.
Unmarked
Width 4 in; 10 cm.
$60-80

Archimede Seguso
Round bowls with overlapping rims, in white and pink *alabastro* and clear raspberry.
Diameter 7-1/2 in;
$300-400 each
Courtesy of Lorenzo Vigier

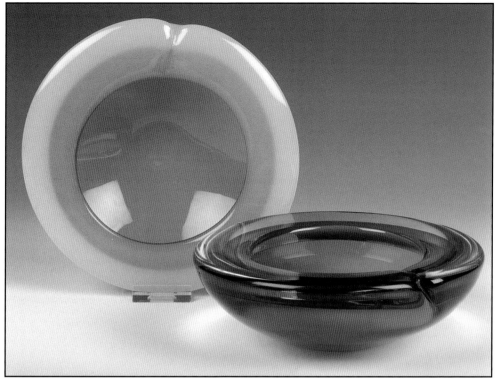

Archimede Seguso
Pink *opalini a coste* bowl with feathery ribs and rim, designed by Archimede Seguso in 1955.
Diameter 7-1/2 in;
$500-700
Courtesy of Lorenzo Vigier

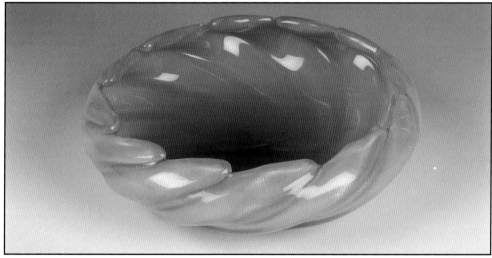

Seguso Vetri d'Arte
Bullicante bowl with an internal layer of green glass and gold foil covered by layers of controlled bubbles, cased in clear glass, the exterior decorated with horizontal and vertical grooves; designed by Flavio Poli, ca. 1937.
Unmarked
Diameter 7 in; 18 cm.
$400-600
Courtesy of Lorenzo Vigier

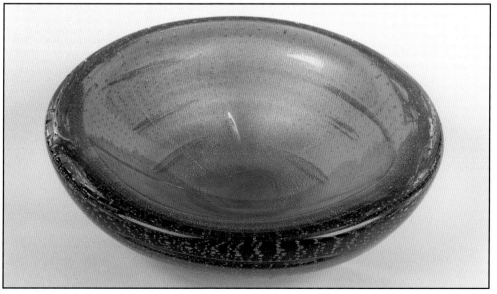

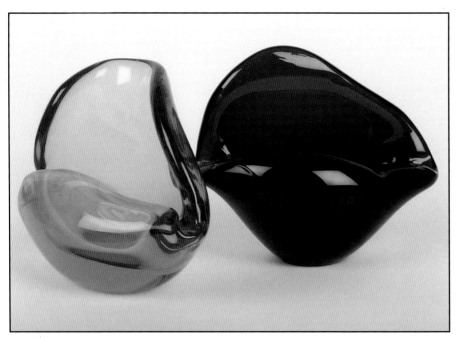

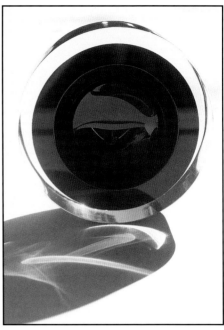

Seguso Vetri d'Arte
Conchiglie bowls in rose color and purple glass.
Unmarked
Length 7 in; 18 cm.
$800-1,000 each
Courtesy of Lorenzo Vigier

Archimede Seguso
Sommerso bowl in deep violet cased in
clear glass.
Signed, Archimede Seguso Murano Italy
Diameter 6-1/4 in; 16 cm.
$400-600
Courtesy of Michael Ellison

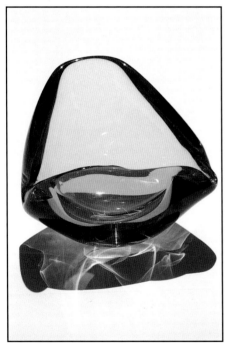

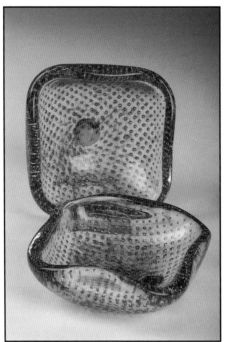

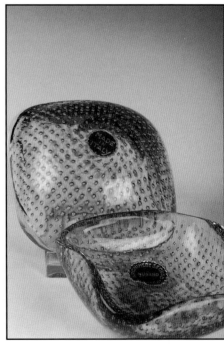

Seguso Vetri d'Arte
Conchiglie bowl designed by Flavio Poli,
in folded shell-like shape in rose glass.
Unmarked
Length 7 in; 18 cm.
$800-1,000
Courtesy of Lorenzo Vigier

Archimede Seguso
Small pink bowls with regular bubble
patterns and squared sides.
Width 3-1/2 in; 9 cm.
$75-100 each
Courtesy of Lorenzo Vigier

Archimede Seguso
Labels.

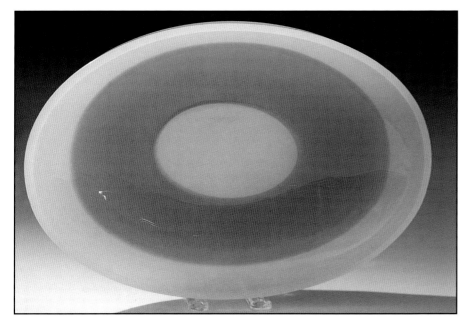

Archimede Seguso
Oval *alabastro* bowl in white with wide orange oval, designed by Archimede Seguso in 1958.
Unmarked
Length 14 in; 35.5 cm.
$600-800

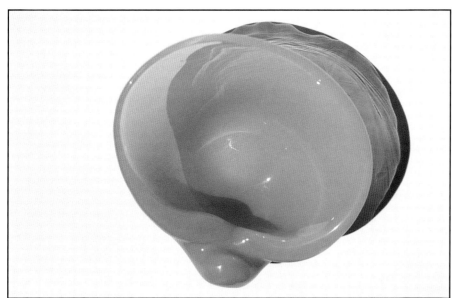

Archimede Seguso
Light bluish opalescent shell-shaped bowl.
Unmarked
Length 7-3/4 in; 19.5 cm.
$250-350

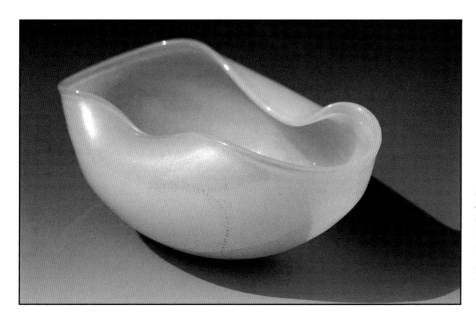

Archimede Seguso
A *cartoccio avorio* bowl, designed by Archimede Seguso in 1958, in folded cased white glass with gold.
Label, Made in Murano Italy
Length 9-1/2 in; 24 cm.
$400-600

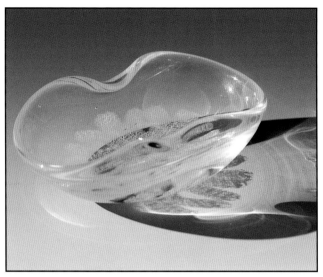

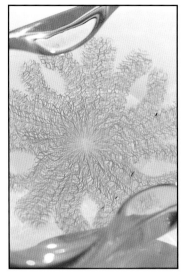

Detail.

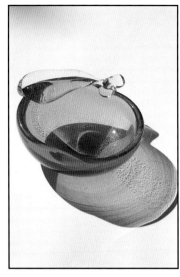

Archimede Seguso
Merletto frastagliato bowl in clear glass with fine internal threadlike yellow decoration, designed by Archimede Seguso in 1955.
Unmarked
Length 7 in; 18 cm.
$500-700
Courtesy of Lorenzo Vigier

Archimede Seguso
Bowl of rose color glass with gold foil, applied clear glass decoration.
Label, Made in Murano Italy
Diameter 5 in; 12.5 cm.
$150-250
Courtesy of Lorenzo Vigier

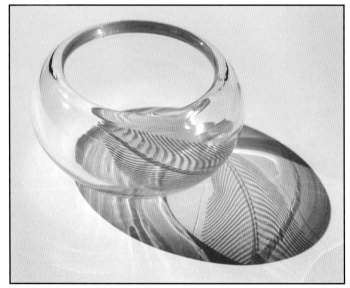

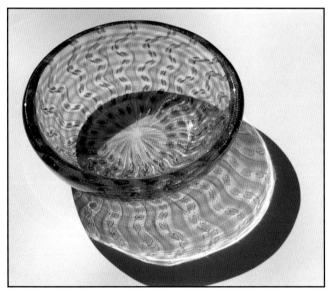

Archimede Seguso
Bowl from *piume* series, designed by Archimede Seguso in 1955, of clear glass with internal orange feather.
Unmarked
Diameter 4-1/2 in; 11.5 cm.
$500-600
Courtesy of Lorenzo Vigier

Archimede Seguso
Bowl of clear glass and gold inclusions, with turquoise pattern resembling cells in a vessel.
Unmarked
Diameter 4-3/4 in; 12 cm.
$200-250

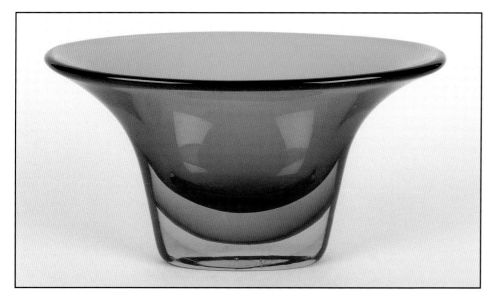

Seguso Vetri d'Arte
Hat form *sommerso* bowl with
squared base and flared rim, in green
and amber, designed by Flavio Poli.
Unmarked
Length 13 in; 33 cm.
$1,000-1,200
Courtesy of Lorenzo Vigier

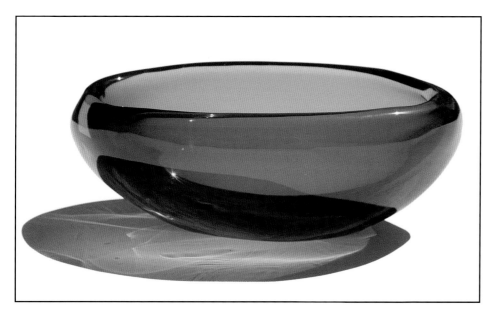

Archimede Seguso
Thick-walled cased oval bowl in green
and amber, c. 1955.
Unmarked
Length 15 in; 38 cm.
$1,000-1,200
Courtesy of Lorenzo Vigier

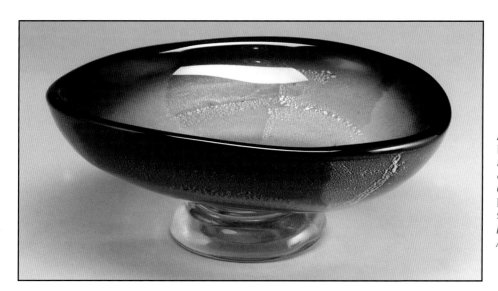

Archimede Seguso
Footed bowl in shaded green, silver,
and amethyst with silver inclusions,
ca. 1953.
Unmarked.
Length 11 in; 28 cm.
$400-600
*Photo courtesy of Rago Modern
Auctions*

149

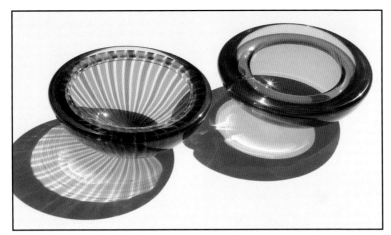

Archimede Seguso
Two round cased bowls with lip: one in raspberry and clear, the other with radiating blue and green stripes.
Unmarked
Diameters 7-1/2 in; 19 cm.
$250-350 each

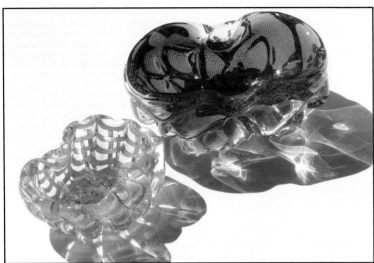

Spider-web bowl with pink scalloped spiral, and heavy cased pink and clear bowl with gold powder.
Unmarked
Lengths 5 and 7 in; 12.5 and 18 cm.
$100-150 each

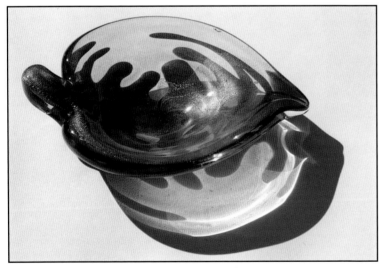

Archimede Seguso
Leaf-shape bowl with internal brick-red veining and gold powder.
Unmarked
Length 8 in; 20 cm.
$300-400

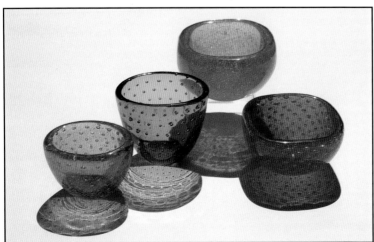

Venini
Oval and square *sommerso a bollicine* bowls in turquoise, amber, pink, and gold, designed by Carlo Scarpa.
Acid stamp, Venini/Murano/Italia
Diameters 3-4 in; 8-10 cm
$150-200 each
Courtesy of Lorenzo Vigier

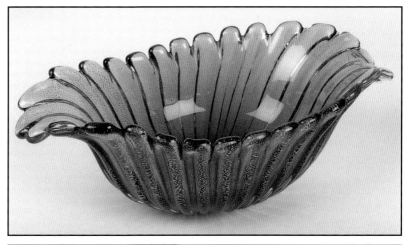

Archimede Seguso
Ribbed *verde oro* bowl in green with gold inclusions, with pulled ends, designed by Archimede Seguso in 1950.
Unmarked
Length 10 in; 35.5 cm.
$400-500

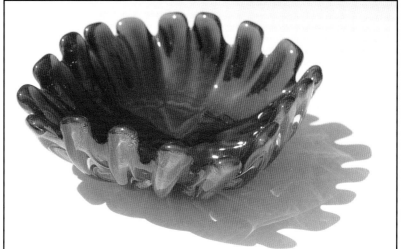

Archimede Seguso
Corallo oro bowl designed by Archimede Seguso in 1950, with red fingers creating a crenelated rim pattern.
Unmarked
Diameter 7 in; 18 cm.
$300-400

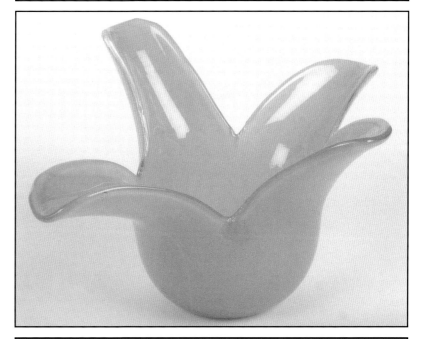

Archimede Seguso
Floriform bowl in pink *opalino* glass with gold powders, ca. 1950s.
Unmarked
Length 10-1/2 in; 27 cm.
$300-400

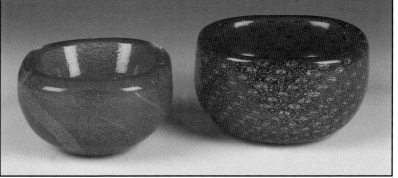

Venini
Sommerso a bollicine bowls, designed by Carlo Scarpa.
Acid stamp, Venini/Murano/Made in Italy
4 and 4-3/4 in; 10 and 12 cm.
$200-300 each
Courtesy of Lorenzo Vigier

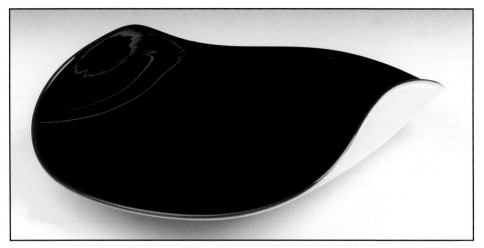

Venini
Cased folded bowl with *lattimo* exterior and purple interior, sides folded to create "potato chip" form, 1983.
Signed, Venini Italia 83
Length 11-1/4 in; 28.5 cm.
$500-700

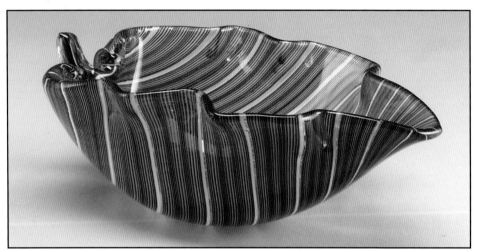

Venini
Purple and white *mezza filigana* leaf-shaped bowl, designed by Tyra Lundgren, ca. 1938.
Acid stamp, Venini/Murano/Italia.
Length 12-1/2 in; 32 cm..
$2,000-2,500
Photo courtesy of Rago Modern Auctions

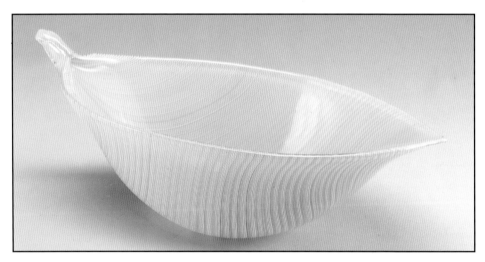

Venini
Orange and white *mezza filigana* leaf-shaped bowl, designed by Tyra Lundgren, ca 1938.
Acid stamp, Venini/Murano/Italia.
Length 14 in; 35.5 cm.
$2,000-2,500
Photo courtesy of Rago Modern Auctions

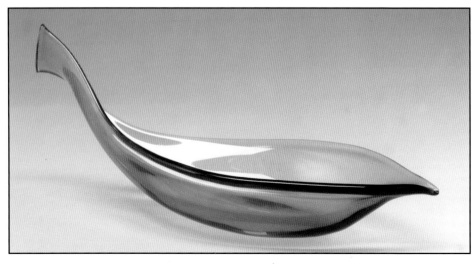

Salviati
Bowl in the form of a fish, in rose and blue, designed by Luciano Gaspari.
Length 16-1/2; 42 cm.
Incised, Luciano Gaspari
$600-800
Photo courtesy of Rago Modern Auctions

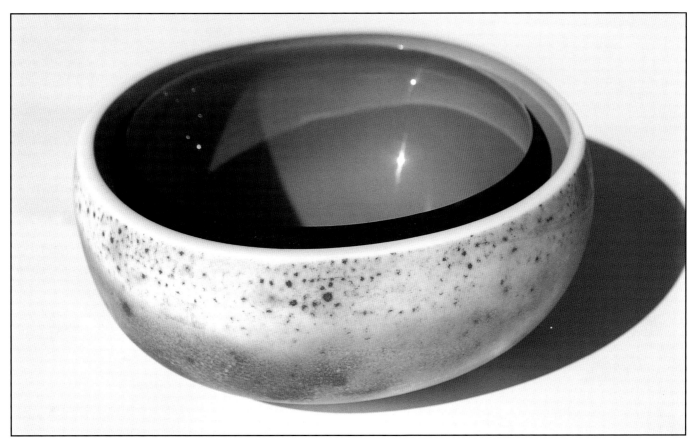

Barbini
Thick-walled cased bowl, exterior of opaque white calcite with violet-fumed, and transparent purple interior, two difficult types of glass to successfully fuse, by Alfredo Barbini.
Signed, Barbini
Diameter 9-3/4 in; 25 cm.
$2,500-3,500
Courtesy of Michael Ellison

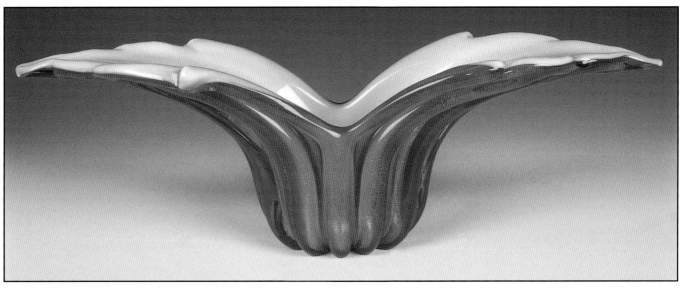

Barbini
Cased wing bowl of clear ribbed exterior with gold powder, and *lattimo* interior, the sides stretched like wings with uneven rim; shown in a Weil Ceramics and Glass importer catalog along with many popular Barbini items from the early 1960s.
Unmarked
Length 18 in; 46 cm.
$300-400
Courtesy of Lorenzo Vigier

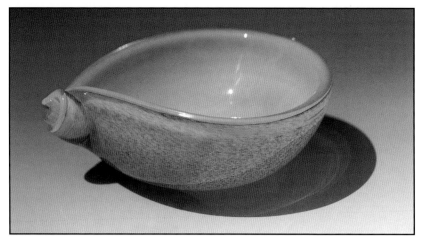

Fratelli Toso
Cased shell-type bowl with mottled pink and white exterior and *lattimo* interior.
Unmarked
Length 8 in; 20 cm.
$100-150

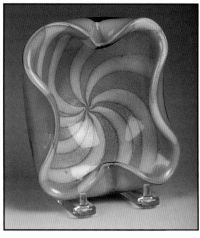

Barbini
"Circus tent" pattern in blue and white with gold powder, folded rim, in Weil import catalog.
Unmarked
Length 6-1/2 in; 16.5 cm.
$100-150

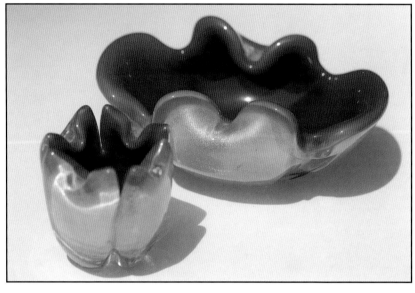

Barbini
Cased floriform bowl with matching little vase, clear and white exterior and hot pink interior.
Unmarked
Bowl length 7-1/4; 18-1/2 cm.
$100-150

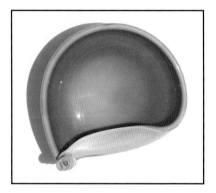

Barbini
Cased shell-shaped bowl with white exterior and purple interior, in Weil import catalog.
Unmarked
Length 5-1/4 in; 13.5 cm.
$50-75

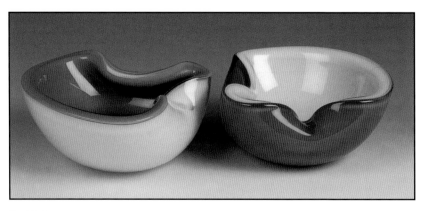

Barbini
Two cased bowls with pinched rims, one in *lattimo* glass over ochre, one in persimmon over *lattimo*.
Unmarked
Length 6 in; 15 cm.
$50-75 each

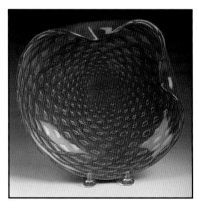

Fratelli Toso
Chinese orange with folded rim and internal pattern of large bubbles.
Unmarked
Length 10-1/2 in; 26.5 cm.
$150-200

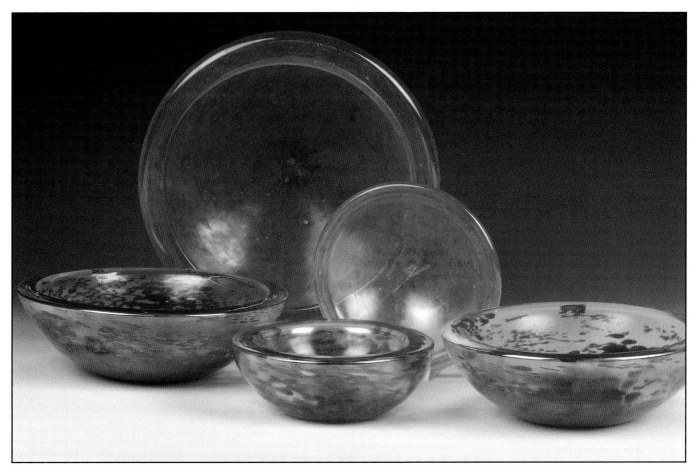

Aureliano Toso
A mace bowls designed by Dino Martens in 1948, with internal
nebulae splashes with matt irridized surface.
Paper labels
Diameters 7-12 in; 20-30-1/2 cm.
$300-600 each

Detail.

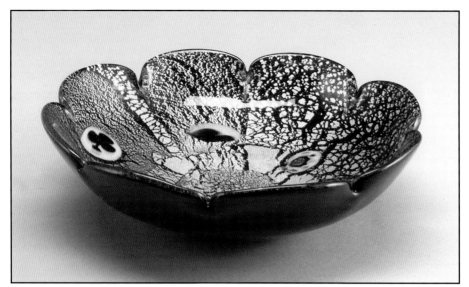

A.VE.M.
Bowl with gold foil and large *murrines* on black glass ground, designed by Giulio Radi.
Unmarked.
Diameter 8 in; 20 cm.
$250-300
Photo courtesy of Rago Modern Auctions

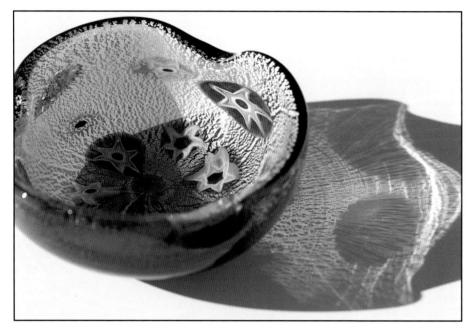

A.VE.M.
Cased bowl with black exterior and inside with silver foil and star *murrines*, likely designed by Giulio Radi.
Label, A.VE.M. Made in Italy Murano
Diameter 6-1/2 in; 16.5 cm.
$250-300
Courtesy of Lorenzo Vigier

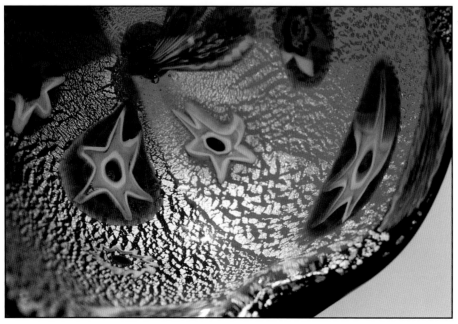

Detail.

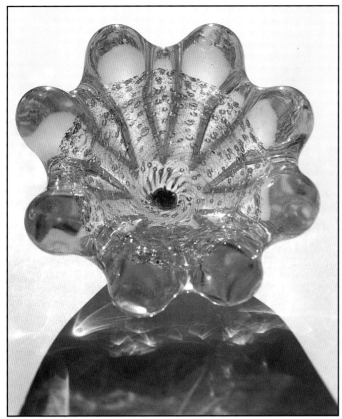

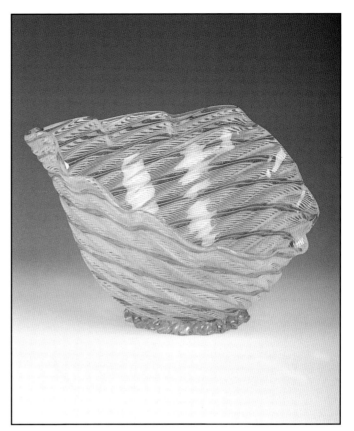

A.VE.M.
Thick-walled clear bowl with six large ribs, internal turquoise and bubbles.
Label, A.VE.M. Made in Italy Murano
Diameter 7 in; 18 cm.
$200-250

Aureliano Toso
Mezza filigrana shell-shaped bowl with irregular rim, designed by Dino Martens.
Unmarked
Diameter 7 in; 18 cm.
$300-400

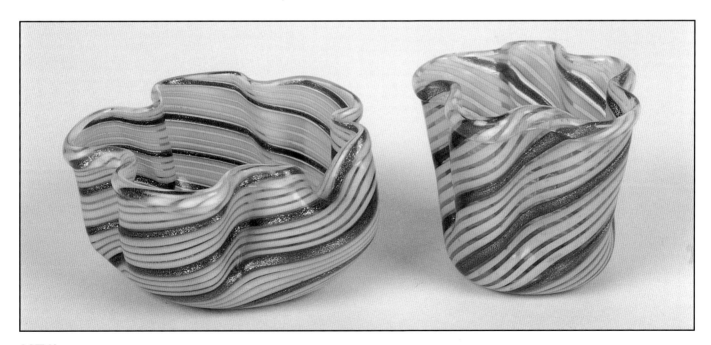

A.VE.M.
Mezza filigrana pinched bowl with robin's-egg blue and gold powder stripes, with matching cigarette holder, c 1950s.
Unmarked
Bowl width 3-1/3 in; 8.5 cm; Vase height 2-1/4 in; 6 cm.
$100-150 each

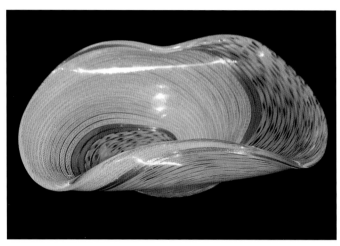

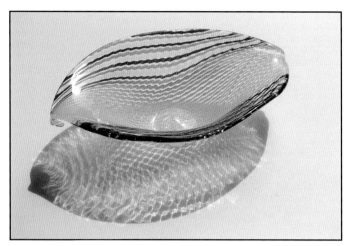

Fratelli Toso
Swirling filigree bowl with folded edges, in pink, white, and gold powder in clear glass.
Unmarked.
Length 13-1/2 in; 34 cm.
$800-1,000

Aureliano Toso
Wavy stripe *a trina* pattern in red-orange, pale yellow, blue, and white, designed by Dino Martens, 1950s.
Unmarked
Length 12-1/2 in; 32 cm.
$800-1,000

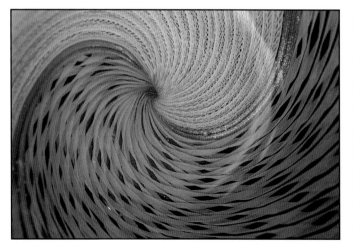

Detail.

Detail.

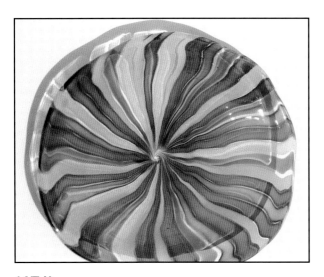

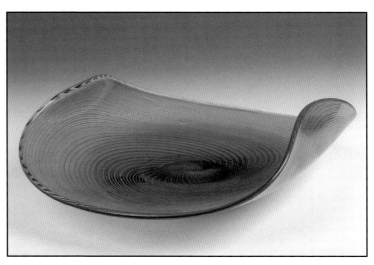

A.VE.M.
Heavy oval bowl with radiating stripes in orange, blue, aubergine, and *lattimo* filigree, designed by Anzolo Fuga in 1956, part of a series with sets of bowls and matching vases exhibited in the 1956 Venice Biennale.
Label, Made in Italy Murano
Length 19 in; 48 cm.
$2,000-3,000

Aureliano Toso
Mezza filigrana bowl in blue and beige, with folded rim and applied clear foot, attributed to Dino Martens for Aureliano Toso.
Unmarked
Length 11 in; 28 cm.
$500-600

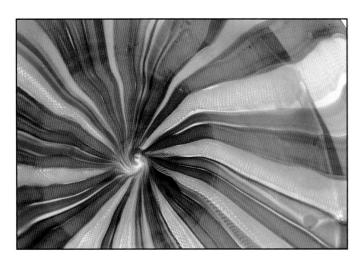

Detail.

Detail.

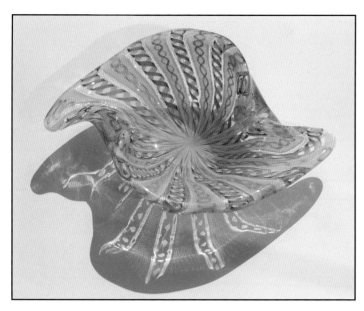
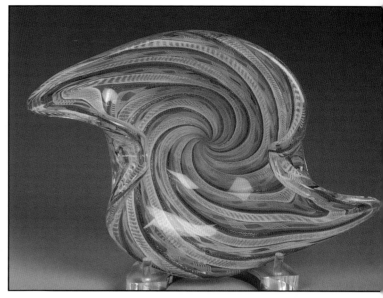

Fratelli Toso
Two styles of pinwheel bowl, each with pulled rims and swirling filigree in pink, white, and clear with gold powder.
Unmarked
Length 11-3/4 in; 30 cm.
$300-400 each

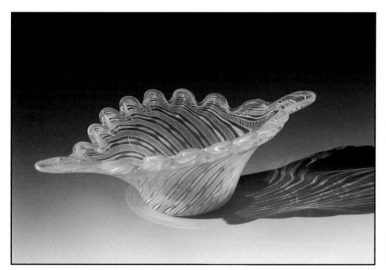
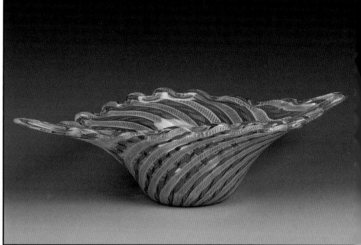

Fratelli Toso
Deep bowl with pulled edges and scalloped rim in white filigree.
Unmarked
Length 17-1/2 in; 44.5 cm.
$600-800

Fratelli Toso
Deep bowl with pulled edges and scalloped rim, in bright orange and gold powder twisted ribbon and white filigree.
Unmarked
Length 18 in; 46 cm.
$700-900

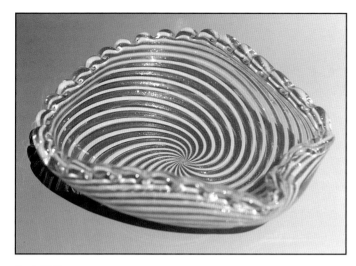

Fratelli Toso
Pinwheel *mezza filigrana* bowl with ruffled edge, in *lattimo* and *aventurine* stripes.
Unmarked
Diameter 7-1/2 in; 19 cm.
$200-300

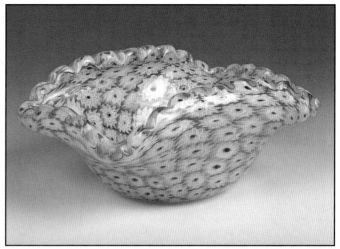

Fratelli Toso
Millefiori bowl, *murrine* in white with red centers on green ground, pulled edges and ruffled rim.
Unmarked
Length 7-1/2 in; 19 cm.
$400-500

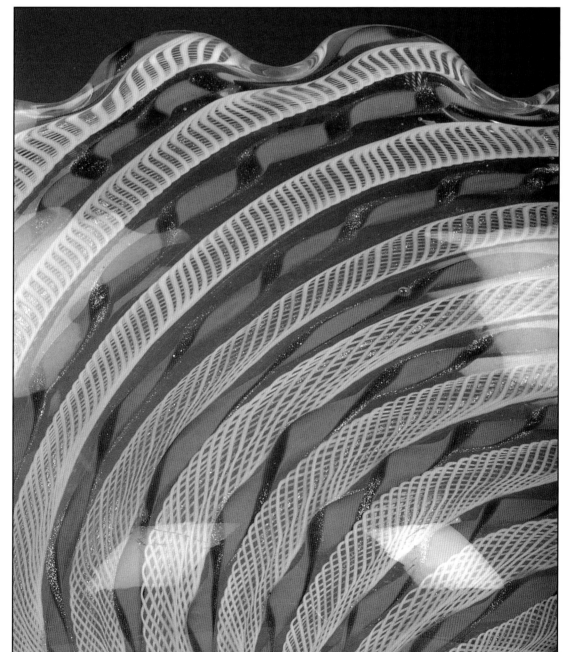

Detail.

161

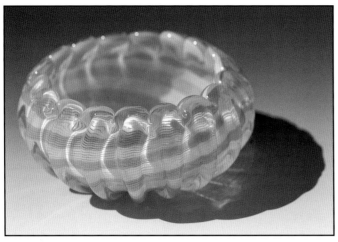

Fratelli Toso
Round fluted *mezza filigrana* bowl with groupings of *lattimo* and turquoise canes.
Unmarked
Diameter 7 in; 18 cm.
$400-600

Detail.

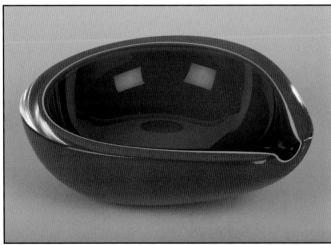

Fratelli Toso
Cased geode-type bowl in four layers of clear, orange, white, and royal blue, water-drop form.
Unmarked
Length 7 in; 18 cm.
$400-500

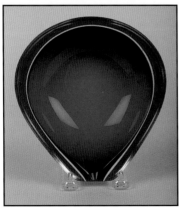

Fratelli Toso
Heavy cased bowl in droplet form with mossy green interior and thick clear glass outer layer with irridized surface.
Round foil label
Length 7 in; 18 cm.
$400-500

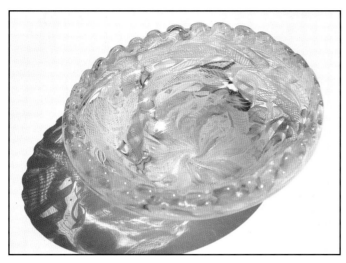

Fratelli Toso
Round scalloped bowl filled with random pink and white filigree and multi-color canes, style similar to A.VE.M.
Unmarked
Diameter 8 in; 20 cm.
$300-400
Courtesy of Lorenzo Vigier

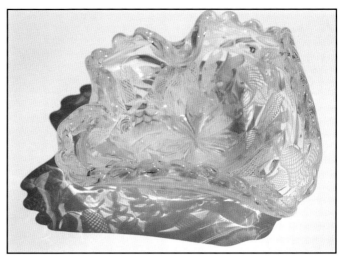

Fratelli Toso
Similar random filigree bowl with pinched rim.
Round foil label
Length 8 in; 20 cm.
$300-400
Courtesy of Lorenzo Vigier

Fratelli Toso
Pinched and pulled turquoise rim on pink and white mottled bowl.
Round foil label
Length 9-1/4 in; 23.5 cm.
$250-350

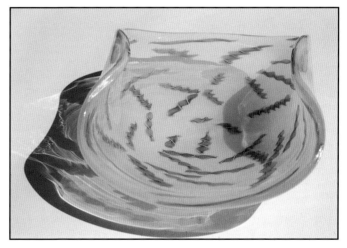

Fratelli Toso
White opalescent bowl with folded rim and random twisted canes, designed by Ermanno Toso.
Unmarked
Length 14 in; 35.5 cm.
$400-600

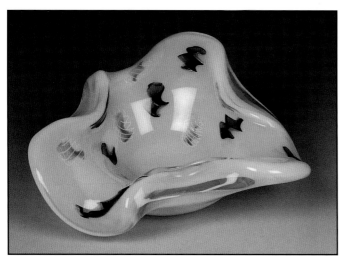

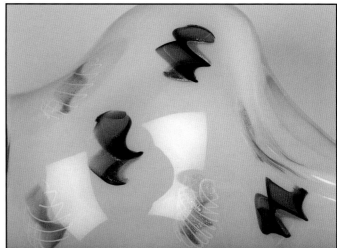

Fratelli Toso
White opalescent bowl with folded rim and random twisted canes.
Unmarked
Length 8 in; 20 cm.
$200-250

Detail.

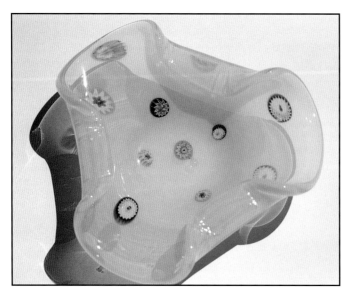

Fratelli Toso
Trefoil bowl in white opalescent with multi-color floral *murrines*.
Unmarked
Length 9 in; 23 cm.
$200-250

Detail.

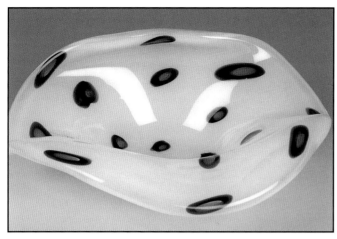

Fratelli Toso
Freeform white opalescent bowl with brown *murrines,* designed by Ermanno Toso.
Unmarked
Length 8-1/2 in; 21-1/2 cm.
$200-250

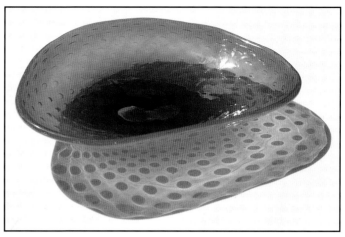

Fratelli Toso
Rose color opalescent bowl with pattern of large bubbles.
Unmarked
Diameter 16-1/2 in; 42 cm.
$500-700
Courtesy of Lorenzo Vigier

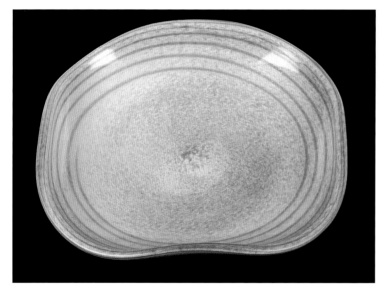

Fratelli Toso
Shallow bowl with undulating rim, of mottled gold on white glass, with thin blue edge striping.
Round foil label
Diameter 11 in; 29 cm.
$300-400

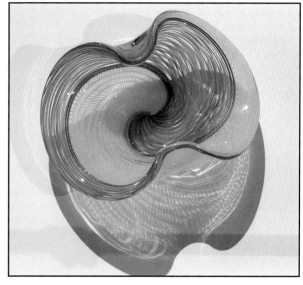

Fratelli Toso
Pinched filigree bowl with yin-yang motif in white and mustard-gold.
Unmarked
Length 8-1/4 in; 21 cm.
$250-350
Courtesy of Lorenzo Vigier

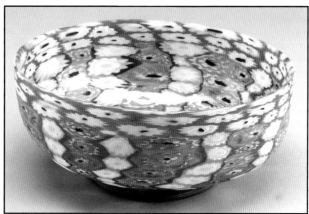

Fratelli Toso
Millefiori bowl with applied foot and rim, multicolored *murrines,* 1910s.
Unmarked.
Diameter 8 in; 20 cm.
$500-700
Photo courtesy of Rago Modern Auctions

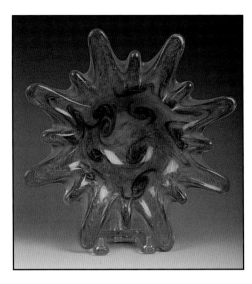

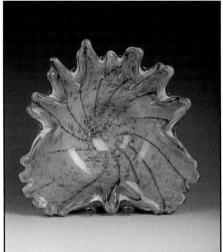

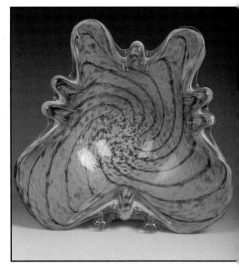

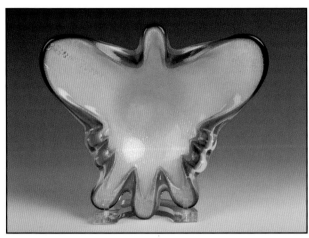

Fratelli Toso
Variety of wild bowls in shapes resembling leaves, flowers, butterflies, and water splashes, designed by Ermanno Toso in the 1950s and 1960s; vivid colors, many with gold powders.
Some with round foil label, Murano Glass Made in Italy.
Width/diameters 10-15 in; 25-38 cm.
$100-200 each

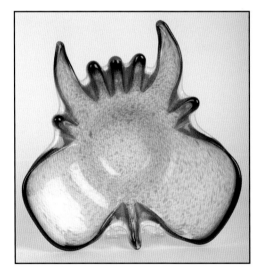

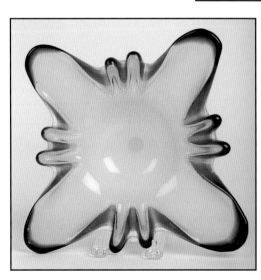

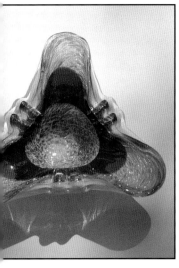

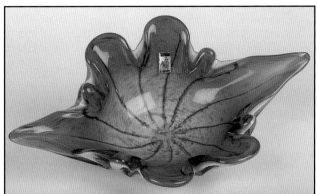

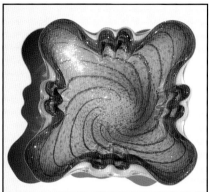

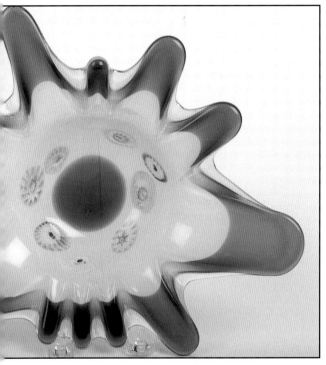

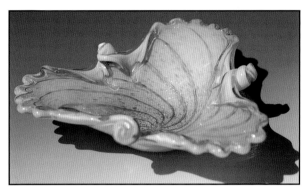

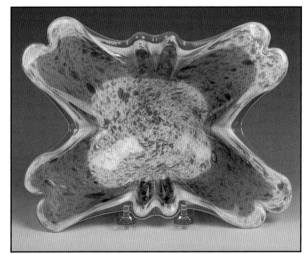

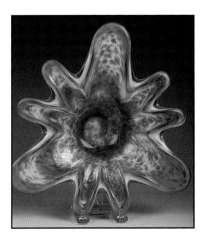

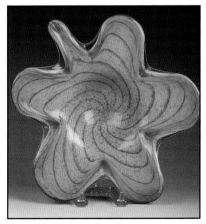

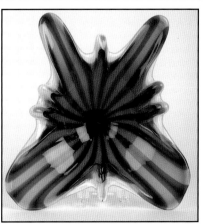

Fratelli Toso
Variety of wild bowls in shapes resembling leaves, flowers, butterflies, and water splashes, designed by Ermanno Toso in the 1950s and 1960s; vivid colors, swirls, and spots, many with gold powders. Some with round foil label, *Murano Glass Made in Italy.*
Width/diameters 9-12 in; 23-30 cm.
$100-200 each

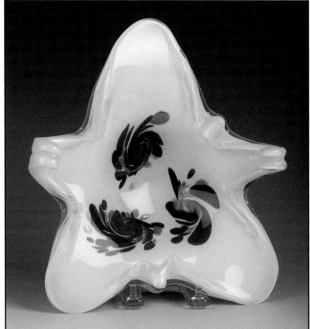

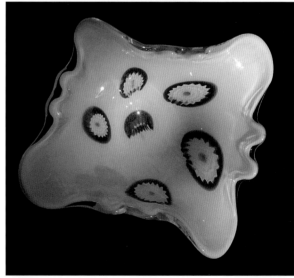
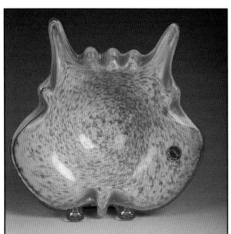
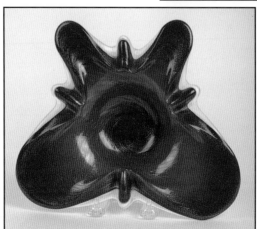

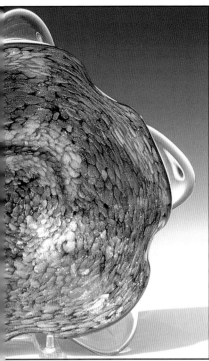

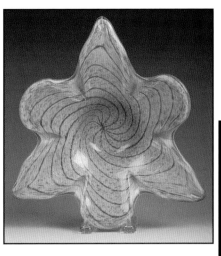

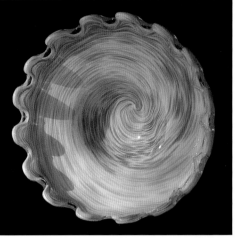

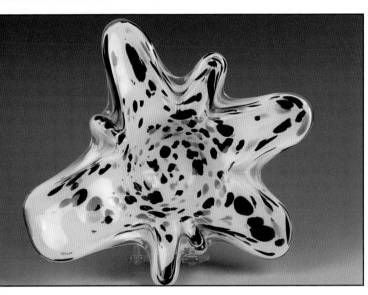

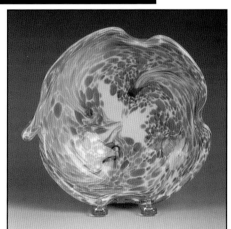

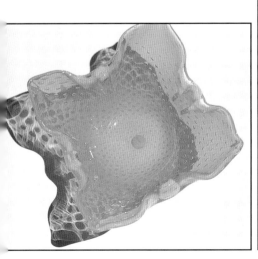

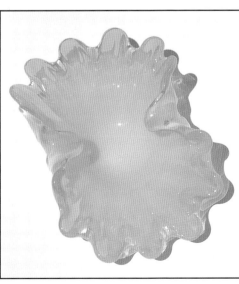

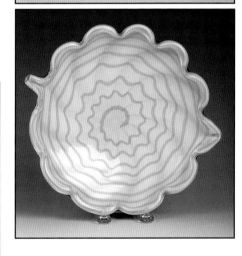

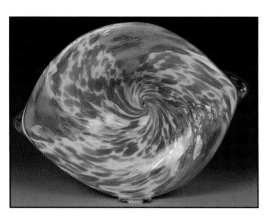
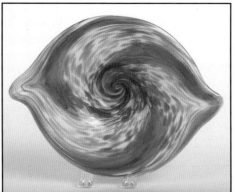
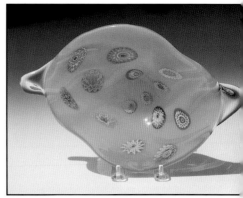

Fratelli Toso
Variety of bowls in organic forms designed by Ermanno Toso in the 1950s and 1960s; vivid colors, gold powders, some opalescent colors, some with colorful *murrines*.
Some with round foil label, Murano Glass Made in Italy.
Width/diameters 9-12 in; 23-30 cm.
$100-200 each; opalescent *murrine* 200-250 each

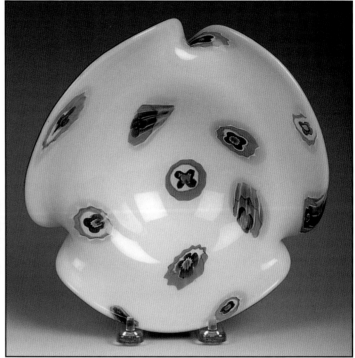

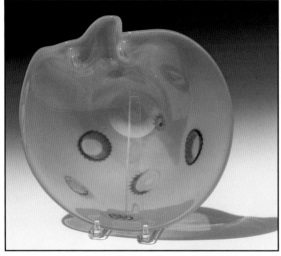

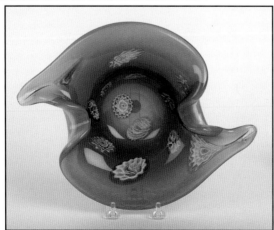

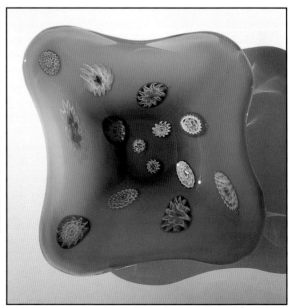

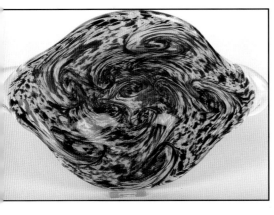
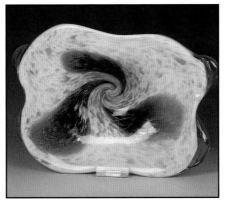
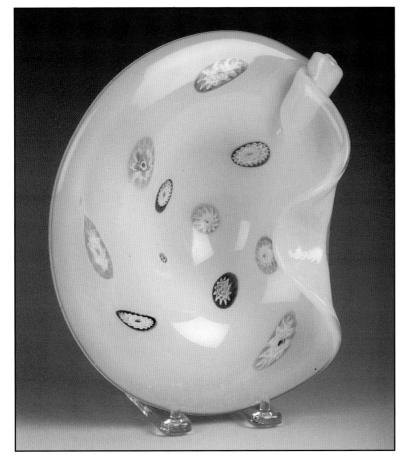

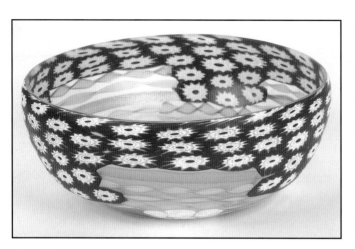

Fratelli Toso
Millefiori and ribbon combination of predominantly white canes on red ground, matte finish.
Unmarked
Diameter 9-1/2 in; 24 cm.
$500-600
Courtesy of Lorenzo Vigier.

Detail.

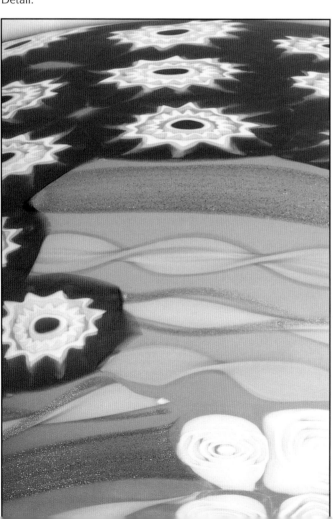

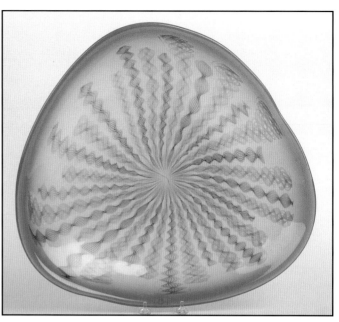

Fratelli Toso
Large opalescent plate with three rounded sides, taupe edge and subtly colored *filigrana* radiating from the center.
Unmarked
Diagonal 17-3/4 in; 45 cm.
$700-900

Detail.

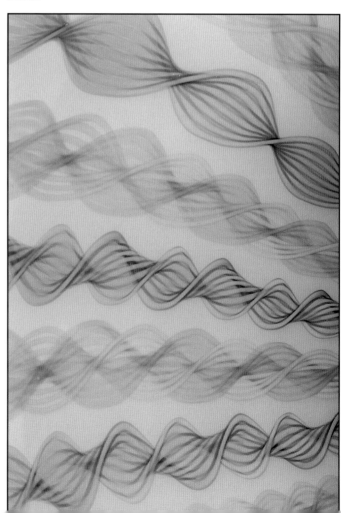

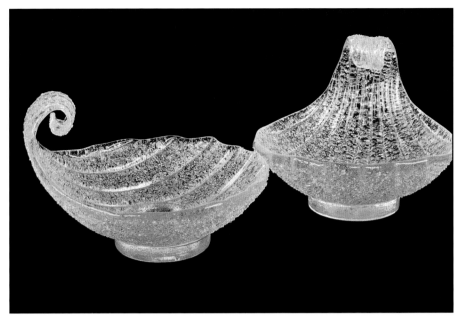

Fratelli Toso
Two pink footed shell bowls with scrolled end and sandy glass exterior.
Paper label, Made in Italy
Length 6 in; 15 cm.
$50-75 each

Fratelli Toso
Footed bowl in lime green with sandy glass bits rolled onto the surface, referred to as "overshot."
Round foil label
Width 7 in; 18 cm.
$75-100

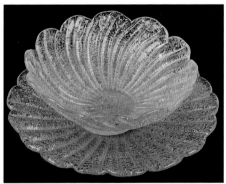

Fratelli Toso
Pink scalloped plate with sandy glass bit finish.
Round foil label
Diameter 8 in; 20 cm.
$50-75

Detail.

"Starry night" detail.

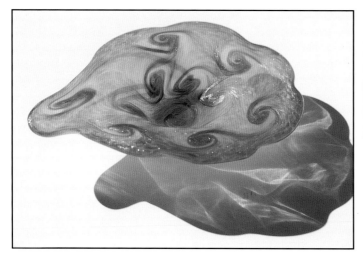

Fratelli Toso
Asymmetrical organic form bowl in green "starry night" motif.
Round foil label, Murano Glass Made in Italy, and castle export label
Length 11-1/2 in; 29 cm.
$100-125

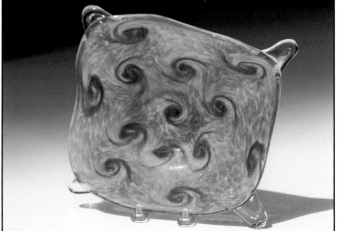

Fratelli Toso
Taupe "starry night" irregular square plate with four clear pulled corners.
Round foil label, Murano Glass Made in Italy.
Diagonal 13 in; 33 cm.
$125-150

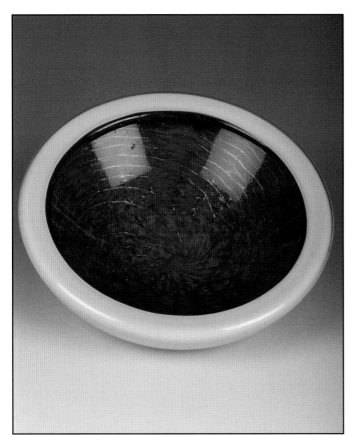

Fratelli Toso
Cased geode style bowl with *lattimo* exterior and orange interior with gold radiating swirls.
Unmarked
Diameter 8 in; 20 cm.
$200-250

Cased white bowl with scrolled ends and colorful spots, possibly by Fratelli Toso.
Unmarked
Length 9 in; 23 cm.
$100-150

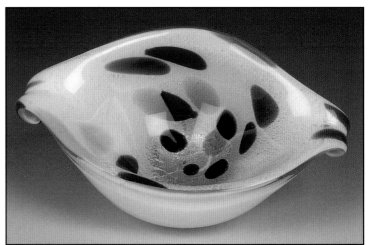

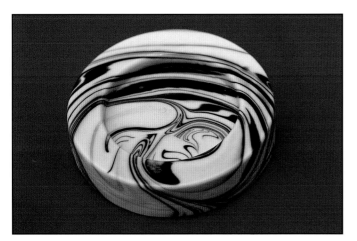

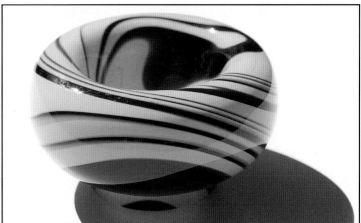

Venini
Molded round dish of opaque dark purple and white marble glass.
Diameter 4-1/2 in; 11-1/2 cm.
$100-150

Carlo Moretti
Puffy bowl in yellow and brown marble glass.
Unmarked
Diameter 6 in; 15 cm.
$70-90

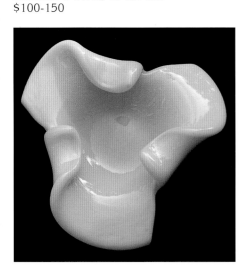

Yellow opaque floriform bowl with sheared and folded edge.
Unmarked
Diagonal 7 in; 18 cm.
$75-100

Cenedese
Shallow sculptural bowl with opening on one side, green *sommerso* in clear glass, attributed to Cenedese.
Unmarked
Length 11 in; 28 cm.
$300-400

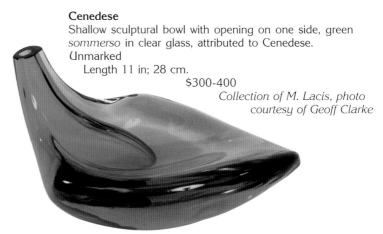

Collection of M. Lacis, photo courtesy of Geoff Clarke

175

Drinkware, Tableware

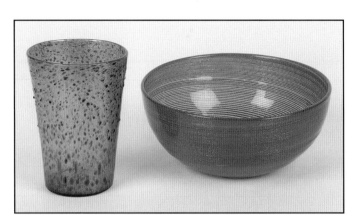

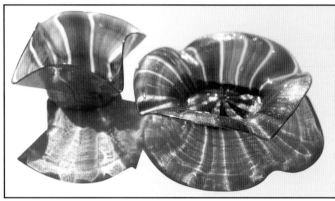

Salviati
Small beaker of *aventurine* and *granzioli* exterior; *aventurine mezza filigrana* bowl, ca. 1900.
Unmarked
Beaker height 3-1/2 in; 9 cm.
Bowl diameter 5-1/8 in; 13 cm.
$100-150; $150-200

Salviati
Finger bowl with plate in *aventurine* and red stripes, ca. 1900.
Unmarked
Diameter 6 & 6-1/2 in; 15 & 16.5 cm.
$300-400 set

Detail.

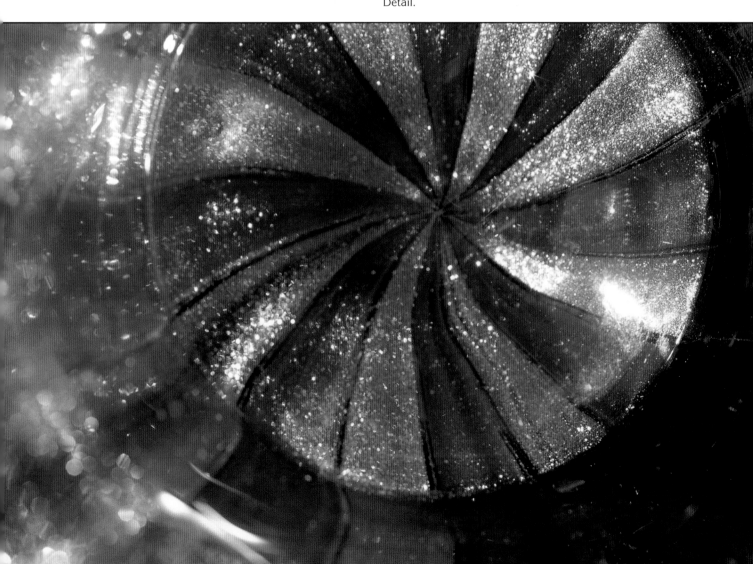

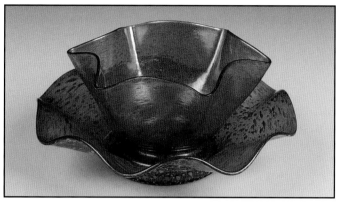

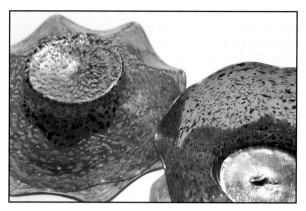

Detail.

Salviati
Aventurine finger bowl on plate with applied turquoise *granzioli,*
ca. 1900.
Unmarked
Plate diameter 6-1/2 in; 16.5 cm.
Plate $200-300

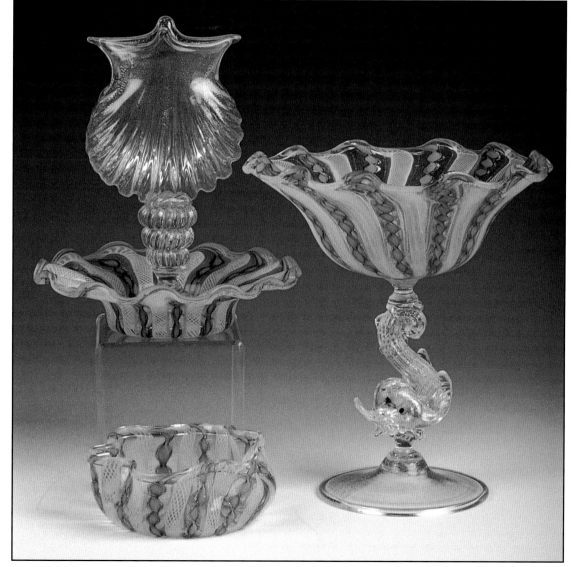

Salviati
Shell vase with three-tier Renaissance-style stem, attached to ruffled plate with blue ribbon and white filigree; small matching bowl; and matching footed compote with figural dolphin stem with gold powders.
Unmarked.
Heights 7 in, bowl width 4 in; 18 & 10 cm.
$300-400 each, bowl $60-90

Detail.

Salviati
Aventurine stripe pitcher in tapered cylindrical form, with applied clear glass raspberries and threading, attributed to Salviati, ca. 1900.
Unmarked
Height 10-1/4 in; 26 cm.
$500-700

A.VE.M
Anse volante pitcher with handle integrated in the form, designed by Giorgio Ferro in 1952.
Height 11 in; 28 cm.
$2,000-2,500
Courtesy of Lorenzo Vigier

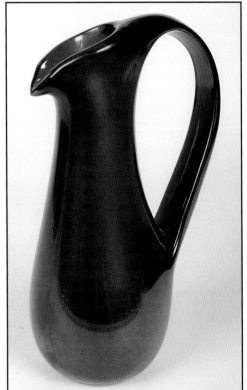

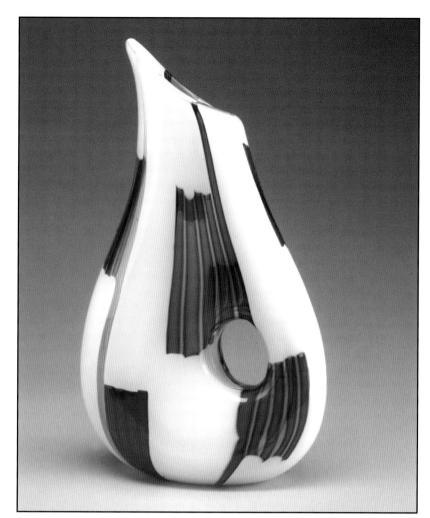

A.VE.M
Patchwork pitcher of *vetri lattimo* with single hole creating a handle, with red, yellow, blue, and green patches of canes, designed by Ansolo Fuga, 1950s. Unmarked
Height 18 in; 46 cm.
$7,000-9,000
Photo courtesy of Rago Modern Auctions

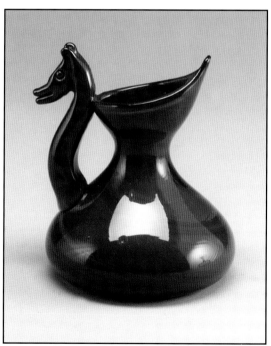

Barovier & Toso
Red chimera vessel form the *Corniola* series, 1959, designed by Ercole Barovier. Unmarked
6-1/2 x 5-1/2 in; 16-1/2 x 14 cm.
$3,000-4,000
Photo courtesy of Rago Modern Auctions

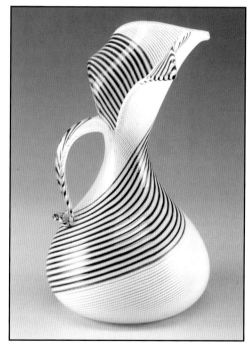

Aureliano Toso
Mezza filigrana pitcher in black, white, and gold with exaggerated spout, designed by Dino Martens, ca. 1954. Unmarked.
Height 11 in; 28 cm.
$1,500-1,800
Photo courtesy of Rago Modern Auctions

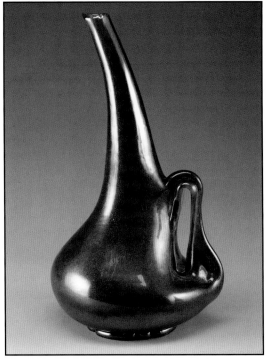

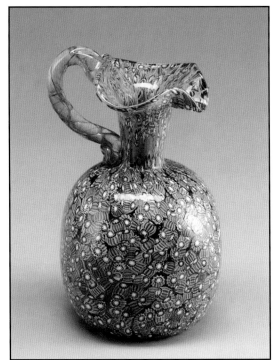

Barovier & Toso
Eggplant and green luster pitcher from the *Eugenio* series, designed by Ercole Barovier in 1951.
Unmarked
14 in; 35.5 cm.
$2,500-3,500
Photo courtesy of Rago Modern Auctions

Fratelli Toso
Pitcher with green, white, and amethyst *murrines* and amethyst handle, ca. 1920.
Unmarked.
Height 7-1/2 in; 19 cm.
$600-800
Photo courtesy of Rago Modern Auctions

Barovier & Toso
Eugenio pitchers and handled urn in cherry red, designed by Ercole Barovier in 1951.
Paper labels.
6, 4-3-/4 and 3-1/2 in; 15, 12, and 9 cm.
$600-800 each
Photo courtesy of Rago Modern Auctions

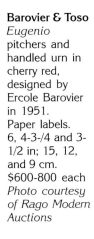

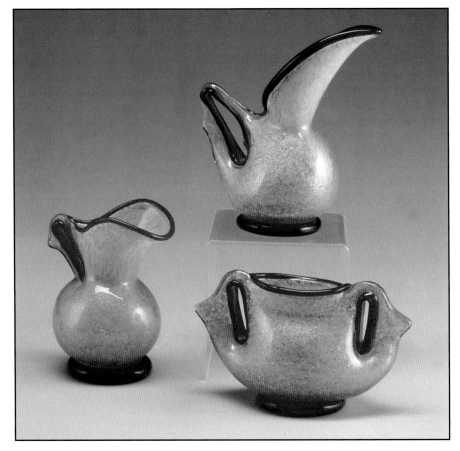

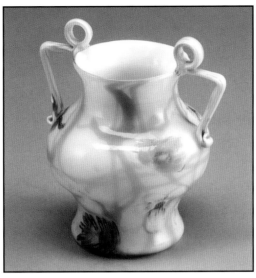

Fratelli Toso
Floriale bulbous urn with applied handles, in white
with green stems and green and yellow flowers.
Unmarked.
Height 4-1/2 in; 11.5 cm.
$1,600-2,000
Photo courtesy of Rago Modern Auctions

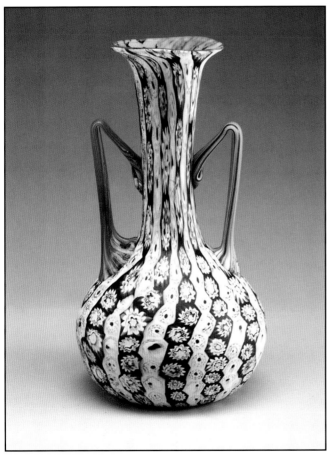

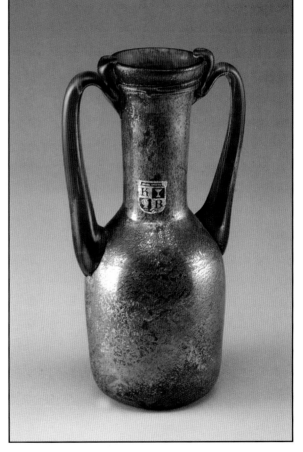

Fratelli Toso
Millefiori urn with blue, purple, and yellow *murrines* and pulled
cane handles.
Unmarked.
Height 14 in; 35.5 cm.
$3,000-4,000
Photo courtesy of Rago Modern Auctions

Archimede Seguso
Scavo urn in caramel brown with silver inclusions and
iridescent handles.
Unmarked (import sticker).
Height 9 in; 23 cm.
$2,000-3,000
Photo courtesy of Rago Modern Auctions

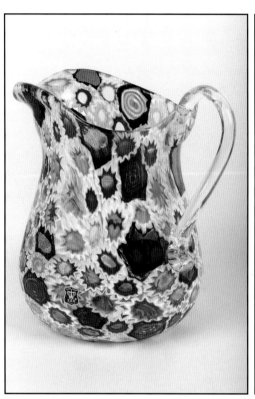

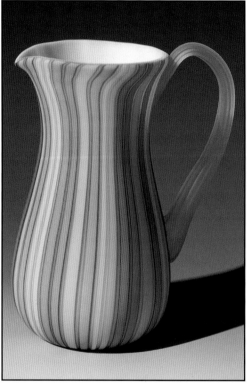

Fratelli Toso
Millefiori pitcher with transparent *murrines* and gloss finish, atypical for Fratelli Toso, whose *millefiori* is usually opaque and matte, ca. 1960.
Import label
Height 7 in; 18 cm.
$400-600

Fratelli Toso
Cased pitcher with white interior covered with pastel-colored canes, applied clear fluted handle, satin finish, ca. 1950.
Unmarked
Height 7-1/4 in; 18.5 cm.
$400-500

Water bottle and pitcher with white satin exteriors cased over green and yellow, each with folded lip to show interior.
Import label, Colony Italy
Heights 9-3/4 and 7-1/7 in; 25 and 19 cm.
$100-150 each

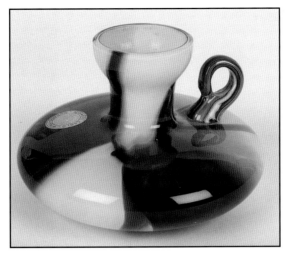

Carlo Moretti
Squat vessel with round handle, in brown and yellow marbleized glass, c. 1960s.
Gold label
Width 5-1/2 in; 14 cm.
$70-90

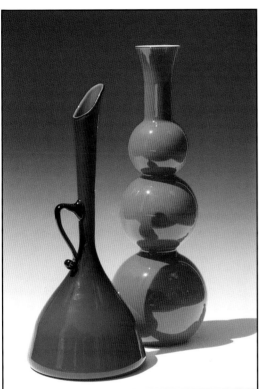

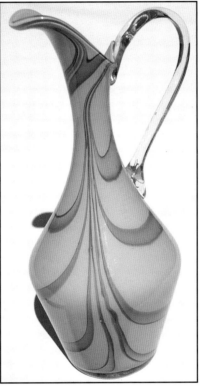

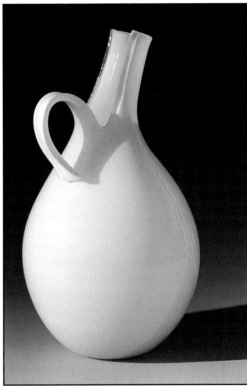

Bright blue cased pitcher with long neck and small handle resembling a bent arm; with orange cased gurgle bottle.
Unmarked
Heights 16-3/4 and 18-3/4 in; 42.5 and 47.5 cm.
$200-250 each

Cased pitcher in sky-blue with olive swirls, clear handle.
Unmarked
Height 14-1/2 in; 37 cm.
$100-150

Cased pitcher of clear and *lattimo* glass, bulbous body and cut rim folded to form spout.
Unmarked
Height 11-1/2 in; 29 cm.
$150-200

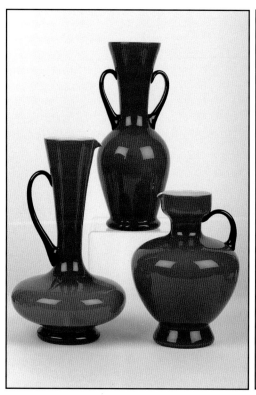

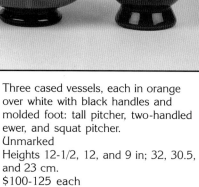

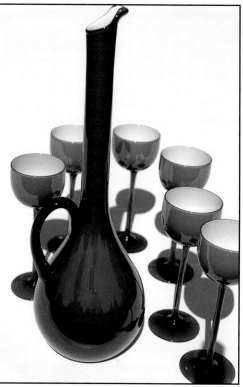

Three cased vessels, each in orange over white with black handles and molded foot: tall pitcher, two-handled ewer, and squat pitcher.
Unmarked
Heights 12-1/2, 12, and 9 in; 32, 30.5, and 23 cm.
$100-125 each

Cased pitcher, green over white, with long neck and matching long stemmed wine glasses.
Unmarked
Pitcher height 14-1/2 in; 37 cm.
Pitcher $100-125; glasses $10-15 each

Carlo Moretti
Lime green *satinato bicolore* covered bottle and four tumblers, ca. 1970s.
Late label
Height 11-3/4 in; 30 cm.
Bottle $100-150; glasses $25-30 each

Carlo Moretti
Variety of *satinato* drinking glasses.
$25-45 each

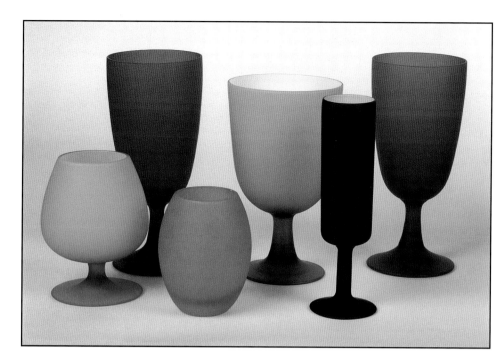

Carlo Moretti
Black *satinato bicolore* water goblets,
ca. 1960s.
Unmarked
Height 9 in; 23 cm.
$35-45 each

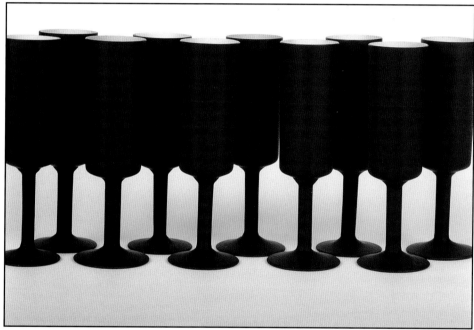

Carlo Moretti
Black *satinato bicolore* wine glasses,
ca. 1960s.
Unmarked
Height 6-3/4 in; 17 cm.
$25-35 each

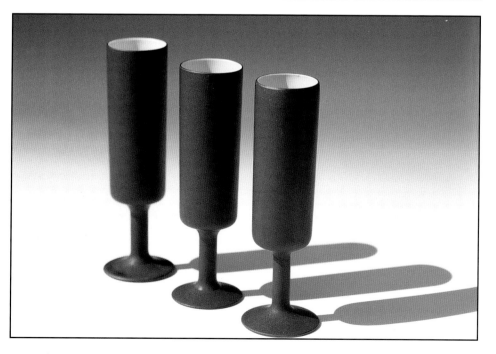

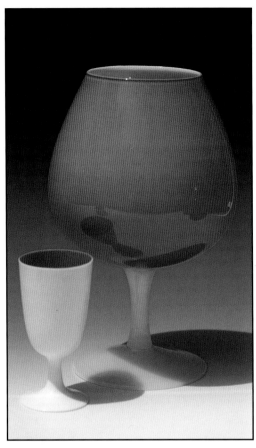

Left:
Carlo Moretti
Black *satinato* compote with clear stem.
Unmarked
Height 7 in; 18 cm.
$40-50

Right:
Carlo Moretti
White over orange *bicolore* Moretti wine glass, ca. 1960, with orange over white oversized brandy snifter with white stem, possibly by Moretti.
Unmarked
Heights 5 & 11 in; 12.5 and 28 cm.
$30-40; $100-125

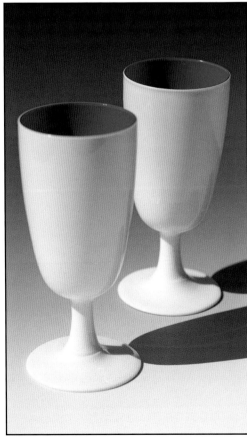

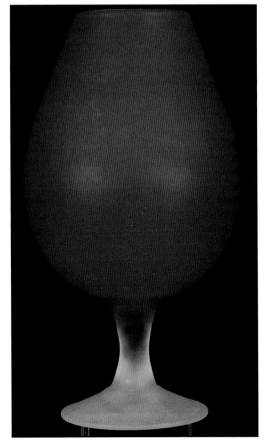

Left:
Carlo Moretti
White over royal blue *bicolore* water goblets, ca. 1960s.
Unmarked
Height 7 in; 18 cm.
$50-75 each

Right:
Carlo Moretti
Orange *satinato bicolore* oversized brandy snifter with clear stem, attributed to Moretti.
Unmarked
Height 13-1/4 in; 33.5 cm.
$100-150

186

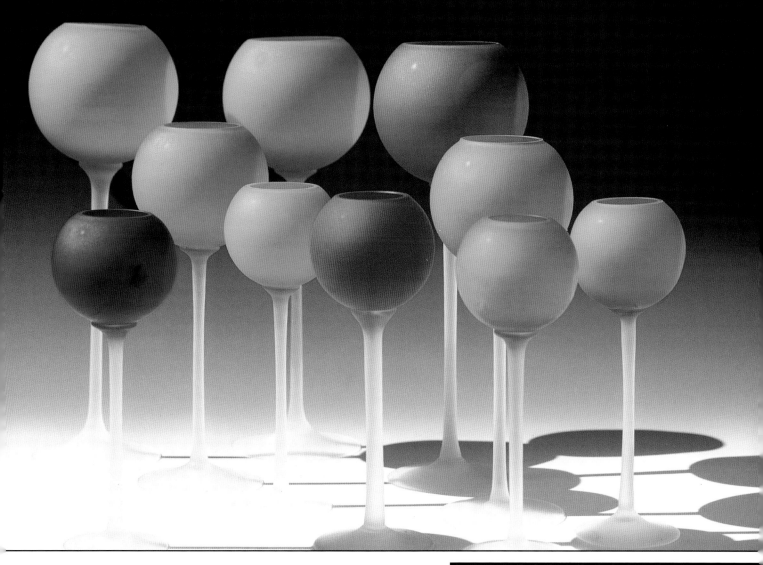

Carlo Moretti
Group of round *satinato* long-stemmed vases in blue, cobalt, green, and orange, ca. 1960s.
Unmarked
Heights 10-1/2, 12-1/2, and 15-3/4 in; 26.5, 32, and 40.5 cm.
$75-150 each

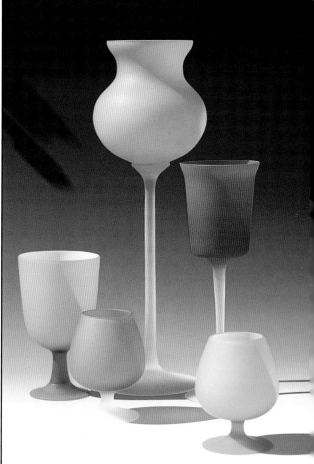

Carlo Moretti
Yellow and orange *satinato* long stemmed vases, shown with small brandy snifters, ca. 1960s.
Unmarked
Heights 16 and 10-1/2 in; 40.5 and 26.5 cm.
Vases $75-150 each

202.101 202.102 202.103

202.107 202.108 202.109

202.104 202.105 202.106

202.110 202.111 202.112

Carlo Moretti *I diversi* designs for the year 2000.
Photos by Sergio Sutto, courtesy of Carlo Moretti

202.113 202.114 202.115

202.116 202.117 202.118

202.119 202.120 202.121

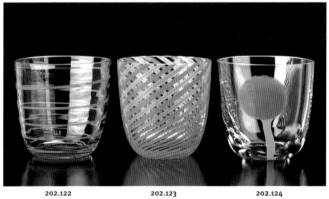

202.122 202.123 202.124

Carlo Moretti designs for the 1990s.
Photos by Sergio Sutto, courtesy of Carlo Moretti

Carlo Moretti designs for the 1990s. *Photos courtesy of Sergio Sutto; courtesy of Carlo Moretti*

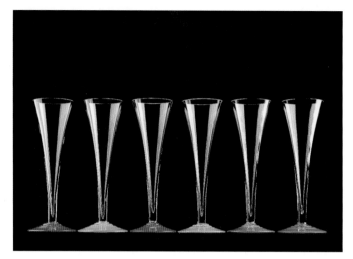
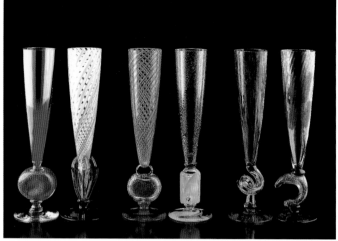
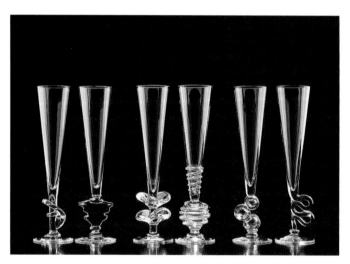
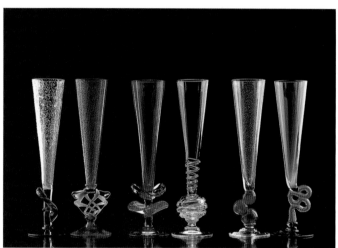
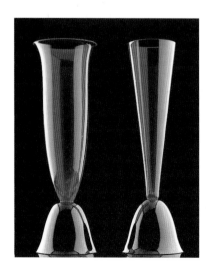
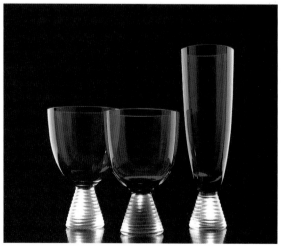
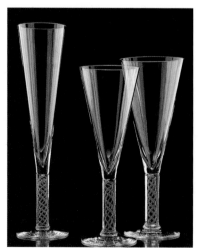

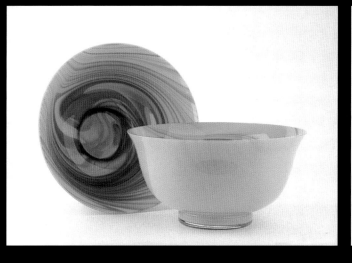
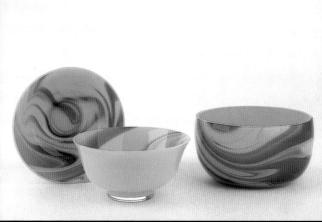
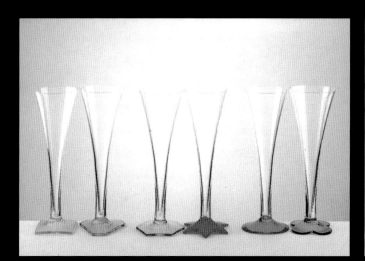
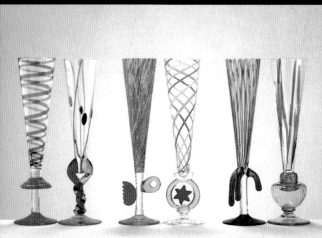
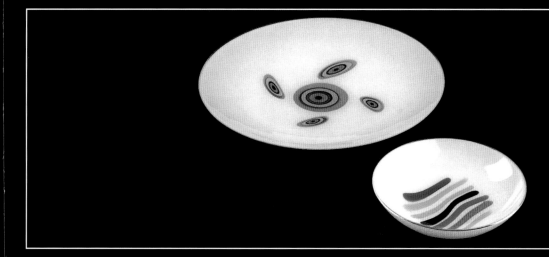

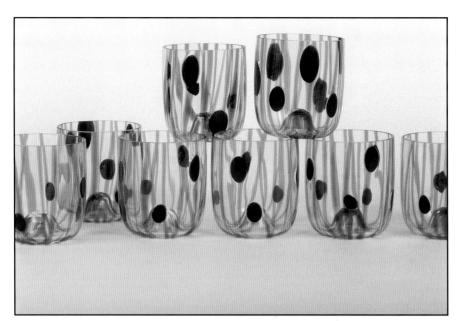

Carlo Moretti
Low *Liberty* tumblers in clear glass with green stripes and purple dots, designed by Carlo Moretti in 1973.
Unmarked
Height 3-1/2 in; 9 cm.
$30-50 each
Courtesy of Lorenzo Vigier

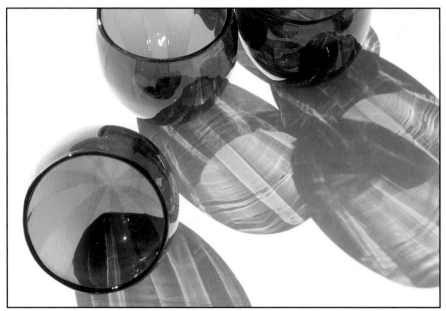

Detail.

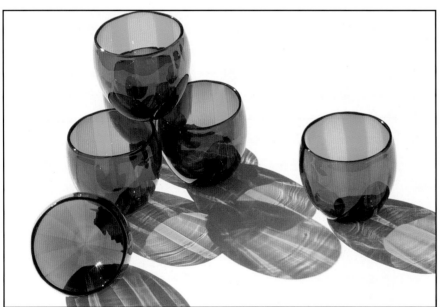

Venini
Five *fasce verticali* rolly polly glasses in green and blue, designed by Fulvio Bianconi.
Unmarked
Diameter 3 in; 7.5 cm.
$40-60 each

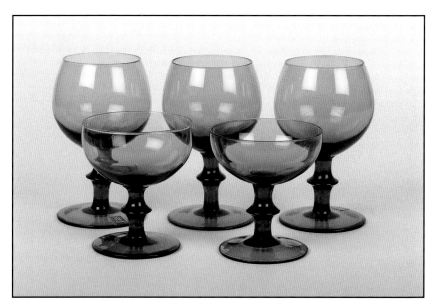

Teal blue goblets and sherbets.
Heights 6-1/4 and 4-1/4 in; 15.5 and 11 cm.
Label Peedee, Handmade in Italy
$10-15 each

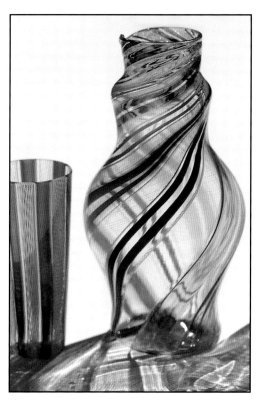

Carafe with stripes of colorful spiral canes and filigree.
Unmarked
Height
$150-200

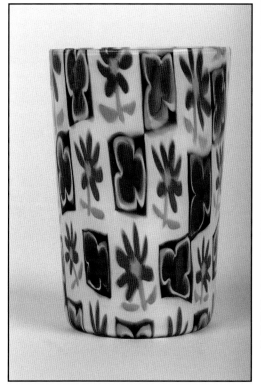

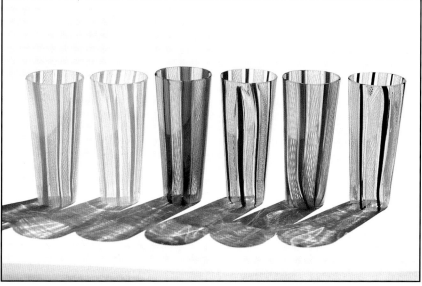

Six tumblers, each with a different color cane stripe and white filigree.
Unmarked
Height
$35-45 each

Barovier & Toso
Tumbler with regular pattern of stylized flower and clover in primary colors on *lattimo* glass.
Unmarked
Height 4-1/2 in; 11.5 cm.
$300-400

193

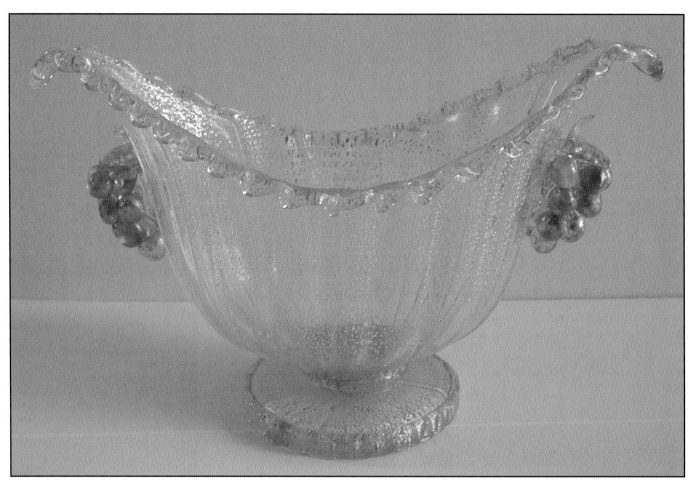

Barovier & Toso
Footed and ribbed console bowl with applied scalloped rim and gold grapes at each stretched end, in clear glass with gold and silver foil, designed by Ercole Barovier, ca. 1940.
Width 10 in. 25.5 cm.
$1,200-1,600
Photo courtesy of PlanetGlass.net

Opaque orange compote with hollow cone foot.
Label, Made in Italy.
Diameter 10-1/4 in; 26 cm.
$100-150

Opaque blue compote with *lattimo* trim and large ball stem with blue and white filigree.
Unmarked
7 x 9-3/4 in; 18 x 25 cm.
$300-400

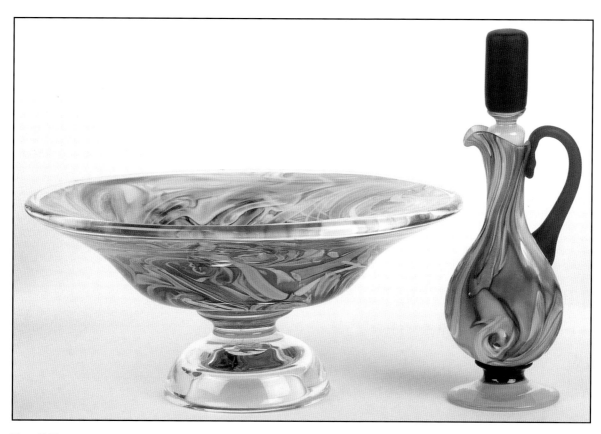

Fratelli Toso
Heavy compote of pastel colors and gold canes swirled in a rich abstract pattern, cased in clear glass, with applied clear foot; with matching cruet with blue satin stopper and handle.
Label, Murano Glass Made in Italy and export label
Diameter 12 in; 30.5 cm; height 10 in; 35.5 cm.
$800-1,000; $300-400

Detail.

Figural, Novelty, Lighting

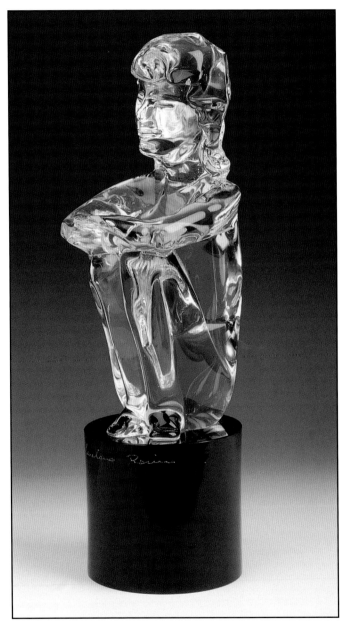
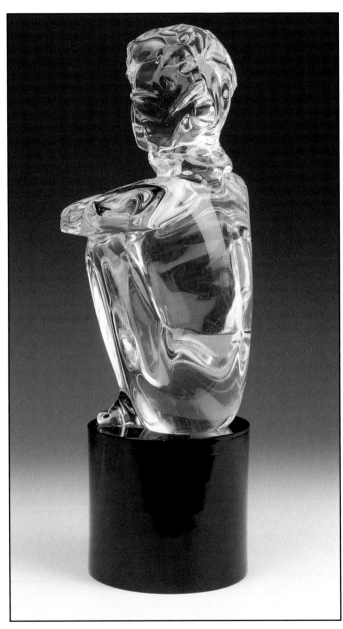

Zanetti
Sculpture of seated nude with arms resting on bent knees, attached to solid cylindrical black base, designed by Loredano Rosin, ca. 1960.
Signed, Loredano Rosin
Height 16-3/4 in; 42.5 cm.
$3,000-4,000

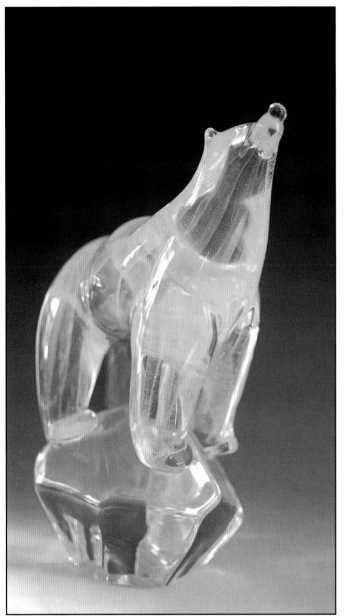
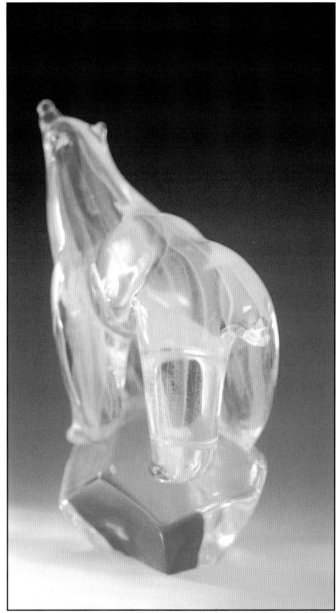

Zanetti
Sculpture of polar bear in opalescent clear glass with internal pattern of small bubbles and lines, standing on an irregular glass rock, designed by Licio Zanetti, ca. 1960s.
Signed, Zanetti L
Height 12-/34 in; 32.5 cm.
$2,000-3,000

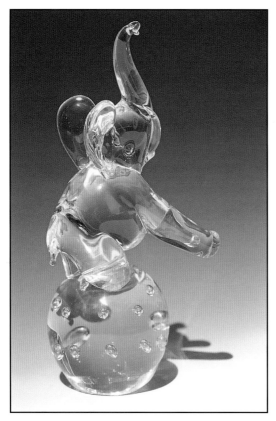

Zanetti
Sculpture of performing elephant on glass ball with bubble inclusions, designed by Licio Zanetti, ca. 1960s.
Signed, Zanetti L
Height 14 in; 35.5 cm.
$1,000-1,500

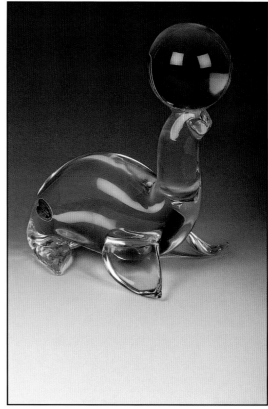

Zanetti
Sculpture of performing seal balancing a glass ball on its nose, designed by Licio Zanetti, ca. 1960s.
Signed, Zanetti L, and foil export label
Height 10 in; 25.5 cm.
$800-1,200

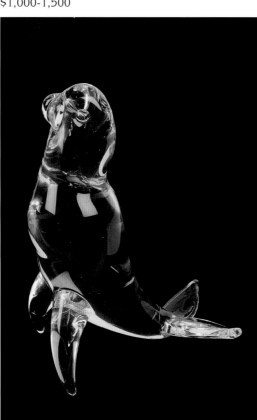

Label

Zanetti
Seal figure in clear glass, designed by Licio Zanetti, ca. 1960s.
Signed, Zanetti L
Height 7 in; 18 cm.
$400-500

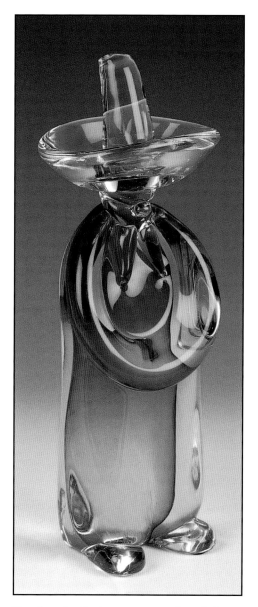

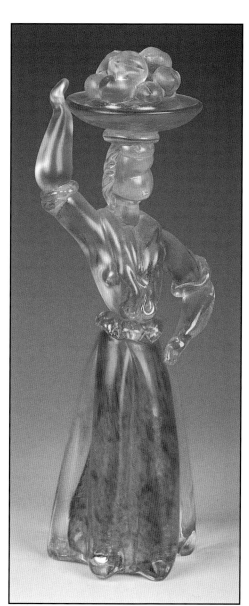

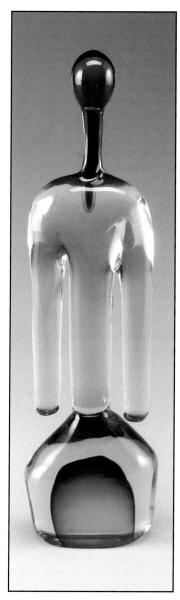

Figurine of a Mexican man in pink and clear *sommerso*, wearing a clear *sombrero*.
Unmarked
Height 10-1/2 in; 27 cm.
$400-500

Archimede Seguso
Figure of a woman holding a bowl of fruit on her head, in clear with gold powders and pink iridescent glass, attributed to Archimede Seguso, c. 1940s.
Unmarked
Height 8-1/2 in; 22 cm.
$400-500

Cenedese
Male figure in stiff posture, in blue, green, and clear *sommerso,* designed by Antonio Da Ros.
Unmarked.
13-1/2 in; 34.5 cm
$1,500-2,500
Photo courtesy of Rago Modern Auctions

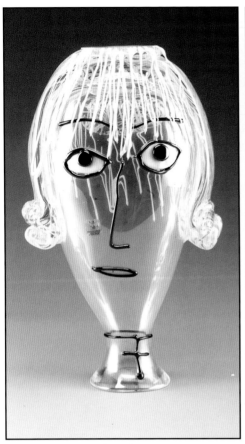

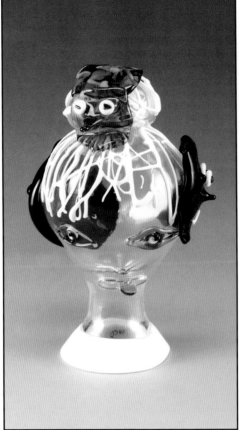

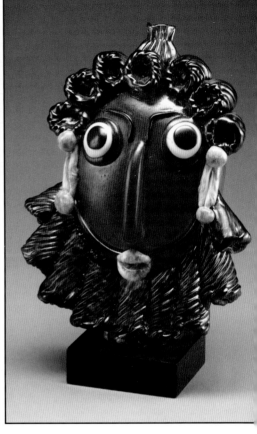

Zanetti
Figural vase of female head in clear glass with applied black and white features and hair, designed by Fulvio Bianconi.
Oggetti import label
Height 17 in; 43 cm.
$4,000-6,000
Photo courtesy of Rago Modern Auctions

Seguso Vetri d'Arte
Figural sculpture with applied masks of the *Comedia Dell'Arte,* in turquoise, cobalt, and black on clear ground, designed by Fulvio Bianconi.
Incised Bianconi
11 x 9 in; 28 x 23 cm.
$4,000-6,000
Photo courtesy of Rago Modern Auctions

Pino Signoretto
Sculpture of a bearded rabbi in raspberry with applied blue and white details.
Inscribed script signature.
Height 14-1/2 in; 37 cm.
$2,000-3,000
Photo courtesy of Rago Modern Auctions

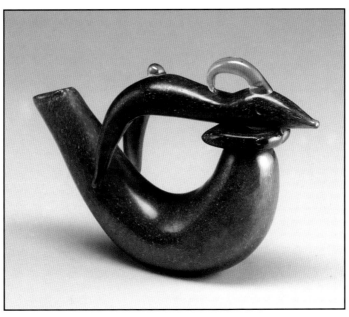

Barovier & Toso
Green chimera vessel from the *Eugenio* series, designed by Ercole
Barovier in 1951.
Unmarked
7 x 9-1/4 in; 18 x 23.5 cm.
$2,500-3,500
Photo courtesy of Rago Modern Auctions

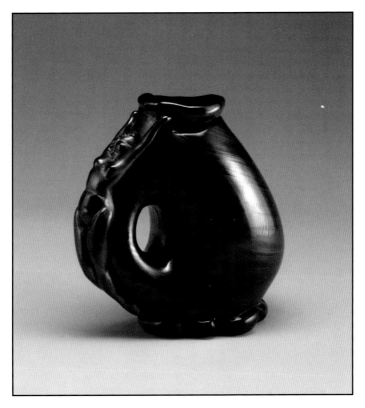

Cenedese
Organic form vessel of black and blue iridescent glass, with one
hole and outstretched female nude, designed and executed by
Alfredo Barbini.
Unmarked.
9 x 8-1/2 in; 23 x 21.5 cm.
$10,000-12,000
Photo courtesy of Rago Modern Auctions

Alfredo Barbini
Corroso sculpture of horse head in black glass with gold patches, on original illuminated stand. Unmarked.
13 x 18 in; 33 x 46 cm.
$8,000-12,000
Photo courtesy of Rago Modern Auctions

Cenedese
Scavo glass sconce with applied figural decoration titled *La Fornace,* from the *La Lavorazione Del Vetro* series, designed by Napoleone Martinuzzi, ca. 1953.
12 x 8 in; 30.5 x 20 cm.
$6,000-8,000
Photo courtesy of Rago Modern Auctions

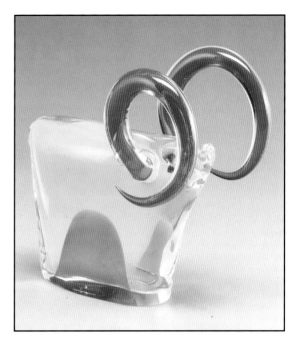

Alfredo Barbini
Corroso figure of a bull, in amber and clear glass.
Unmarked
7-1/2 x 13 in; 18 x 33 cm.
$1,800-2,200
Photo courtesy of Rago Modern Auctions

Cenedese
Stylized yak figure in orange and vaseline *sommerso* with orange swirling horns, designed by Antonio Da Ros.
Unmarked
9 x 9 in; 23 x 23 cm.
$800-1,200
Photo courtesy of Rago Modern Auctions

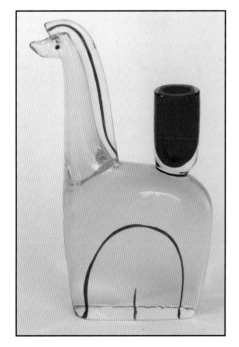

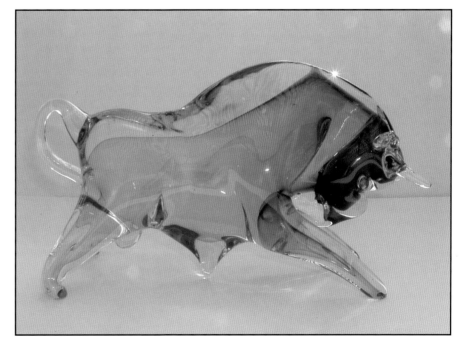

Cenedese
Figural horse in vaseline with red details, with red candle holder attached to its back, attributed to Antonio Da Ros for Cenedese.
Unmarked
Height 9-1/2 in; 24 cm.
$1,500-2,000
Collection of M. Lacis, photo courtesy of Geoff Clarke

Sommerso bull figurine in green, vaseline, and clear glass.
Unmarked
Length 12 in; 30.5 cm.
$500-700
Photo courtesy of PlanetGlass.net

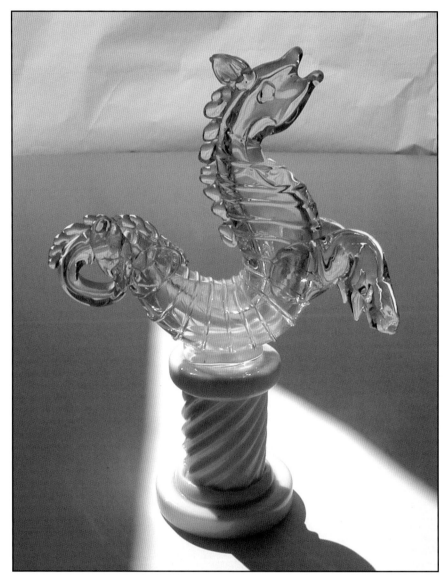

Venini
Hippocampe (sea horse) figure on pedestal base, in crystal with gold leaf, part of a table centerpiece of nine separate marine figures, designed by Napoleone Martinuzzi ca. 1926.
Unmarked
Height 7 in; 18 cm.
$2,500-3,500
Photo courtesy of PlanetGlass.net

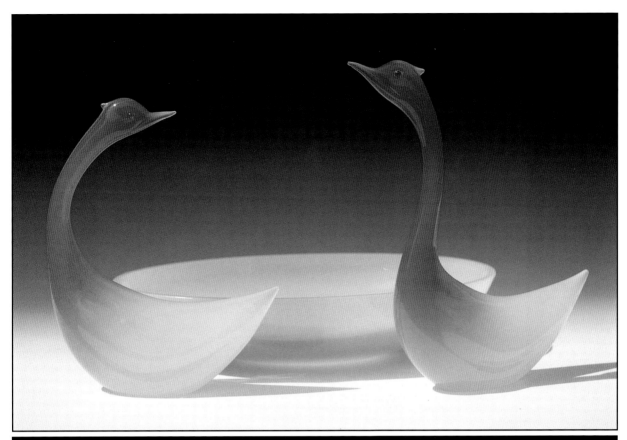

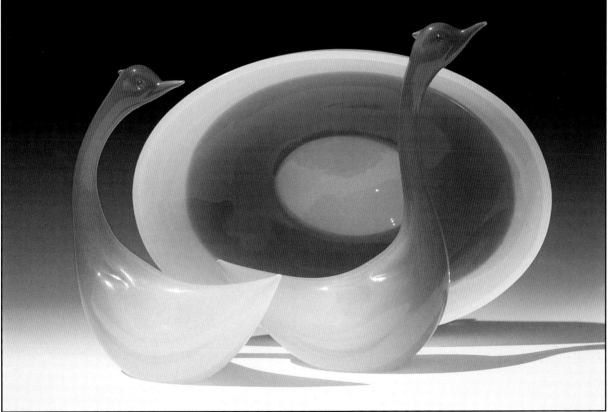

Archimede Seguso
Figural water birds in orange and white *alabastro* glass, shown with matching bowl,
designed by Archimede Seguso, ca. 1959.
Unmarked
Height 9-1/2 in; 24 cm.
$600-800 each

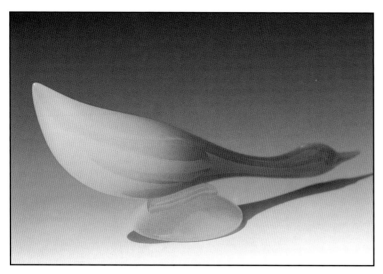 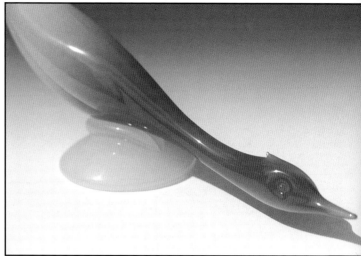

Archimede Seguso
Figural water bird in rose and white *alabastro* on white stand, designed by Archimede Seguso, ca. 1959.
Unmarked
Length 15 in; 38 cm.
$600-800

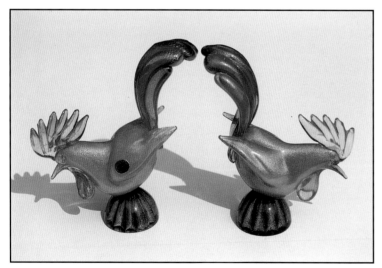

Archimede Seguso
Pair of colorful cocks, each with gold powders, blue tail and tall crest on stand.
Label, Archimede Seguso Made in Murano Italy
Height 8 in; 20 cm.
$250-350 each

Label

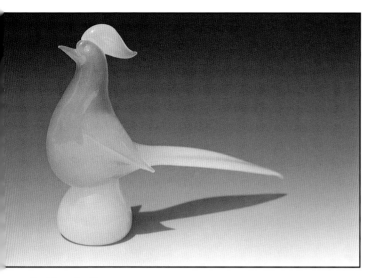

Archimede Seguso
Male bird in rose, standing on white *alabastro* stand.
Unmarked
Length 11-1/4 in; 30 cm.
$400-600

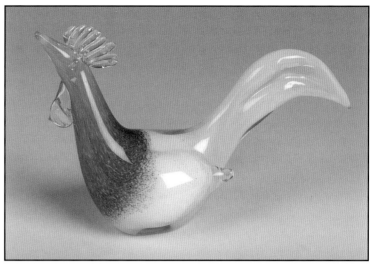

Fratelli Toso
Blue, yellow, and white rooster with clear crest.
Label, Murano Glass Made in Italy
Length 6-3/4 in; 17 cm.
$200-250

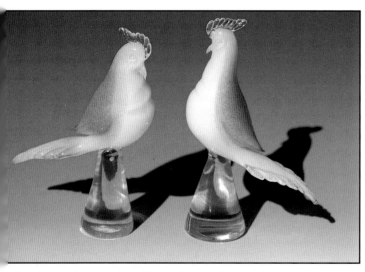

Fratelli Toso
Pair of rose and white roosters on clear conical stands.
Label, Murano Glass Made in Italy
Height 8 in; 20 cm.
$150-200 each

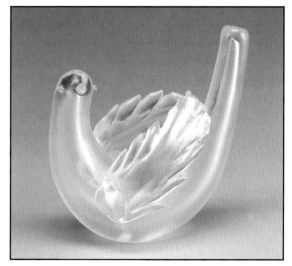

Venini
Corroso glass bird designed by Tyra Lundgren, ca.
1938.
Acid stamp Venini/Murano/Made in Italy
7 x 7 in; 18 x 18 cm.
$800-1,200
Photo courtesy of Rago Modern Auctions

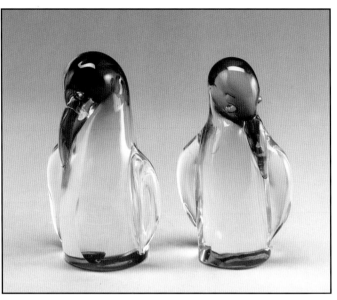

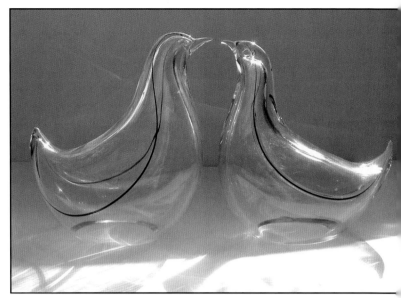

Archimede Seguso
Pair of penguin figures in amber and clear.
Foil labels.
Height 6 in; 15 cm.
$150-200 each
Photo courtesy of Rago Modern Auctions

Livio Seguso
Pair of stylized birds in hollow clear glass, with black stripes, designed by Livio Seguso, who started his own company in 1969.
Signed, Des. L. Seguso
Height 9 in; 23 cm.
$600-800
Photo courtesy of PlanetGlass.net

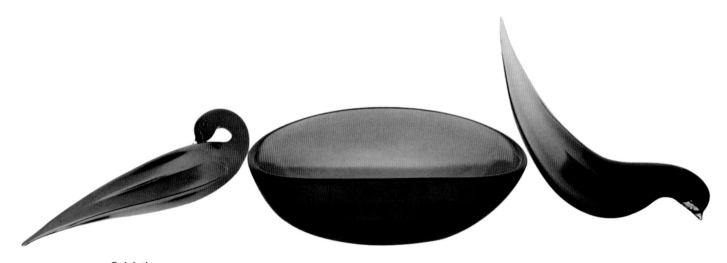

Salviati
Large bowl and two matching birds in cranberry glass cased in pale blue, attributed to Luciano Gaspari.
Paper label
Bowl length 11 in; 28 cm and birds 11-12 in; 28-30 cm.
$700-900
Photo courtesy of PlanetGlass.net

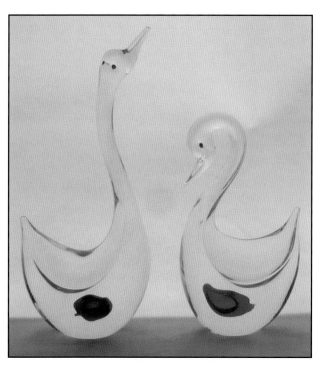

Cenedese
Pair of stylized swans in vaseline glass with applied ruby eyes, each with a single internal bubble trapped in ruby glass.
Unmarked
Heights 8-1/2 and 6-1/2 in; 22 and 16.5 cm.
$200-300 each
Photo courtesy of PlanetGlass.net

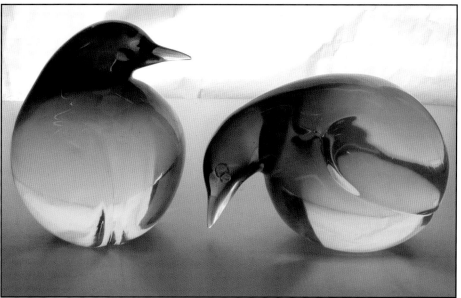

Salviati
Pair of stylized birds in vaseline glass.
Labels
Heights 7 and 5-3/4 in; 18 and 14.5 cm.
$500-800
Photo courtesy of PlanetGlass.net

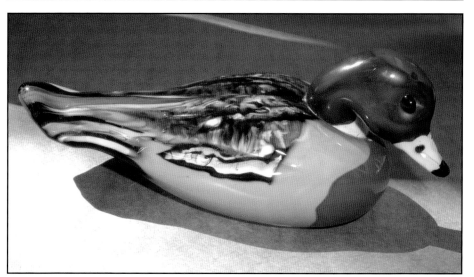

Venini
Cased multi-color duck by master glassblower Cotelli, made for the 1964 Biennale exhibition.
Unmarked
Length 7-1/2 in; 19 cm.
$500-800
Photo courtesy of PlanetGlass.net

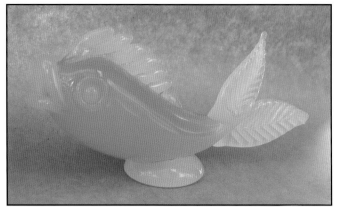

Archimede Seguso
Opaque pale blue and white *opalino* fish figure.
Foil label
Length 7 in; 18 cm.
$150-200
Photo courtesy of PlanetGlass.net

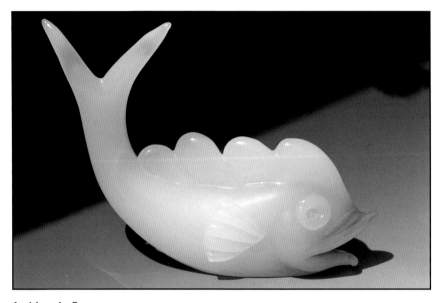

Archimede Seguso
Figural fish with tail up, in white *alabastro* with purple face, designed by
Archimede Seguso, ca. 1959.
Label, Archimede Seguso Made in Murano Italy
Length 10-1/4 in; 26 cm.
$700-900

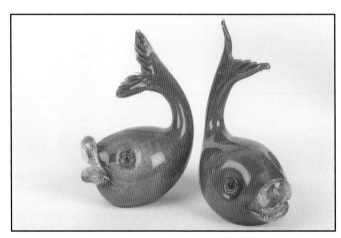

Fratelli Toso
Pair of orange fish with gold powders, raised tail and applied
clear and gold "lips."
Foil label
Height 5 in; 13 cm.
$200-300 pair

Salviati
Pair of stylized fish or birds in clear glass with applied eyes, attributed to Luciano Gaspari, 1950s.
Height 15 in; 38 cm.
$700-900
Photo courtesy of PlanetGlass.net

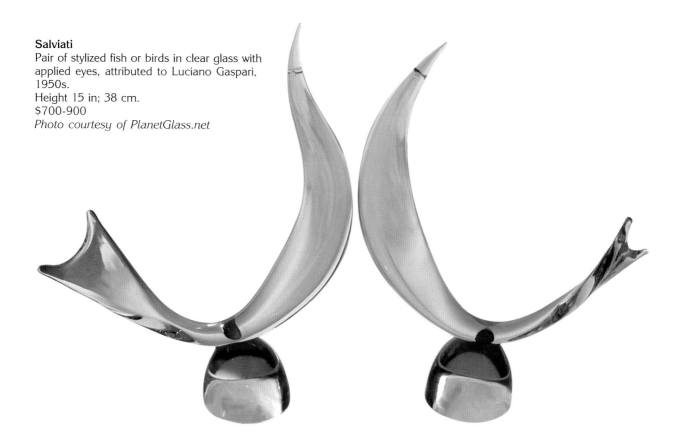

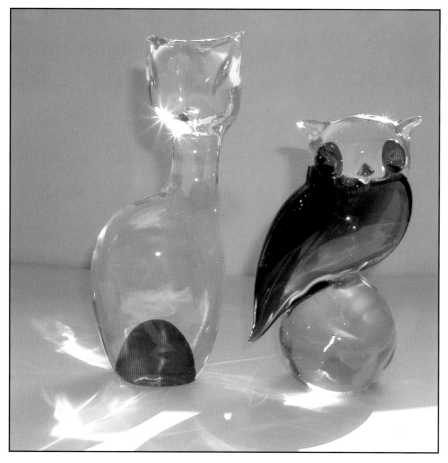

Cenedese
Stylized cat figure in vaseline glass with red core and blue eyes, attributed to Antonio De Ros; owl with olive wings and applied ruby eyes, on clear base.
Heights 10-1/4 and 6-1/2 in; 26 no 16.5 cm.
Import label
$400-600 and $300-400
Photo courtesy of PlanetGlass.net

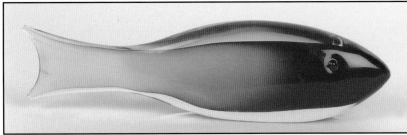

Cenedese
Sommerso fish in red and vaseline, designed by Antonio Da Ros.
Unmarked
Length 11-1/4 in; 28.5 cm.
$1,000-1,500
Courtesy of Lorenzo Vigier

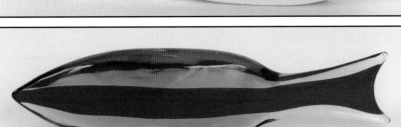

Cenedese
Pink *sommerso* fish red interior extending from the nose to the tail, designed by Antonio Da Ros.
Paper label
Length 19 in; 48 cm.
$3,000-4,000
Courtesy of Geoff Clarke (Australia)

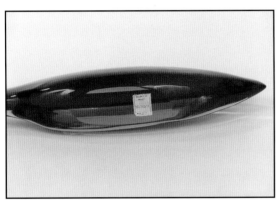

Label

Two pair of angel fish on clear and green conical fluted stands: one in opalescent pink, one in green, possibly by Archimede Seguso, purchased in Murano by an Australian tourist, ca. 1960.
Unmarked
Heights 18-12 and 17-1/4 in; 47 and 44 cm.
$1,000-1,500 each

Opposite page:
Detail.

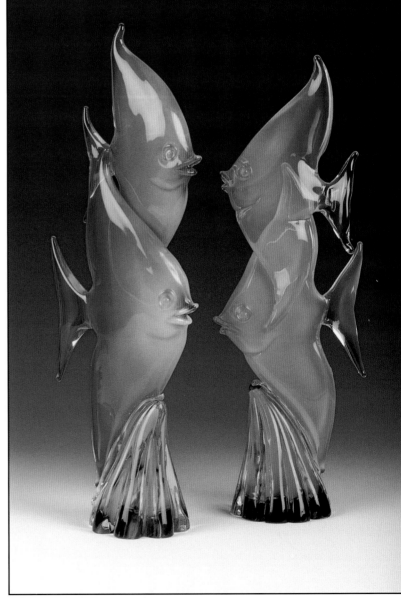

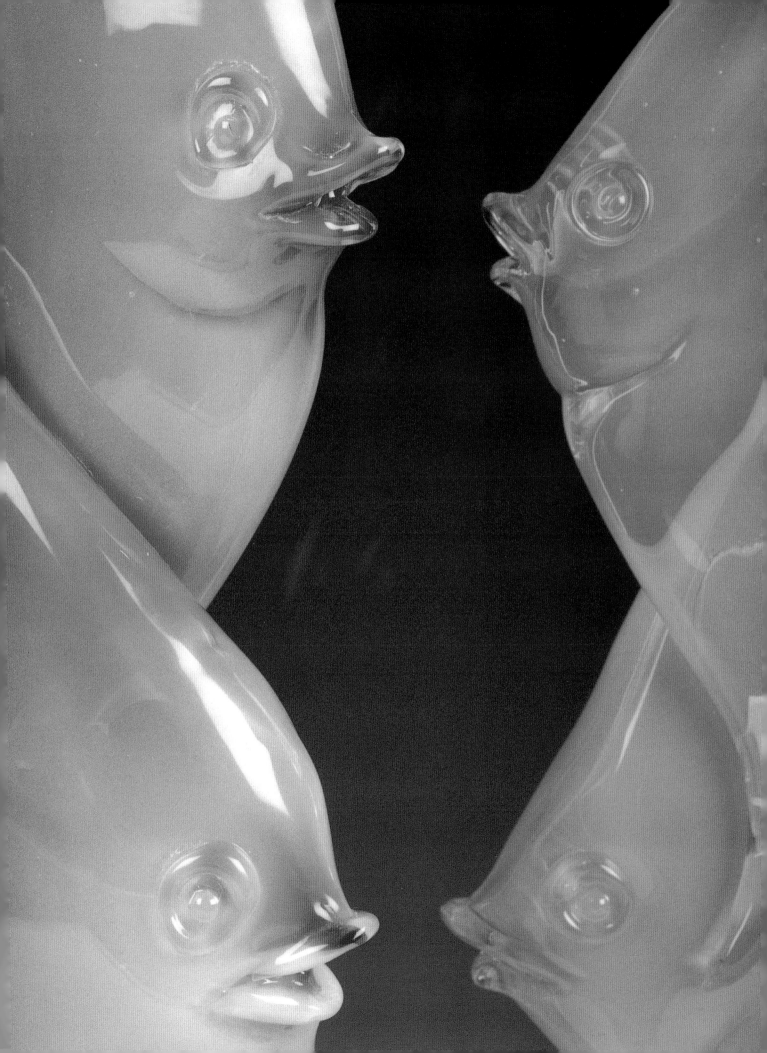

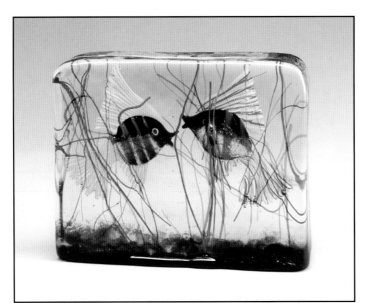

Cenedese
Aquarium block sculpture of clear glass with
internal polychrome fish and marine plants,
attributed to Cenedese.
Unmarked.
7-1/4 x 9 in; 8.5 x 23 cm.
$600-800
Photo courtesy of Rago Modern Auctions

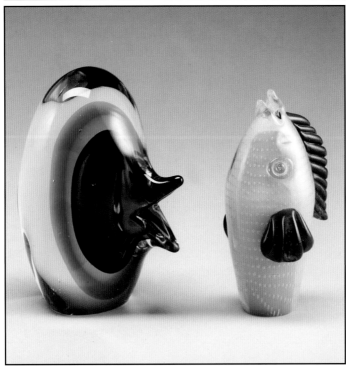

Cenedese
Stylized Cenedese fish in purple and turquoise
sommerso with open mouth; with unidenti-
fied fish in white opalescent with red fins,
likely by Fratelli Toso.
Unmarked.
Heights 6-1/2 and 6 in; 16.5 and 15 cm.
$200-300 each
Photo courtesy of Rago Modern Auctions

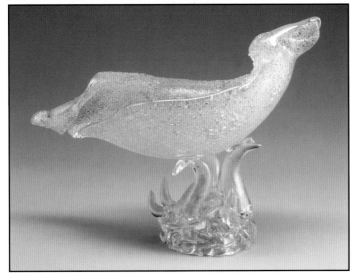

Barovier & Toso
Rugiada seashell mounted on complex foot,
clear glass with gold foil patches, designed by
Ercole Barovier in 1940.
11 x 15 in; 28 x 38 cm.
$4,000-5,000
Photo courtesy of Rago Modern Auctions

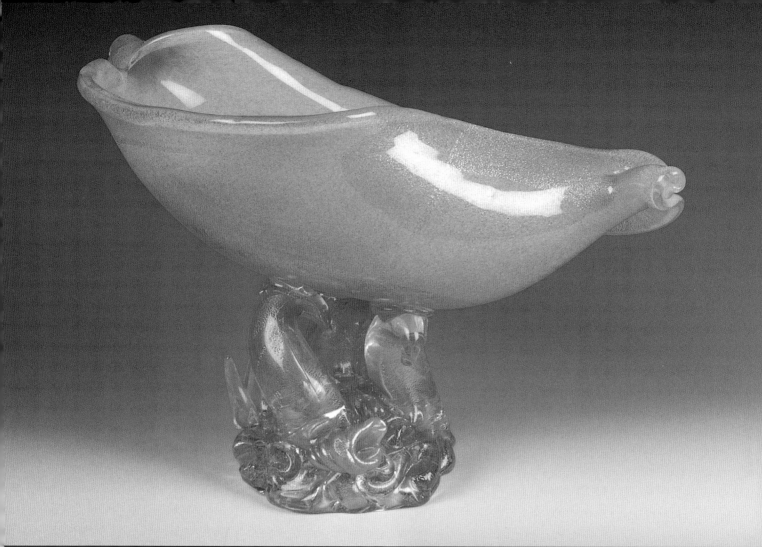

Barovier & Toso

Pink *conchiglia* compote with elaborate clear and gold base in the form of marine vegetation with small pink shell, designed by Ercole Barovier in 1940 and shown in the Biennale of that year.
Remnant of paper label
8-1/2 x 15 in; 22 x 38 cm.
$5,000-6,000

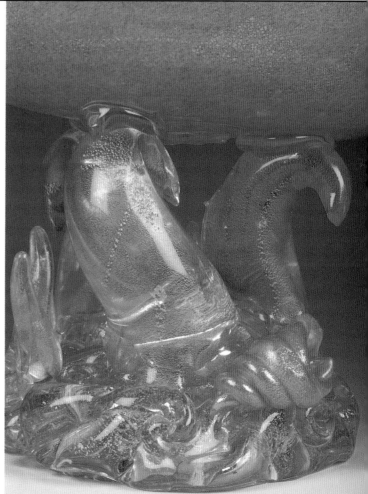

Detail.

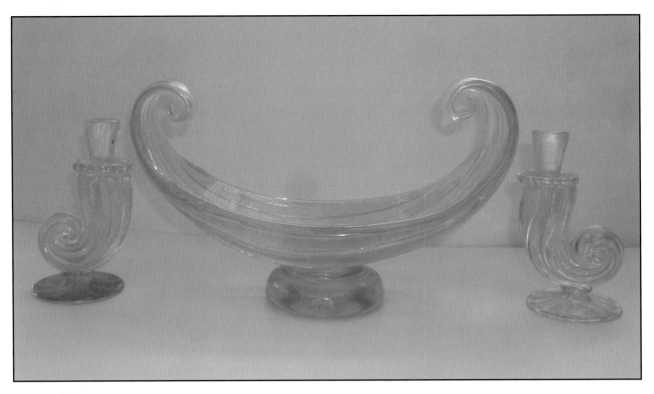

Barovier & Toso
Large console bowl with two candleholders in the form of shells, in clear glass with iridescent finish, attributed to Ercole Barovier, c. 1930s.
Unmarked
Length 14 in; 36 cm and candle height 6-1/2 in; 16.5 cm.
$1,000-1,500 set
Photo courtesy of PlanetGlass.net

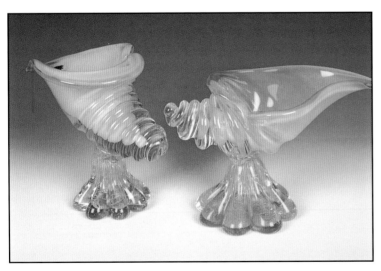

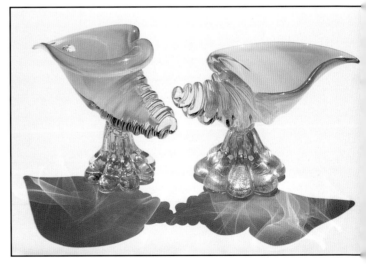

A.VE.M.
Pair of pink opalescent seashells cased in clear glass, mounted on ribbed pedestal with gold inclusions.
Label remnant.
Lengths 10-1/2 and 11 in; 26 and 28 cm
$1,000-1,500 each
Courtesy of Lorenzo Vigier

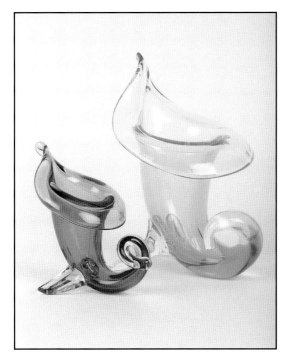

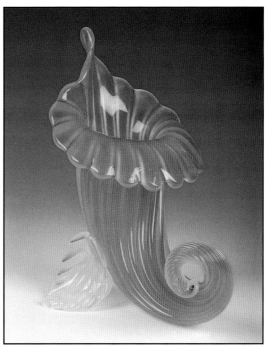

Archimede Seguso
Sommerso cornucopias with applied feet in combinations of amethyst and light blue and aquamarine and clear glass, designed by Archimede Seguso ca. 1956.
Label
Length 8-11 in; 20-28 cm.
$500-900 each
Courtesy of Lorenzo Vigier

Archimede Seguso
Alabastro cornucopia with an internal layer translucent pink glass, cased with twisted and externally ribbed translucent white glass, and applied feet in translucent white glass; designed by Archimede Seguso ca. 1958.
Signed Archimede Seguso Murano
Length 11 in; 28 cm.
$800-1000
Courtesy of Lorenzo Vigier

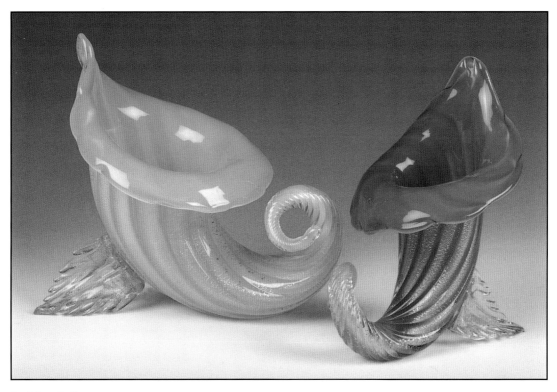

Archimede Seguso
Opalino cornucopias with an internal layer of (light and deep) blue opaline glass with gold foil, cased with twisted and externally ribbed clear glass, and applied feet in clear glass with gold foil. Designed by Archimede Seguso ca. 1955.
Labeled
Length 9-11 in; 23-28 cm.
$600-900 each
Courtesy of Lorenzo Vigier

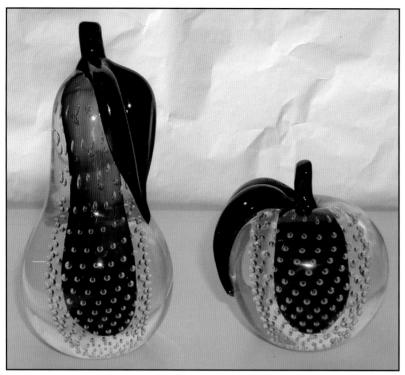

Pear and apple *bullicante* paperweights or book-
ends in lime green vaseline glass with deep red
interiors and applied leaves and stems.
Heights 8-1/2 and 5-1/4 in; 21.5 and 14 cm.
$300-500 pair
Photo courtesy of PlanetGlass.net

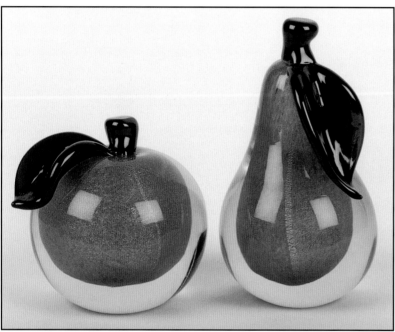

Archimede Seguso
Sommerso apple and pear, each with gold center
cased in clear, with applied dark green leaf; Barbini
made similar pieces.
Unmarked
Height 6 in; 15 cm.
$100-150 each

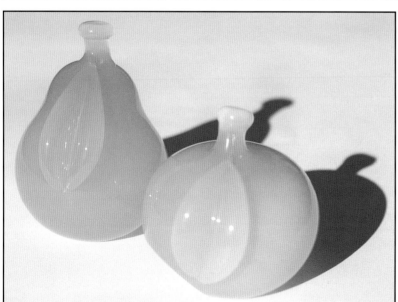

Archimede Seguso
Yellow and white *alabastro* paperweights in the
form of a pear and apple, designed by Archimede
Seguso, ca. 1959.
Unmarked
Heights 6 and 4-1/2 in; 15 and 11.5 cm.
$250-300 each

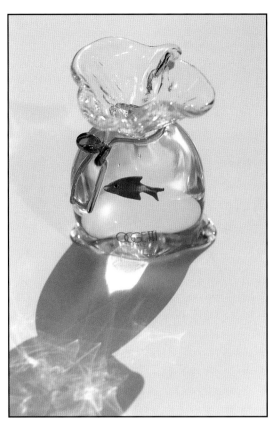

Zanetti
Goldfish in a bag with blue
string,, late 20th century.
Oggetti import label
Height 4-1/2 in; 11 cm.
$30-40

Archimede Seguso
Yellow lemon with green
stem, designed by Archimede
Seguso.
Unmarked
Length 9 in; 23 cm.
$100-150
Courtesy of Lorenzo Vigier

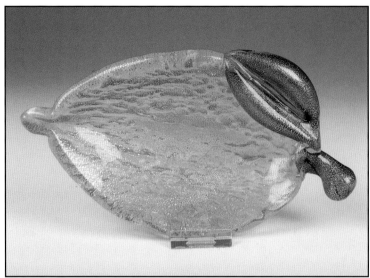

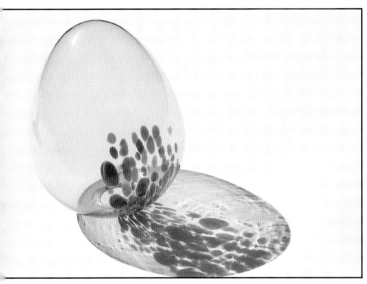

Venini
Glass egg with bottom opening, in pale yellow with red spots,
attributed to Ludovico Diaz de Santillana, ca. late 1960s.
Diamond point, Venini Italia
Height 7-1/2 in; 19 cm.
$500-700
Courtesy of Lorenzo Vigier

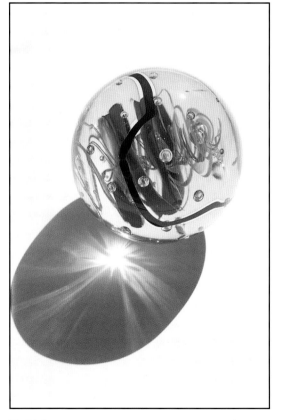

Barbini
Paperweight orb with abstract painterly design in
red and cobalt, with black line, and bubbles,
designed by Alfredo Barbini, ca. 1955.
Signed, Alfredo Barbini
Diameter 5 in; 12.5 cm.
$500-700
Courtesy of Michael Ellison

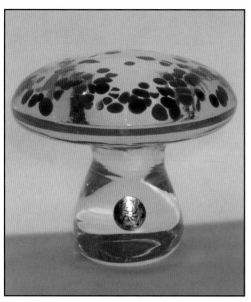

Mushroom in vaseline glass with cherry red spots.
Murano labels
Height 2-1/2 in; 6 cm.
$50-100
Photo courtesy of PlanetGlass.net

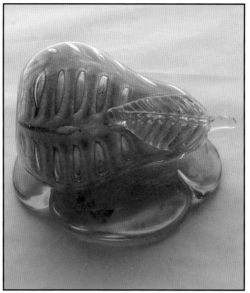

Barovier & Toso
Paperweight in the form of a pear in green, white, and gold on aqua base.
Unmarked
Length 5 in; 13 cm.
$200-250
Photo courtesy of PlanetGlass.net

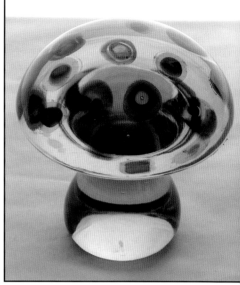

Cenedese
Alexandrite mushroom with colorful *murrine* spots, attributed to Cenedese.
Height 4 in; 10 cm.
$100-150
Photo courtesy of PlanetGlass.net

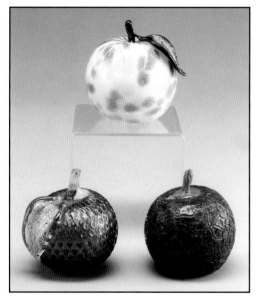

Glass fruits, ca. 1930s.
Unmarked
3-1/2 and 4 in; 9 and 10 cm.
$100-150 each
Photo courtesy of Rago Modern Auctions

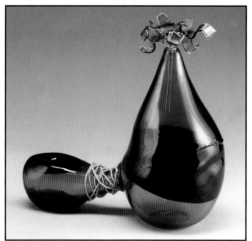

Salviati
Gourd-like sculpture of amber and black glass with floral stopper, designed by Luciano Gaspari.
Incised, Salviati.
12 x 12 in; 30.5 x 30.5 cm.
$3,000-4,000
Photo courtesy of Rago Modern Auctions

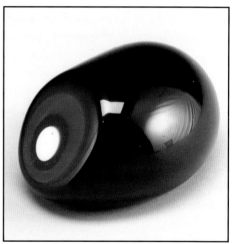

Vistosi
Sommerso paperweight with concentric rings of white, olive, and black.
Etched signature.
2 x 4 in; 5 x 10 cm.
$300-400
Photo courtesy of Rago Modern Auctions

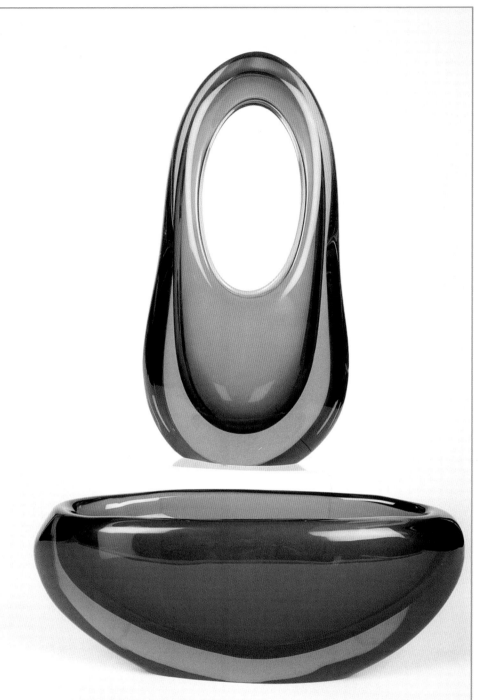

Basket shown with matching bowl.

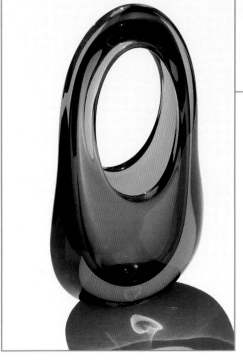

Archimede Seguso
Heavy *sommerso* basket in green cased with amber,
designed by Archimede Seguso.
Unmarked.
Height 14-1/2 in; 37 cm.
$1,500-2,000
Courtesy of Lorenzo Vigier

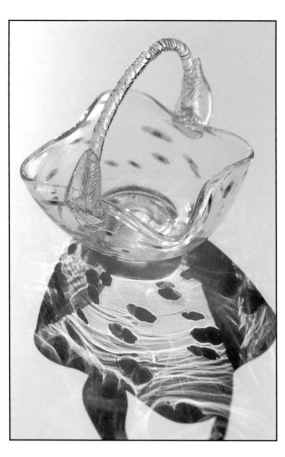

Early 20th century basket of clear glass with gold powder and *murrines*, applied glass rope handle with leaf at each end.
Unmarked
Height 7-1/2 in; 19 cm.
$300-500

Detail.

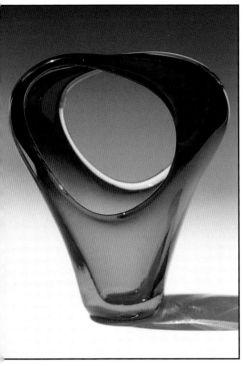

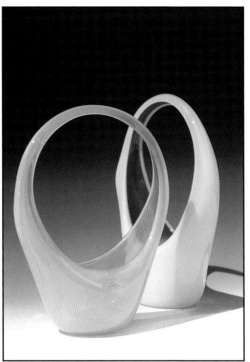

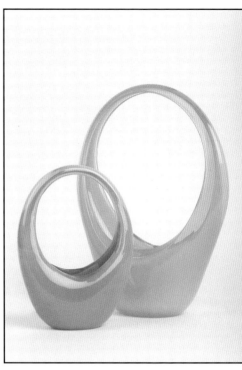

Fratelli Toso
Sculptural *sommerso* basket with wide twisted handle, in red, blue, and green.
Unmarked
Height 8-1/2 in; 21.5 cm.
$300-400

Fratelli Toso
Opalescent baskets with large circular opening, white cased over yellow and red, ca. 1950s.
Paper label, Made in Italy
Height 12-1/2 in; 32 cm.
$300-400 each

Smaller in bluish opalescent basket, with yellow and white to show scale.
Unmarked
Height 8-1/4 in; 21 cm.
$150-200

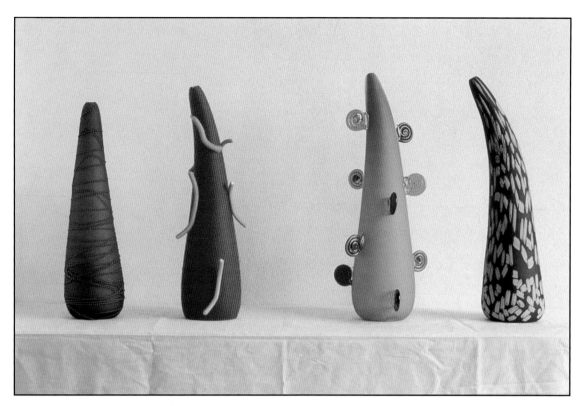

Memphis
Memphis Extra, *Dhritara, Virinda, Vimpa,* and *Vaisra* horn-shaped sculpture, each in a distinct colorful
decoration, designed by Andrea Anastasio in 1991.
Heights 18-1/2 in; 47 cm.
$1,000-1,500 each

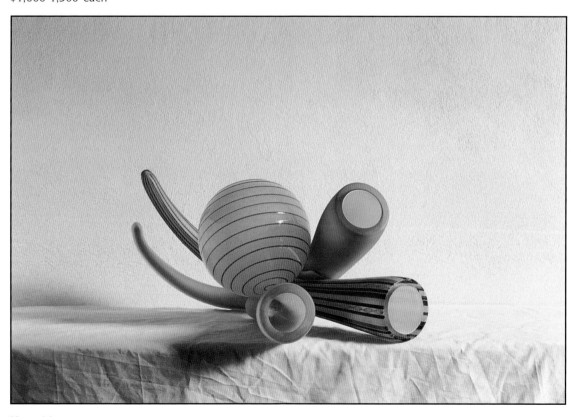

Memphis
Memphis Extra, *Chepaer* sculpture with striped ball and three horn shaped parts, designed by
Andrea Anastasio in 1991.
9-1/2 x 21-1/4 in; 24 x 54 cm.
$2,000-2,500

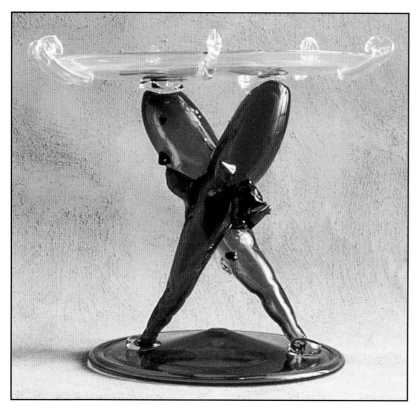

Memphis
Memphis Extra, *Era* compote with blue base and red and green diagonal overlapping supports, designed by Luigi Serafini in 1991.
Height 11-1/2 in; 29 cm.
$2,000-2,500

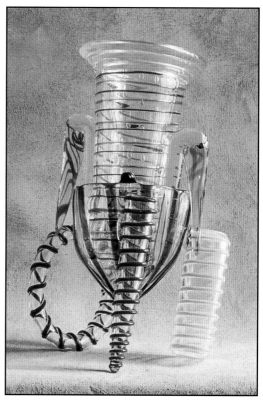

Memphis
Memphis Extra, *Rom* sculpture of clear glass parts with applied colorful ropes, designed by Luigi Serafini in 1991.
Height 16-1/2 in; 42 cm.
$2,000-2,500

All Memphis photos are courtesy of Memphis

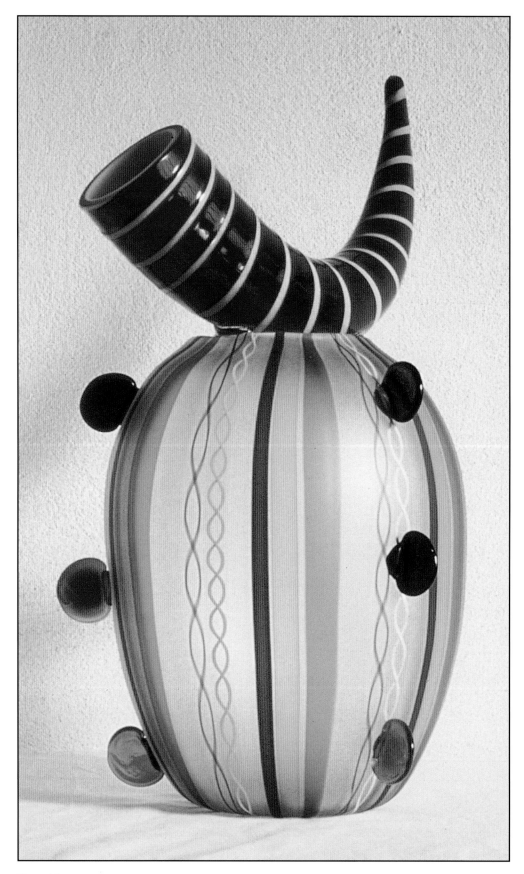

Memphis
Memphis Extra, *Nilo* sculpture of striped melon-form with applied appendages and striped horn on top, designed by Andrea Anastasio in 1991.
Height 17-1/4 in; 44 cm.
$2,000-2,500

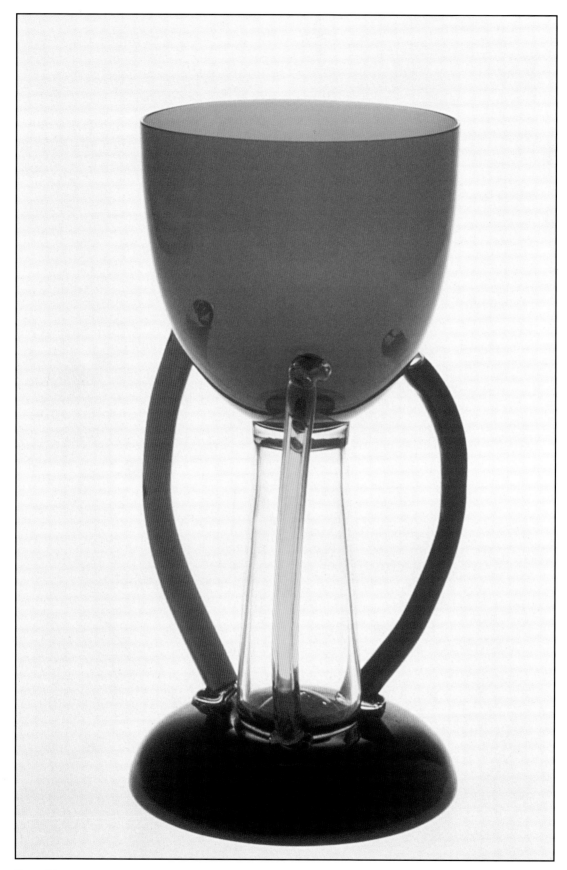

Memphis
Memphis Extra, *Deneb* sculptural chalice of blue vessel connected to the base with three colored tubes, designed by Ettore Sottsass in 1982.
Height 9 in; 23 cm.
$2,500-3,000

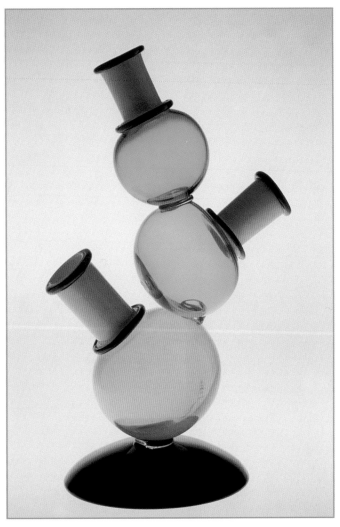

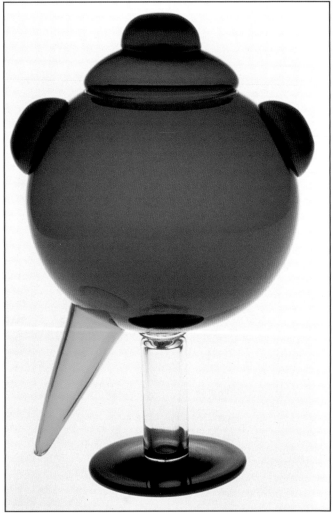

Memphis
Memphis Extra, *Antares* sculpture with green, blue, and yellow balls with applied pipes, designed by Michele De Lucchi in 1983. Height 18-1/2 in; 47 cm.
$2,500-3,000

Memphis
Memphis Extra, *Rigel* sculpture of covered blue and red vessel on clear stem with one conical green leg, designed by Marco Zanini in 1982.
Height 13-3/4 in; 35 cm.
$2,000-2,500

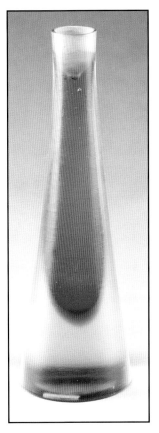

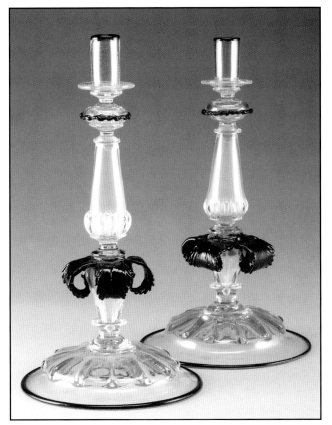

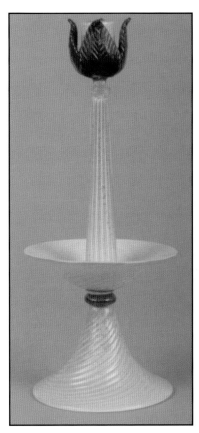

Venini
Inciso tapered candle
holder in amber
sommerso, designed by
Paolo Venini, ca. 1950.
Acid stamp Venini/Murano/
Italia
Height 9-1/2 in; 24 cm.
$600-800
*Photo courtesy of Rago
Modern Auctions*

Venini
Soffiati candle holders with applied black leaves, attributed
to Vittorio Zecchin.
Unmarked
Height 17 in; 43 cm.
$3,000-4,000 pair
Photo courtesy of Rago Modern Auctions

Candle holder of *lattimo* glass with
gold powders, reeded column and
swirled conical base, with four
brown and gold leaves.
Unmarked
Height 13 in; 33 cm.
$200-300

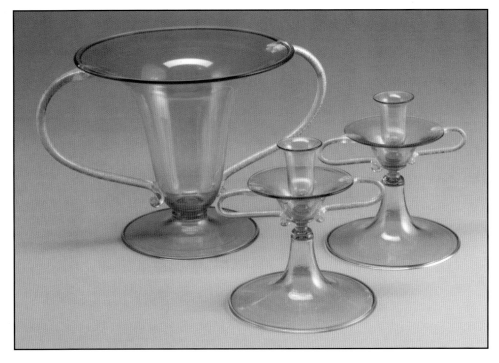

Venini
Libelulla console set of blue glass
with gold handles, pair of candle
holders and compote, designed by
Vittorio Zecchin, early 1920s.
Unmarked.
Console 7- 3/4 x 12-1/2 in; 19.5 x
32 cm.
$2,000-2,500 set
*Photo courtesy of Rago Modern
Auctions*

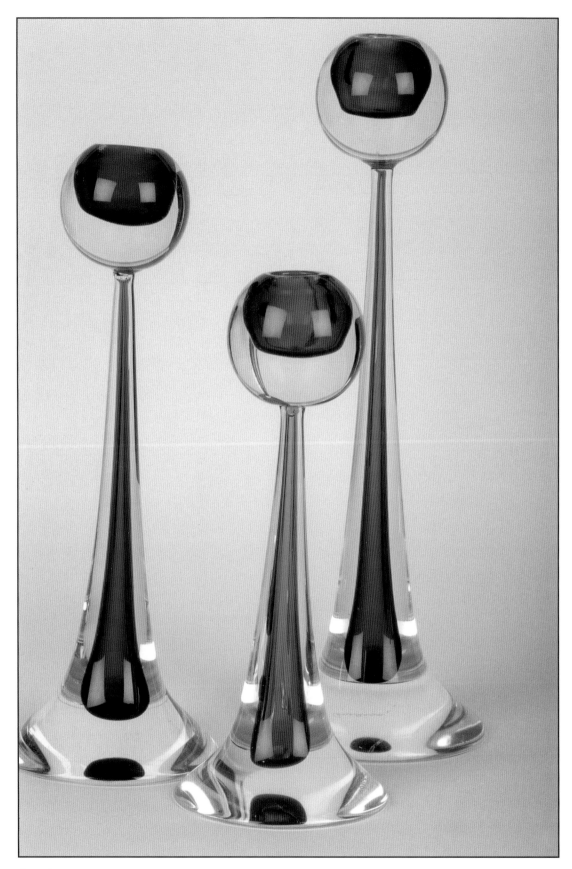

Cenedese
Sommerso candle holders of brown cased in clear glass, round tops and long exaggerated conical base.
Signed, Cenedese
Heights 12-1/4, 10-1/4, and 14-1/2 in; 31, 26, and 37 cm.
$400-600 each

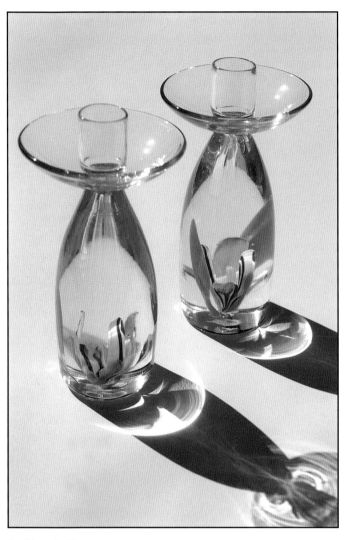

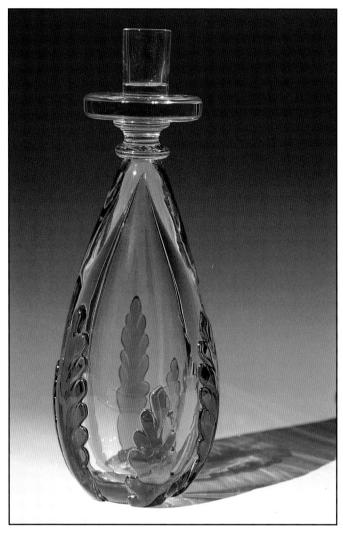

Archimede Seguso
Pair of paperweight candle holders with internal canes in flower motif, designed by Archimede Seguso.
Round foil label, Made in Murano Italy
Height 7 in; 18 cm.
$300-400 each

Archimede Seguso
Heavy clear glass candle holder with applied green leaves, designed by Archimede Seguso as a presentation piece for photographer Herb Ritts.
Signed Archimede Seguso with inscription to Ritts.
Height 15-1/2 in; 39.5 cm.
$1,000-1,500

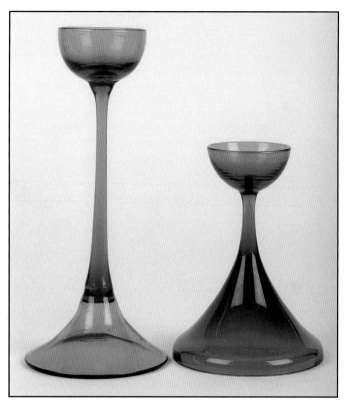

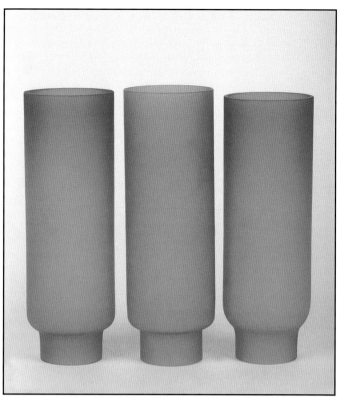

Long-stemmed holders for round candles, designed by Cari Zalloni. His design for German firm WMF (right) is heavier and finer quality than the Italian version (left).
Some with WMF or Made in Italy label
Heights
$40-60 each

Carlo Moretti
Three hurricane shades in green satin glass.
Sunset 64 import label
Height 7-1/2 in; 19 cm.
$20-30 each

Carlo Moretti
Red and white marbleized glass table lamp in the form of a mushroom.
Unmarked
Height 8 in; 20 cm.
$100-150

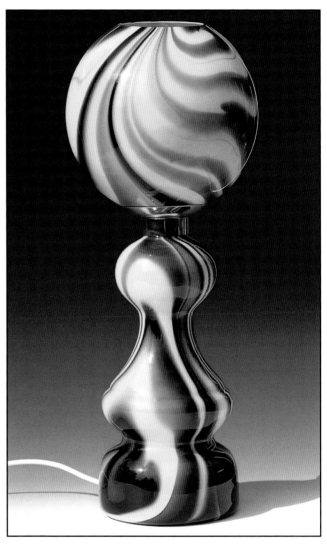

Carlo Moretti
Table lamp in red and white marble glass, shown with vase to show
scale, 1960s.
Gold label
Glass height 12-1/2 in; 32 cm.
$300-400

Carlo Moretti
Large table lamp in two parts joined by a metal strap, round
top and three-section base, in brown and yellow marble glass,
ca. 1980s.
Black label
Height 24 in; 61 cm.
$500-700

Venini
Orange cased table lamp, designed by Massimo Vignelli in 1955. Unmarked
Height 7-3/4 in; 19.5 cm.
$300-400

Label

Lattimo swirl table lamp in the shape of a mushroom, late 20th century.
Label, Vetri VM Murano
Height 14 in; 35.5 cm.
$150-200
Courtesy of Michael Ellison

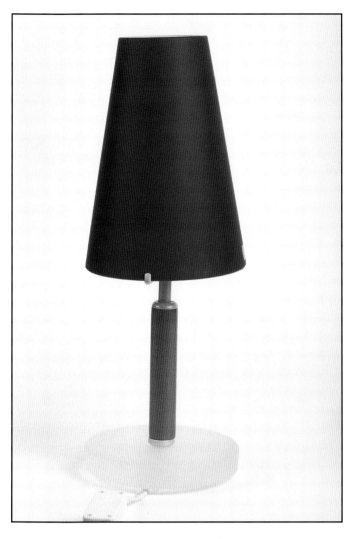

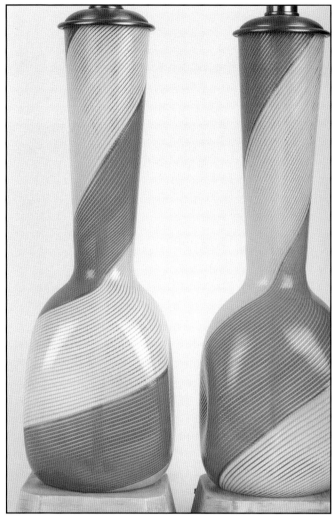

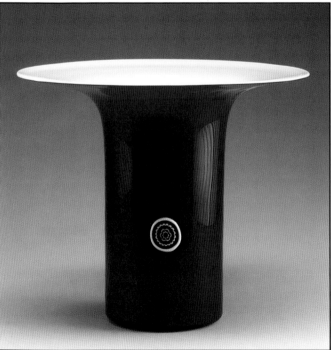

Top left:
Table lamp with clear satin glass base, fruitwood column, and cased shade in deep cobalt over white.
Label remnant
Height 15-1/2 in; 39.5 cm.
$250-350

Top right:
Aureliano Toso
Pair of table lamps in groups of white and pink *mezza filigrana* with intermittent gold stripe.
Unmarked
Height of glass 13-3/4 in; 35 cm.
$500-700 each

Vistosi
Large hanging fixture in cobalt cased over white, with single large *murrine*.
Unmarked
14 x 15 in; 35.5 x 38 cm.
$600-800
Photo courtesy of Rago Modern Auctions

Glossary

Ending vowels of Italian words — a, e, i, o — do not change the general meaning, but indicate the specific language usage. For example, *vaso inciso* or *coppa incisa*. Since many of these terms refer to types of glass, the ending "o" from *vetro* (glass) is commonly used, ie., *inciso*.

Aborigeno. Color achieved by heating inclusions of metal oxides in a colorless layer of glass.

Abrasion. Powders and mechanical devices remove portions of the surface; engraving, cutting, and carving are decorating methods using abrasion.

Acid. Chemical treatment to alter and decorate the surface; frosting, etching, and deep etching use acid.

Alabastro. Opaque glass resembling alabaster stone.

Ambrato. Decorative surface treatment achieved by covering the surface with silver foil and reheating.

Applicazioni. Application of glass threads or other forms to add three-dimensional decoration to the formed object.

Argentato. Silver foil covers the hot gather of glass and breaks into a crackled pattern.

Aurato. Gold foil covers the hot gather of glass and breaks in to a crackled pattern.

Aventurina, aventurine. In the 15th century aventurine glass achieved its metallic effect by using gold inclusions; since the 17th century the same effect has been accomplished by combining copper particles with the hot glass.

Barbarico. Rough surface created by covering the object with a thick layer of oxides which do not melt or fuse when heated.

Battuto. Beaten glass, in which the surface is mechanically scored or carved with a wheel to create a matte finish with deep incisions.

Bicolore. Cased in thin layers of different color glass.

Bollicine. Tightly packed air bubbles in glass created by introducing chemicals, which when heated, generate the frothy texture.

Bullicante. Air bubbles placed in a regular pattern in the glass; the surface is smooth.

Calcedonio, **chalcedony.** Opaque glass resembling chalcedony, the semi-precious stone and type of agate.

Canne. Glass rods used in striped glass and twisted filigree or sliced so that sections of polychrome patterns can be used in mosaic or *murrine* glass.

Carving. Three-dimensional pattern deeply engraved in heavy glass using sandblasting or other method.

Cased. Two or more layers of different colored glass blown one over the other.

Chemical polishing. Acid mixture is used to dissolve a thin layer of glass.

Coroso. Corroded appearance achieved by treating the surface with acid.

Crackled *(vetro a ghiaccio).* Hot glass is dipped into cool water to produce fine pattern of cracks on the surface, then reheated for stability and smoothness.

Crepuscolo. Steel wool is embedded between layers of glass and creates a brownish thread pattern when burned off.

Cristallo. Italian soda glass using ashes from the burned barilla plant. It is easily worked, clear and transparent, and similar in appearance to rock crystal. It was perfected by Angelo Barovier in the mid 15th century and called *cristallo.*

Dorico. Large square *murrines* fused into the glass.

Egeo. Similar to *dorico,* but the *murrines* have perforated edges.

Eugeneo. Coloration achieved by oxides trapped between two layers of transparent glass.

Fasce. Wide glass bands applied to the surface or fused and made into objects.

Fazzoletto. Handkerchief-shaped vase originally designed by Fulvio Bianconi for Venini in 1949 and one of the most typical fifties shapes.

Filigrana, **filigree.** Technique using glass threads or fine canes twisted around a clear cane or embedded in clear glass to produce either fine net-like patterns or parallel threading. Similar terms include *latticino* and *zanfirico.*

Fire polishing. Removal of tool marks and smoothing the surface by reheating with fire.

Giada. Opaque colored object is covered with copper pieces and then enclosed or cased in clear glass.

Gold leaf, silver leaf. Pieces of gold or silver leaf applied to the hot glass break up into flakes of various sizes and minute particles as the vessel is blown.

Granzioli. Applied "grains" of glass giving a textured surface.

Grinding. Abrasive powders and polishing wheels used at high speeds to remove unwanted areas such as pontil marks.

Incamiciato. Thin layers of colored glass are fused (cased) usually with a layer of opaque glass between.

Incalmo. Two gathers of hot glass are fused, permitting the combination of distinct colors or techniques on a

single vessel.

Inciso. Incised glass, in which a wavy effect is created by lightly scoring the surface in one direction.

Inclusion. Glass, bubble, or other material included, or embedded between layers of glass.

Iridato. Iridescent surface created by spraying metal compounds onto the hot glass and reheating.

Latticino. Filigree in stripes or net-like patterns, originally of white glass threads, and later to include colors, and among the most distinctive techniques used in Murano.

Lattimo. Opaque white glass, or milk glass (*latte* = milk), resembles porcelain when used to case or form a vessel; also used in various filigree techniques.

Merletto. There are two versions of this lacework design: one, developed by Archimede Seguso in 1952, is a type of *latticino* using fine threads of glass; the other, by Venini, produces a similar effect by using an acid etching technique.

Mezza filigrana. *Mezza filigrana,* or half filigree, is used for filigree threads running diagonally and parallel to each other, as well as for wider rods creating a diagonal striped pattern.

Millefiori. Type of *murrine* glass, in which slices of multicolored canes are embedded in clear glass to create a "thousand flower" design.

Mold blown. Glass is blown into a wood or metal mold to give it shape and surface decoration.

Mosaico, **mosaic.** Pieces of colored glass, such as *murrine,* are fused into the vessel.

Murrine, **murrhine.** Mosaic technique where colored cane sections are embedded into the hot glass before the piece is blown into its final shape. In ancient Rome "*murra*" referred to an ornamental precious stone used in making vases and other articles, and "*murrini*" was the ancient mosaic glass technique. The terms "*murrina,*" and "*murrine.*" (English "murrhine") were adjectives meaning "made of murra," but in the late nineteenth century were used to describe the ancient mosaic glass. More recently, these terms have also come to be used to describe the mosaic pieces or slices of canes used in the technique.

Off-hand. Free-blown method of forming glass by blowing and manipulating with tools, without the use of a mold.

Opachi, **opaque.** White *(lattimo)* or colored glass that is not transparent or translucent.

Opalino. Transluscent milky glass in white or color.

Pennelate. Brush stroke effect by repeatedly touching the hot surface with colored canes.

Pennelato. "Painted glass," in which swirls of colored glass give the impression of painting.

Pezzato. Literally meaning patchwork, Barovier and Toso and Venini are especially noted for this technique.

Pioggia. Similar to *tessuto,* but rather than narrow stripes of opaque glass, the stripes (canes) are cut and staggered to produce the effect of falling rain, like in a Japanese wood block print.

Polishing. Smoothing the surface by fire, chemicals, or abrasion.

Pontil mark. Rough (unless it is ground smooth) mark left at the bottom of a blown piece of glass after it has been broken off of the pontil rod; also called "punty."

Pulegoso. Literally bubbled (*puliga* = air bubble), the technique uses randomly placed air bubbles of various sizes which sometimes burst on the surface of the glass like little craters.

Reticello (filigrana a reticello). Netted filigree where the threads criss-cross diagonally, usually with an air bubble in each diamond shape enclosed by the threads.

Retortoli (filigrana a retortoli). Twisted filigree in a spiral shape, also called *zanfirico.*

Rod. Monochrome cane, but the term cane is usually used.

Sandblasting. Glass is bombarded with grit (sand) which removes the surface for some etching and deep carving techniques; the surface becomes translucent and rough.

Satinato. Satin finish achieved by dipping in acid.

Scavo. Surface covered with half melted glass powders mixed with sand.

Sfumato. Technique producing a smoky effect by enclosing fine inner veils of color in the glass.

Slumped. Sheet glass heated and "slumped" into a mold.

Soffiati. Thinly blown, light weight glass.

Sommerso. Submerged glass, in which small particles or larger colored glass shapes are encased in clear or differently colored thick glass, usually producing a heavy and sculptural effect.

Tessere. Patches of glass in various sizes and shapes placed in a pattern and fused together.

Tessuto. Literally meaning fabric, spiral filigree or groups of canes produce a fabric or lace effect; also refers to fine parallel vertical canes.

Velato. Wheel carving done with a light touch, giving the glass a satiny finish.

Zanfirico. *Twisted thin glass threads wrapped around glass canes. Twenty distinct styles of the zanfirico* technique have been used by Venini. Other terms include *filigrano, latticino,* and *a retortoli.*

Selected Bibliography

Aloi, Roberto. *Esempi Vetri D 'oggi di Decorazione Moderna di Tutto il Mondo*. Milan: Ulrico Hoepli, 1955. Good reference with black and white illustrations. (Italian text)

Barovier, Marina. *Fantasie di Vetro*. Venice: Arsenale Editrice, 1994. Exhibition catalog with wonderful photographs of Venetian glass in mosaic and filigree techniques with a focus on fifties. (Italian text)

Barovier, Marina, ed. *Venetian Glass: the Nancy Olnick and Giorgio Spanu Collection*. New York: American Craft Museum, 2000. Arranged by artist in full-page color photographs, catalog of the glass with thumbnails, artist biographies with photos, glossary, bibliography by year.

_____. *Art of the Barovier Glassmakers in Murano 1866-1972*. Venice: Arsenale Editrice, 1993. Exquisite photographic history of Barovier glass and labels with text in English.

Barovier, Marina, Rosa Barovier Mentasti, & Attilia Dorigato. *Il Vetro di Murano Alle Biennali 1895-1972*. Milan: Leonardo Arte, 1995. Story of the Venice Biennales with color and black and white illustrations of pieces exhibited. (Italian text)

Barovier, Marino. *Il Vetro a Venezia*. Milano: Federico Motta Deitore, 1999. Nice color photos for identification. Companies, glossary, captions in Italian and English.

Barovier Mentasti, Rosa. *I vetri di Archimede Seguso dal 1950 al 1959*. Turin: Umberto Allemandi, 1995. Exhibition catalog of Seguso's 1950's work with beautiful color photographs. Introduction in French and English, captions Italian.

_____. *Venetian Glass 1890-1990*. (English translation edition) Venice: Arsenale Editrice, 1992. Oversized book with gorgeous color photographs and text by leading authority.

_____. *Venetian Glass*. Excellent video adaptation of the book, produced by Key Pictures, distributed by Award Video & Film, 3520 Bayou Louise Lane, Sarasota, Florida, 34242. (34 minutes)

_____. *Glass in Murano*. Venice: Chamber of Commerce, 1984. Examples of work from glassmaking companies currently operating in Murano are nicely presented together with essays on history and technology.

_____. *Mille Anni di Arte del Vetro o Venezia*. Venice: Albrizzi, 1982. Excellent illustrated reference on Venetian glass from the earliest examples up to the present; reprinted in 1988. (Italian text)

Barovier & Toso. *Objects*. 1998 catalog with great color photos and drawings of 1990s production.

Barr, Sheldon. *Venetian Glass: Confections in Glass 1855-1914*. New York: Harry N. Abrams, 1998. Beautiful color photos make this an excellent source for identifying 19th cent. glass.

Beard, Geoffrey. *International Modern Glass*. New York: Charles Scribner's Sons, 1976. Lengthy section on glass manufacturers and artists.

Bova, Aldo, et al, eds. *The Colours of Murano in the XIX Century*. Venice: Arsenale Editrice, 1999. Text in Italian and English with beautiful photographs of 19th century glass.

Byars, Mel. *The Design Encyclopedia*. New York: John Wiley & Sons, 1994. Many entries covering mid-century design with references.

Cappa, Giuseppe. *L'Europe de L'Art Verrier 1850-1990*. Liege, Belgium: Pierre Mardaga, 1991. Good section on fifties glass. (French text)

Christie's East. *An Important Private Collection of Italian Glass*. Nov. 30, 2000. Beautifully illustrated, 119 lots.

_____. Christie's East. *Venetian Glass*. Dec. 12, 1995. Excellent reference with 199 lots of Venetian glass, mostly circa fifties.

_____. Christie's Amsterdam. *Robots, Spacetoys, and Post-War Glass*. May 2, 1988.

_____. Christie's London. *Modern Glass and Ceramics*. June 23, 1987.

Cocchi, Maurizio. *Vetri di Murano del '900 , 50 Capolavari*. Milan: In Arte, 1991. Nice color photos for identification. (Italian text)

Corning Museum of Glass. *New Glass Review*. Corning, New York, 1982-present. Latest examples of glass art plus an extensive bibliography of recent publications about glass are featured in this illustrated annual.

_____. *Glass 1959*. Corning, New York: Corning Museum, 1959. Contemporary catalog of an international exhibit of modern glass with black and white illustrations; a classic.

David Rago Auctions. *20th Century Modern Auctions*. 1996-2002 catalogs. Beautifully illustrated catalogs primarily of mid-century furniture and glass, especially *Modern Italian Glass Auction*. Oct. 21, 2000. Excellent resource with 118 lots of Italian glass.

Deboni, Franco. *Vetri Venini*. Torino: Umberto Allemandi & Co., 1989. Lavishly illustrated monograph includes detailed technical information, artist biographies, and history of Venini. (Italian text)

Deboni, Franco & Maurizio Cocchi. *Vetri di Murano del '900: 50 Capolavori*. Milan: In Arte, 1991. Beautifully illustrated exhibition catalog with works by the major companies in Murano and a section on company histories and artist biographies. (Italian text)

Decorative Art Studio Yearbook. London: The Studio Limited. Annual publication, an excellent contemporary source for articles and illustrations of objects.

Domus. Milan: Editoriale Domus, 1928-present. Some of the best contemporary photographs of high style interior design and decorative arts can be found in this Italian periodical.

Dorigato, Attilia. *Ercole Barovier 1889-1974*. Vetraio Muranese. Venice: Marsilio Editori, 1989. Color illustrations and chronology of Barovier's work make this one of the best references on the subject. (Italian text)

_____. *Murano Glass Museum. (English edition)*. Milan: Electa, 1986. A history of Venetian glass illustrated with examples from the collection.

_____. *Murano il Vetro a Tavola Ieri e Oggi*. Venice: Museo Vetrario, 1983. Good illustrations make this a useful reference. (Italian text)

Eidelberg, Martin, ed. *Design 1935-1965 : What Modern Was:* New York: Abrams, 1991. Le Musée des Arts D'ecoratifs de Montreal organized an outstanding traveling exhibiton of decorative arts representing the period, including glass. This comprehensive catalog contains a wealth of information on artists, designers, companies, and design history.

Fifty/50. *Venini & the Murano Renaissance: Italian Art Glass of the 1940s & '50s*. New York: Fifty/50, 1984. Small, beautifully-illustrated exhibition catalog with information on companies.

Fischer, Jürgen. Murano Glass: An Important Private Collection. Dec. 2, 2000. German auction, organized by company, 199 lots beautifully illustrated, an excellent reference. (English)

Franzoi, Umberto, ed. *Art Glass by Archimede Seguso*. Venice: Arsenale Editrice, 1991. Beautiful catalog, among the best sources for examples of Seguso's glass and information about the artist and company.

Habsburg, Feldman. *Twentieth Century Decorative Arts*. Geneva: May 13 & 14, 1990. Well-illustrated auction catalog with an excellent section on fifties glass — 105 lots of mostly Venetian.

Heiremans, Marc. *Dino Martens*. Stuttgart: Arnoldsche, 1999. Excellent source for identifying Martens work through the 1960s, with color photos and archival black and white photos. (German, Italian, English)

_____. *20th century Murano Glass*. Stuttgart: Arnoldsche, 1996. Excellent reference on designers and companies, color illustrations, with section of labels for intentification.

_____. *Art Glass from Murano (Glas-Kunst aus Murano) 1910-1970*. Stuttgart: Arnoldsche, 1993. Comprehensive oversized book with stunning color photographs, nine pages of labels, artist biographies, and company histories.(English and German editions)

_____. *Murano Glas 1945-1970*. Antwerp: Gallery Novecento, 1989. Contemporary and new photographs make this small softcover book an

excellent reference for identifying Murano glass of the period. (German and English text)

Hiesinger, Kathryn. *Design Since 1945*. Philadelphia: Philadelphia Museum of Art, 1983. Excellent source for all of the applied/decorative arts, including glass. Essays written by designers and biography section.

Jackson, Lesley. *20th Century Factory Glass*. London: Mitchell Beazley, 2000. Lavish coffee-table book and excellent source for information and examples of international glass companies, including Italian.

_____. *New Look: Design in the Fifties*. New York: Thames and Hudson, 1991. Well-illustrated catalog of an exhibition by the Manchester City Art Galleries with examples of glass scattered throughout, plus a short section on fifties glass.

Klein, Dan & Ward Lloyd, eds. *The History of Glass*. London: Orbis, 1984. Survey with an especially nice chapter on glass since 1945.

Knower, Ramona & Franklin. *Erickson Freehand Glass*. Columbus, Ohio: Knower, 1971. Color and black-and-white photographs make this little catalog useful for identifying the glass.

Liegè, Museé Curtius. *Aspects de la verrerie contemporaine*. Liegè, Belgium: Museé Curtius, 1958. Black and white illustrations of a contemporay exhibition and a useful reference. (French text)

Losch, Rainier and Ursula et al. *Design of Form: Design of Color, Finnish and Italian Glass from the Losch Collection*. Museum Kunst Palast-Glasmuseum Hentrich: Dusseldorf 2002. Beautifully presented and written, this comprehensive and historical collection spans the works of five modern European designers: T. Lundgren, C. Scarpa, F. Bianconi, G. Nyman, and T. Sarapaneva. Extremely useful for identification of pieces, techniques, and dates. (German and English).

Mariacher, Giovanni. *Vetri Di Murano*. Milan: Carlo Bestetti, 1967. Multilingual history of Venetian glass with good color illustrations of glass by the major companies.

Masters of Murano. Wonderful video showing three master Muranese glass artists at work. Landmark Films, 3450 Slade Run Dr., Falls Church, Virginia 22042. (17 minutes)

Micheluzzi Massimo. *100 Vetri di Archimede Seguso dal 1937 al 1996*. Nice little overview of Seguso's work. Italian text. Italy, 1996.

Migliaccio, Puccio, ed. *Vetri in Tavola (Glass for the Table)*. Venezia: Arsenale e Junck, 1999. Small paperback catalog with excellent photos, plus Fratelli Toso catalog pages from 1900. (Italian and English)

Moretti, Carlo, et al. *Carlo Moretti: Cristalli di Murano 1958-1997*. Venice: Editoriale Giorgio Mondadori, 1997. Chronological overview of the work in beautiful color illustrations. (Italian text)

Murano: Il Vetro la sue Gente/ Murano: Its Glass and its People. Venice: Consorzio Venezia Vetrro, 1986. Nice hardbound book produced by the Italian government to promote Venetian glass, with history, glossary, and color photos of current products.

Murano Magic: The Marvelous Glassmakeres of Venice. http//www.boglewood.com/murano/production. Muriel Karasik Gallery. *The Venetians: Modern Glass 1919-1990*. New York: Muriel Karasik, 1989. Beautifully-illustrated exhibition catalog with essays by curator William Warmus and glass designer Thomas Stearns.

Neuwirth, Waltraud. *Italian Glass 1950-1960* . Vienna: Waltraud Neuwirth, 1987. Exhibition catalog in English, French, German, and Italian; an excellent source for identifying pieces from contemporary black and white and recent color illustrations.

Ohira, Yoichi. *A Guide to Venetian Glass*. Padora: Edizioni, 1991. Brief, but nicely-illustrated glossary of 16 terms in Italian, English, German, French, Spanish, and Japanese.

Osborne, Carol. M. *Venetian Glass of the 1890s: Salviati at Stanford University*. London: Philip Wilson, 2002. Beautiful exhibition catalog of early Salviati glass.

Piña, Leslie. *Fifties Glass, 2nd ed*. Atglen, Pennsylvania: Schiffer: 2001. Revision of 1993 edition, with additional examples and information on Italian glass.

_____. *circa Fifties Glass*. Atglen, Pennsylvania: Schiffer, 1997. Emphasis on Italian and Scandinavian glass plus American examples in color plus labels, illustrated glossary, biographies, and histories.

Polak, Ada. *Modern Glass*. New York: Thomas Yoseloff, 1962. Good black and white illustrations and historical survey of European and American glass from the first half of the twentieth century; a classic.

Quittenbaum. *Murano-Glas 1920-1970*. April 8, 2000. Munich auction house with sumptuous catalogs. 136 lots beautifully presented.

_____. *Murano-Glas 1910-1990*. June 9, 2001. Italian glass in 293 lots.

_____. *Murano-Glas 1910-2000*. March 23, 2002. Overview of twentieth-century Italian glass in 167 lots.

Ricci, Franco Maria. *Venini: Murano 1921*. Milan: FMR, 1989. History of Venini illustrated with stunning oversized color photos.

Ricke, Helmut and Eva Schmitt. *Italian Glass Murano/Milan 1930-1970: The Collection of the Steinberg Foundation*. Munich and New York: Prestel-Verlag, 1997. Exhibition catalog with large color photos and information on manufacturers and artists.

Rizzi, Paolo. *I Quaderni di Archimede Seguso*. volumes 1-14. Firenze, 1994-2000. Nice series of 16-page volumes with text illustrated with Seguso's work. Italian and English.

St. Petersburg Museum of Fine Arts. *Murano Glass in the Twentieth Century*. St. Petersburg: Museum of Fine Arts, 1983. Exhibition catalog with good illustrations, useful for identification.

Skinner, Inc. *20th Century Italian Art Glass*. Boston, Oct. 27, 1995. Outstanding reference with 261 lots of glass, mostly fifties Venetian. Skinner sales in the category "Art Glass & Lamps, Arts & Crafts, Art Deco & Modern" also include fifties glass at both Boston and Bolton Massachusetts locations.

Smithsonian Institution & Venini International. *Venini Glass*. Washington D.C.: Smithsonian, 1981. Catalog of a traveling exhibition with historical background, excellent chronology of Venini, a glossary, and good illustrations provided by Venini.

Sotheby's. *Important 20th Century Glass: the Hal Meltzer Collection*. May 16, 1998. Includes 133 lots of Italian glass in beautiful photos.

_____. *English & Continental Glass 1500-1960*. London, March 25, 1991. Includes 149 lots of Venetian glass, mostly circa fifties.

_____. *Arti Decorative del Sec. xx*. Milano, Dec. 13, 1990. Includes 95 lots of Venetian glass, mostly fifties.

_____. *Venetian Glass 1910-1960*. Geneva, Nov. 10, 1990. Beautifuly-illustrated hardbound auction catalog and an informative reference with 141 lots of circa fifties Venetian glass.

_____. *Glass Since 1945: The Dan Klein Collection*. London, Nov. 29, 1984. Pioneering collection and auction with 139 lots of fifties glass.

_____. Sotheby's. *Arts Decoratifs Styles 1900 et 1925*. Monaco, Oct. 9, 1983. One of the first auction catalogs to introduce fifties glass with 41 lots.

Stennett-Willson. *The Beauty of Modern Glass*. London: Studio, 1958. Well-illustrated book written in the 1950s, provides a good contemporary view of glass.

Toso, Gianfranco. *Murano: A History of Glass*. Venice: Arsenale Editrice, 2000. Little paperback book filled with excellent history and illustrations.

Treadway Gallery. *Important Italian Glasss*. Cincinnati: Don Treadway and Ripleys' Antiques Galleries, November 15, 1992. Auction catalog of 256 lots of Italian glass, with a focus on the 1950s; an excellent source for identification and pricing with two pages of illustrated labels. In addition, Treadway's regular "Twentieth Century" sales, to the present, have included fifties glass.

Venini Diaz de Santillana, Anna. *Venini Catalogue Raisonné 1921-1986*. Milano: Skira, 2000. Sumptuous color pictures, plus black and white illustrated chronology and catalog pages, glossary, bibliography by year.

Venini spa. *Venini Glass Objects 2000*. Company catalog with new designs and reissues.

Vetri Veneziani del '900: La collezione della Cassi di Risparmio di Venezia Biennali 1930-1970. Venice: Marsilio Editori, 1994. Rosa Barovier Mentasti curated this exhibit; the catalog has excellent photographs, artist biographies, and detailed chronology. (Italian text)

Wright 20th Century Auctions, Chicago. Gorgeous catalogs focus on furniture and other modern decorative arts including Italian glass.

Index

US $69.95

9780764319297 56995

ISBN: 0-7643-1929-9